Contemporary
Painting
in Context

Contemporary Painting in Context

edited by **Anne Ring Petersen**
with **Mikkel Bogh**
Hans Dam Christensen
Peter Nørgaard Larsen

Museum Tusculanum Press
University of Copenhagen 2010

Anne Ring Petersen, Mikkel Bogh, Hans Dam Christensen and
Peter Nørgaard Larsen (eds.). *Contemporary Painting in Context*

© Museum Tusculanum Press and the authors, 2010
Copy editor: Jordy Findanis
Layout, typesetting and cover design: Åse Eg Jørgensen
Printed by Narayana Press, www.narayanapress.dk
ISBN 978 87 635 2597 8

This volume is part of five planned titles in the series
The Novo Nordisk Art History Project

About the series:
The Novo Nordisk Art History Project explores the intersections
between art history and cultural history. The overall aim of the
project is the presentation and development of new perspectives
in a contextual approach to the analysis of visual art and culture.

Series Editors:
Mikkel Bogh, Hans Dam Christensen,
Peter Nørgaard Larsen and Anne Ring Petersen

Forthcoming titles:
Images of Culture: Art History as Cultural History
Anthro/Socio: Towards an Anthropological Paradigm in Practices,
 Theories and Histories of Art?
Let's Get Critical: Reception in Art History and Art Criticism
Documents: Art, History and Cultural Memory

This book is published with financial support from
The Novo Nordisk Foundation

Museum Tusculanum Press
126 Njalsgade
DK-2300 Copenhagen S
Denmark
www.mtp.dk

Contents

Introduction

Anne Ring Petersen

> The monster of painting absorbs you with lightning speed; the
> great, embracing and possessive mother of painting. Even street
> art is roped in – for better or for worse. And in there you will meet
> all the others, all the other artists that you thought you rebelled
> against. You will meet all the old cousins, all the old arseholes and
> ghosts. It is a scary place, and it is here, in the centre, that *The
> Battle* takes place. But it is here you should be. You will end up as a
> diehard if you try to stay on the periphery. The challenge is to be in
> the centre where the others are sitting.
>
> Tal R, interviewed in *Politiken*, 1 September 2007

Two attitudes have been prevalent in the discourse on painting of the last
decades. One has been inherited from the 1960s and implies that paint-
ing is a burnt-out institution that only survives thanks to the demand of
the art market for this utterly conservative and outmoded art form. This
attitude is probably motivated by the fact that today's painting is the off-
spring of a centuries old tradition of easel painting as well as a medium
that has not cut its ties to Modernism; on the contrary, the legacy of non-
figurative painting constitutes an important and clearly visible historical
background of contemporary painting. Thus, painting is still the medium
that most readily lends itself to formalist interpretations although few
contemporary painters have purely formalist intentions. The other at-
titude implies that painting is still going strong. It has been fused into
innovative hybrids with so many other art forms and media that it has
transformed itself and transcended its former limitations. Its possibilities
of expression and its diversity seem to be limitless, and the only common

denominator to be identified is that painting, like most contemporary art, rests on a conceptual basis. These opposing views on the state of painting place recent painting in an ambivalent position as a discipline that appears to be simultaneously exhausted and inexhaustible.

The reason for this is not only to be found in the long history of painting itself, but also in the common visual culture and the development of new types of image production and consumption, of new optical systems and new types of visual experience – a development in which painting takes part. On the one hand, painting has lost ground to new visual technologies. Thus, it is a commonly held opinion that painting, with its time-consuming mode of reception and short distance of communication, loses the competition with the fast and far-reaching electronic media and the cheaper, mass-reproduced types of pictures. On the other hand, visual culture, consumer culture, and the general historical processes of transformation are also vital sources of the ongoing self-renewal of painting and its inexhaustibility.

The purpose of this anthology is to explore the transformation and expansion of the field of painting over the last decades in relation to the more general lines of development in contemporary culture and visuality. It poses questions like: How do paintings present themselves to us today; how are they 'framed' experientially, institutionally and culturally? In which way can paintings of today be said to reflect and reflect on the historical transformations of culture, visuality and image production and consumption? Is it possible to 'explain' some of the changes and extensions of the field of painting by placing it in the wider context of cultural history or visual culture studies? And which methodological challenges does such a heavy-handed contextualisation pose to an aesthetic discipline in which many art works are based on the suggestive effects of colours and abstract or semi-abstract forms?

The continued presence of painting today raises a series of questions. The essays in this book do not answer all of them. They are based on papers presented at the conference "Contemporary Painting in Context" held in Copenhagen in November 2005 as part of the Novo Nordisk Art History Project. The ambition of the conference was to present an up-to-date overview of how artists and scholars can engage with 'painting' in a critical way that focuses on how various social, economic and cultural factors have shaped the practices and discourses of painting and contributed to make 'painting' what it is today. Hence, the core of the conference

was not 'painting' as an esoteric art form reflecting on its own internal state, but rather as an art form bound to the cultural meanings, spaces, media, modes of perception, etc., that characterise our time.

The contributors to this anthology pursue five lines of inquiry. Accordingly, the book is divided into five parts. The issue at stake in the first part, "Painting in the Common Culture", is the question of how painting can be situated in relation to a wider cultural context by focusing on the relationship between recent developments in painting, its 'contemporaneity', and "the scopic regimes" (Jay 1988) and historical processes of late modernity. Jonathan Harris's opening essay, "'Contemporary', 'Common', 'Context', 'Criticism': Painting after the End of Postmodernism", identifies some of the keywords of the discourse on 'contemporary painting' and examines their conceptual complexity and ideological values and meanings. He disentangles the intricate relationship between the term 'painting', which is complicated in itself, and the two terms 'contemporary' and 'modern'. Both of them have an ambiguous relationship to 'the past' and 'the future' and to notions of topicality and historical development. Jonathan Harris also discusses the nature of art criticism – 'modern' as well as 'contemporary' – and puts forward his own thought-provoking contention "that we have lost painting, and modern art, from an understanding that is anything other than – for want of some better words! – tendentiously *fictionalised, made-up, far-fetched*, or what I will call *subjunctural*." Art is always an object of subjective interpretations, not of true and certain knowledge. So, what criticism does, according to Harris, is not to produce factual definitions of what art really is or objective criteria of evaluation of art, but to produce subjective wishful thinking about what art could be.

The text by Peter Weibel was first published in the exhibition catalogue of an important exhibition of paintings from the 1990s, *Pittura Immedia. Malerei in den 90er Jahren*. The show was curated by Peter Weibel at Neue Galerie am Landesmuseum Joanneum and Künstlerhaus Graz in Graz, Austria, in 1995. Originally published in German, "Pittura/Immedia: Painting in the Nineties between Mediated Visuality and Visuality in Context" is now available in English in an unabridged version for the first time. Peter Weibel's article is one of the most perceptive surveys of the ways in which 'painting' was transformed when artists started to appropriate images and techniques from mechanical and electronic media like photography, film, TV, video and, more recently, the

computer and the Internet. After discussing the historical development of abstract painting and how it has shaped the practices of contemporary painting, he proposes that recent mediated painting is characterised by *immediation*, that is, a process of going through different media before ending with a 'painting' that restates the question of the nature of the visual with an emphasis on its mediated, coded and contextual character. Weibel stresses that this mediation of the painted image should not be seen as a sign that painting has become inferior or subservient to mass media and new technology. "Post-medial painting" should rather be perceived as a kind of second-order painting that is capable of outdoing and transcending the mass media. Peter Weibel identifies two dominant *modi operandi* in contemporary painting: "Mediated visuality" involves an attempt to redefine the painted image by stressing mediation, instead of the immediacy associated with painting in the Romantic-Expressionist tradition, and by connecting painting to the wider context of visual culture; "Visuality in context" involves a heightened sensitivity to the way in which images and works of art construct their own physical and discursive spaces, e.g. a painting in a museum, or a photo in the newspaper. The two methods of operation are interdependent. As Weibel concludes, "This new type of painting enters a sea of mediated visuality and ponders anew the visual in a context of technical images."

As Weibel pointed out in his keynote address at the conference, 'painting' has lost its former superior and hegemonic position to the machine-based media that permeate everyday life and mass culture with their reproducible and widely circulated images constituting an image culture of immense proportions. According to Weibel contemporary painting has developed into a "vampire" that sucks the blood of the other media. As painting is also a stable 'storage medium', its future *raison d'être* could be to serve the mass media and digital media, with their fugitive images and information and their relatively short storage time – as an agent of selection as well as storage. Hence, Weibel suggested that even immediated painting, or, rather, especially that kind of painting, upholds painting's old function as a guardian of collective memory for posterity.

While Peter Weibel's essay focuses on mediation and the impact of visual mass culture as something endemic in the paintings of today, the essays in the second part of the book, "Rethinking the Ontology of Painting", address the question of how to define the ontological nature of painting today. It is a long time since we left behind the modernist

notion that painting has a universal and irreducible 'core' or 'essence' that remains unchanged at all times. The definition of painting changes inexorably over the course of history. As American art historian Michael Fried has observed, the form of painting regarded as important during a given phase of history is the form of painting that can convince its audience that it complies with the current paradigm (Fried 1995). Thus, the task of contemporary painters is not to seek for the essence of painting, but to discover the conventions and rules, or the *model*, that will establish their works as paintings pertinent to their own time (Bois 1993). Thus, one could ask: Must one consent to Jonathan Harris's conclusion: "So the situation exists now where there is no possible meaningful (that is, adequate or compelling) definition of painting and no consensus either about how people have been trying to make sense of this situation for ten years or so." Or could painting be redefined as a discipline with certain identifiable characteristics? If so, what is the prevalent model or models of 'painting' today? And what has become the prevalent model of spectatorship in relation to this type of painting?

In "Object or Project? A Critic's Reflections on the Ontology of Painting," Barry Schwabsky discusses the central problem in speaking about the ontology of a specific medium: 'an ontology of painting' requires the identification of some specific characteristics of painting. As Schwabsky notes, "Painting would have to be a particular category of being." Taking the hybridity and the countless different manifestations of painting today into consideration, it is not possible to uphold such a conviction in the material and technical distinctiveness of painting as an object. Barry Schwabsky takes the commonly held notion of today's art world that contemporary painting is "essentially conceptual" as a starting point for considering an alternative way of explaining why, despite his rejection of ontological explanations, he – like many others – still feels that there is a particularity to 'painting'. Schwabsky proposes that if we wish to pinpoint the particularity of 'painting', we should not primarily be looking at the material objects themselves, but rather at the artistic project, that is, at the artistic intentions, concepts and processes that govern the creation of paintings.

Taking another approach to the difficulty in defining the specificity of painting, Stephen Melville shifts the focus of the discussion on ontology away from the artist's intentions and towards the spectator's experience. In his essay "Painting: Ontology and Experience," Melville uses

some of the observations made by Michael Fried in his seminal essay on Minimal Art, "Art and Objecthood", to renew the discussion on the relations between painting and experience. One of the things that Michael Fried made clear was that Minimalism differed from Modernism in that it valued the beholder's subjective experience of the object instead of the art object in itself. Melville deduces the "art-specific moral" from Fried's general reflections on the slippery notion of experience that "painting does not exist outside the experience of painting", which means that 'painting' presupposes that somebody is there to have that experience; 'painting' is not simply given as an object. Redefined in this phenomenological way, the term 'painting' makes more sense, also as a designation of the new installational type of painting introduced in the next part of the anthology, "The Expanded Field": the often site-specific crossover between painting and installation art that colonises entire rooms, transcending the flatness of painting that Modernist critics celebrated as an 'essential' quality of painting, as it turns the object painting into a spatial ambience that surrounds the viewer.

In a much more radical sense than 'conventional' easel painting these recent works are organised around the individual experience of a viewer who, almost literally, has to enter the work in order to perceive its spatial and painterly qualities. The phrase "The Expanded Field" originates in another essay on the Minimalists and the generation of artists who followed on them: American art historian Rosalind Krauss's "Sculpture in the Expanded Field" from 1978. In this influential essay Krauss formulated a theory of how sculpture in the 1960s and 1970s developed into an inclusive, expanded field where a new relation to place and space and a new freedom in the treatment of various materials and structures became possible (Krauss 1987). The expansion that Krauss is talking about is not a merely quantitative expansion, an inclusion of the sculptural materials and means of expression that makes it possible to construct sculptures out of mirror glass, soil or felt and enlarge them to the size of Robert Smithson's *Spiral Jetty* (1969-70). It is not synonymous with an expansion of the discipline 'sculpture' in itself. What Krauss identifies as 'the expanded field' is a new set of relations between 'sculpture' and two other categories that are not 'sculpture' and cannot be subsumed under the category of 'sculpture': 'architecture' and 'landscape'. Thus, in Krauss's terminology 'the expanded field' is an expression that refers to the exploration of innovative interrelations and combinations between

categories that are fundamentally different, not the limitless and eclectic assimilation of new stuff. Thus, the primary thing that the explorations added to sculpture was not greater variety, but a new set of cultural terms and structural principles with which to work.

As Stephen Melville notes, the notion of a medium's relational existence within an 'expanded field' at first proposed by Krauss has subsequently lost much of its initial rigour. It now denotes little more than that the discipline in question has vastly expanded its means of expression and range of materials and has developed a considerable overlap with other disciplines and media. Melville introduces a useful distinction between practices that continue to explore the complex relations between the syntax of historical disciplines like painting, sculpture and architecture, and other practices that try to free themselves from this syntax altogether, as can be seen in parts of installation art and in the kinds of contemporary art sometimes termed relational aesthetics, interventionist strategies, etc.

The German artist Katharina Grosse is an internationally renowned representative of the first kind of practice. Her contribution to the third section, "The Expanded Field", offers the reader a privileged insight into her way of working and the considerations underlying the execution of her large-scale projects. In "The Poise of the Head und die anderen folgen," Katharina Grosse reflects on the relations between painting and architecture and on the perception of space, colour and form. In her comments on the drifting point of view of a mobile spectator that her installations presupposes, Grosse expresses a notion of 'painting' as existing only in the experience of painting which is akin to that of Stephen Melville. Katharina Grosse has designed the blocks of texts, the illustrations and the general graphic layout of her essay as an integrated whole that sets itself off from the layout of the rest of the book. In this way she has succeeded in creating, or 'installing', her own painterly space inside the book. Starting with a snapshot of a pair of yellow rubber boots worn by a little boy on a visit to an art museum, she guides us through a series of projects that shows us the scope of her work and how she blends the syntax of painting with the syntax of site-specific installation in order to transform the meaning of 'the support' – in Grosse's case, the architecture of the room she paints and the objects and materials she brings into it – and in order to enhance the temporal and performative quality of her works and the viewer's experience of those works.

Today, it is a commonly held opinion that over the last decades painting has undergone an expansion similar to that of sculpture in the 1970s. This transformation – some critics would call it a dissolution – of the discipline of painting is the subject of the second essay in part three, "Painting Spaces" by Anne Ring Petersen. Until the 1970s, painting usually extended the traditional domain of figurative painting either by exploring the possibilities of abstraction or by appropriating images from popular culture and the mass media. In recent years, Ring Petersen observes, a remarkable number of painters have begun to explore the possibilities of broadening the definition of what constitutes 'space' in relation to painting. Today much of the experimental energy is put into expanding the medium physically by exploring painting's relations to objects, space, place, and various aspects of everyday culture. After sketching out some of the ways in which artists can transform painting into a three-dimensional work or explore the relations between painting and its physical and semiotic contexts, Ring Petersen focuses on works of art that are conceived as an installation based on the medium of painting. She explores how the transformation of painting into installational painting affects the relationship between the work and its contexts and viewer, and she proposes that installational painting is characterised by an ambiguous relationship to its contexts as it represents both an opening of modern painting towards the surrounding world and a withdrawal from it that is at odds with the bulk of the activities in contemporary art. In part four the perspective shifts away from the 'expansion' of painting to the 'critique' of painting, and more specifically the critique of the gender bias within this discipline. Thus, the essays in part four, "Painting and the Question of Gender-Specificity", open up the discussions on painting for wider social and political questions of identity politics, power and marginalisation.

One of the reasons why painting became such a hotly disputed discipline in the 1960s and 1970s is the gradual unmasking of the strong male domination in the field of painting and in the art world in general. It is feminist art historians and artists who have taken the lead in the critical examination of the gender hierarchy in the institutional system of the visual arts. They are the ones who started asking questions such as the one that Linda Nochlin used as the title of her influential essay from 1971, "Why Have There Been No Great Women Artists?" Linda Nochlin and other feminists of the 1970s and 1980s pointed out that the art-historical canon of great Western masters only included male painters, and that

women artists had very little chance of gaining recognition on their own terms. Making a career within this field was difficult because tradition had created the prejudice that women were unable to make real 'masterpieces.' Accordingly, many women artists preferred to work within other disciplines or develop new fields like body art and video art.

Since the 1990s this situation has changed dramatically. Quite a number of women have chosen painting as their primary medium. Think of painters such as Laura Owens, Elizabeth Peyton, Angela de la Cruz and, in a Scandinavian context, Judith Ström, Cecilia Edefalk, Tiina Elina Nurminen, Kathrine Ærtebjerg and Ellen Hyllemose.

The new generations of women painters often use a palette of pastels, a girlish pictorial language, or other visual effects and signs that are readily associated with femininity. By doing so they are challenging the established notions of what a 'powerful' or 'great' painting could be, and their works call for a re-evaluation of such vital questions of gender-specificity in painting as: What are the connections between gender and the choice of medium, style, subject matter, and pictorial means of expression? Does it make any difference whether a painting has been created by a man or a woman? Are there any significant differences between the way women and men use and express themselves through artistic media? And, finally, can art – and painting in particular – contribute to the critique of the stereotyped notions of masculinity and femininity?

In "Claims for a Feminist Politics in Painting," Katy Deepwell discusses the historical conditions for a feminist politics in painting today. Deepwell points out some of the problems that painting has posed for feminist artists in the last forty years. Feminists have generally regarded painting as an exclusionary discipline that historically has been dominated by canonised white male painters and subjected too long to a narrow formalist agenda inherited from Modernism. Deepwell avoids the usual negative conclusions concerning painting's relevance for feminist projects by blurring the lines of the claims to medium specificity. This broadening of the definition of painting enables her to uncover a number of hitherto overlooked overlaps and continuities between the tradition of painting and early feminist art works that have usually been placed in the categories of other media like performance and installation art. The uncovering of historical contact zones between painting and feminism finally leads Katy Deepweel on to contemporary women painters and their constructive ways of employing feminist strategies in figurative painting.

Like Deepwell, Rune Gade begins his explorations of the gender implications underlying the declarations of 'the end of painting' in the 1960s, or, to be more specific, in the late sixties when conceptual art was promoted at the expense of painting, and body art, informed by among other things feminism, made its entrance on the art scene. In "Matter and Meaning: 'The Slime of Painting,'" Gade refers to American art historian Jane Blocker's account of 'the death of painting' as being closely related to a both somaphobic and a misogynist bias in the writings on painting from this particular moment in history. According to Blocker the real threat that feminism and upcoming women artists posed to the hegemony of men in the art world was displaced and projected onto painting which was regarded as a menace to the intellectual aspirations of male artists at the time. Hence, it was because painting was considered a threat to masculine identity and hegemony that it was rejected and declared dead. Gade then brings Blocker's critique up to date by demonstrating that this disparaging 'feminisation' of painting still plays an active, but rarely recognised, part in what art historian Jason Gaiger has called "post-conceptual painting." Rune Gade examines the discourses informing a prominent example of this, Jonathan Meese and Tal R's collaborative work Mor ("Mother") – a spectacular hybrid installation that integrated and foregrounded the gesture of painting in the work as its dominating effect. It is a work that at first glance looks like an innovative experiment, but at closer scrutiny turns out to carry with it old stereotypes of masculinity and femininity that are articulated not least by means of a 'messy' and 'slimy' expressionist use of pink paint.

The last part of this anthology, "Painting, Institutions, Market", deals with the role of painting in the institutional and economic systems in order to shed light on the ways in which they contribute to sustaining the high status of painting. At least as a starting point, their holding of painting in high esteem must be seen in relation to the historical adaptation of these systems to primarily painting. That other, mostly new, media have been less adaptable to institutional and economic interests (e.g. digital art, performance art, installation art) might be an indirect token of this adaptation. Gitte Ørskou's essay focuses on the public art museum, Chintao Wu's essay on the private collector. What they have in common is a critical approach to the institutional and economic role of painting. Gitte Ørskou examines how the hegemony of painting in the permanent museum collections is being seriously challenged, even undermined, by new

acquisition and exhibition policies. By analysing the way in which the British art collector and art dealer Charles Saatchi operates in the world of contemporary art, Chin-tao Wu points to the danger of economic exploitation that basically threatens all kinds of art, but easel painting more than other media because of its marketability caused by the fact that it is durable, easily circulated and readily recognised as 'Art'.

In "The Longing for Order: Painting as the Gatekeeper of Harmony," Ørskou sets out to revise the role of painting in art museums which have historically defined a certain set of codes that determine the curatorial approach as well as the reception of paintings by the museums' visitors. Ørskou proposes that the advent of new art forms like photography, video art and installation art has substantially altered the way in which easel painting is displayed. While the paintings may basically still look the same – "a square, flat surface covered with paint and either figurative or abstract in content" – they are not approached and experienced in the same way by contemporary viewers. The visitors have grown accustomed to the new art forms inviting the viewer to take an approach that is different in terms of bodily, perceptual, cognitional and interactive engagement in the work of art. This familiarity affects painting, too, Ørskou argues, changing both its exhibition qualities and the way the audience relates to it, eventually turning painting into "the gatekeeper of harmony".

In "YBA Saatchi? – from Shark Sensation to Pastoral Painting," Chin-tao Wu sheds light on the influence of 'the market' on painting today by analysing the strategic and economic motives of private collector Charles Saatchi for turning to collecting 'traditional' paintings on canvas. The case of Charles Saatchi is interesting because he originally won his powerful position in the British art world and his international fame for promoting the so-called YBA generation in the 1990s – that is, young British artists like Damien Hirst, Sarah Lucas, Marc Quinn and Tracey Emins who produced spectacular and often provocatively realistic art in 'new' media that placed the artists and their collector in the spotlight of the mass media. Wu investigates Saatchi's skilful use of the media in 2005 at the time he was launching his scheduled series of exhibitions *The Triumph of Painting,* and she discloses the string of companies that Saatchi had set up for his art trading activities. She also suggests that Saatchi's considerable investments in painting from Germany may be motivated by a wish to make the name Saatchi known in Europe before the planned expansion of

the advertising company M&C Saatchi into the European market, rather than by aesthetic and philanthropic interests alone.

The five parts of *Contemporary Painting in Context* concentrate on different issues, but many of the essays are interconnected by three recurrent questions or leitmotifs. The first question concerns the *expansion and transformation* of the traditional practice and notion of 'painting' which leads to attempts to define as well as to discussions of the nature of the recent conceptual and material transformations of the object 'painting'. The second question concerns *painting* and *experience*. It is closely related to the first, but leads in another direction. The first question emphasises the 'production side' of painting, its 'objectivity', so to speak, meaning here its existence as a material object. The latter foregrounds the 'reception side' of painting. It focuses on 'subjectivity', that is, the 'meaning' a painting makes and the 'experience' it gives to the perceiving subject.

The third question is about the interrelations between *painting* and *discourse*. In this case, the contributors' attention is not given primarily to the processes and material manifestations of painting – that is, the paintings and the practice of painting – nor to the response of spectators. Attention is focused on the institutional role of the discipline of 'painting' and the way the characteristics of 'painting' and 'paintings' are articulated, contested, attacked, defended, politicised and gendered in the writings of artists, critics and art historians. For most of the contributors, taking the discourses on painting into consideration becomes a way to emphasise that works of art are not autonomous, that the study of 'contemporary painting' cannot be reduced to the study of the objects, the 'paintings' themselves; they must be studied in the relevant context, that is, examined in relation to the ways in which they are experienced, the ways people speak about them, the ways they are perceived, interpreted and 'translated' into verbal texts, the ways in which they are exhibited, and the ways they relate to wider social, political and economic structures. In several essays the analysis of historical discourses on painting becomes a means to revise and update some of the theoretical positions inherited from the last century: those of Clement Greenberg, Rosalind Krauss, feminist thinkers, and, not least, Michael Fried, whose essay "Art and Objecthood" is a recurrent reference in this book. What is at stake here is a reconsideration of which parts of this legacy can provide starting points and theoretical frameworks for the discourse on paintings

of today. This reconsideration is important inasmuch as it corresponds to considerations among contemporary painters of how Modernist and Conceptual traditions can be carried on and at the same time redefined and tuned to the different historical context of the twenty-first century. Hence, this anthology bears witness to a widespread recognition among artists and scholars that paintings present themselves differently to viewers in the present historical and cultural situation which foregrounds technically sophisticated and interactive digital media as well as the traceless transfer and flexible exchange of images and codes between media. Moreover, it shows that, even in an age dominated by technical reproduction media, there is still a need for 'painting' and a general recognition that there is some kind of particularity to painting, even though this particularity has become increasingly difficult to define.

Bibliography

Bois, Yve-Alain (1993), *Painting as Model*, Cambridge, Mass. and London: The MIT Press.

Fried, Michael (1995), "Art and Objecthood", in *Minimal Art: A Critical Anthology*, ed. Gregory Battcock, Berkeley, Los Angeles, London: University of California Press: 116-147.

Jay, Martin (1988), "Scopic Regimes of Modernity", in *Vision and Visuality*, ed. Hal Foster, Seattle: Bay Press.

Krauss, Rosalind (1987), "Sculpture in the Expanded Field", in *The Originality of the Avant-Garde and Other Modernist Myths*, Cambridge, Mass. and London: The MIT Press: 276-290.

Ross, Trine (2007), "Der hvor døden er et eksploderende jordbær" ("Where Death is an Exploding Strawberry"), interview with Tal R, *Politiken*, 1 September.

Part One: Painting in the Common Culture

'Contemporary', 'Common', 'Context', 'Criticism':
Painting after the End of Postmodernism

Jonathan Harris

…"I forget whose marble fireplace, there was certainly more than one Zack peed in. He was pathetic when he was drunk. He had no gift for alcohol, not like Ruk, who was always aware, always civil. Zack reverted to infancy, this drastic insecurity and megalomania, burbling, showing his penis, doing what it took to make himself the center of attention, punching somebody. He liked upsetting a table with all the food on it. He did that to me more than once." The Thanksgiving feast with his family from California; the gallery party after the *Life* article had come out and celebrity had turned him ugly: the incessant ornate humiliations of those last Long Island years, all her attempts to make a decent home overturned and rebelled against, have unexpectedly affected Hope's eyes, Old age does that: senility of the ducts. As a young woman, she took pride in never crying, no matter how stung or insulted – in not giving the evil, creaturely, colorful world the satisfaction.

John Updike, *Seek My Face* (London, Penguin: 2002): 53-54

What 'Hope' for Painting, then?

Painting once again, perhaps, as what T.J. Clark called "a practice, a set of possibilities, a dream of freedom"? (Clark 1999b: xxx). Or painting as the opposites of these: a dead end of futile moves 'not adding up to a language'; a set of impossibilities, illusions, and *dis*illusions; a nightmare

of slavishly "ornate humiliations" and overturned tables? And what about commentary: where would (what would) painting be without criticism – without the intervening voices and the difficult essays, all the "typing and the writing", to paraphrase Greenberg? For sure, we have all these things still, *now*, painting as a practice or set of practices; myriad species of paintings, indeed, in their tens of thousands, like migration time on the Serenghetti Plain; critics and rhetorics; analysis and voluble dream work. The contemporary art world is a boiling, capacious, polyvocal, pluralistic engine of global productivity: *Biennial-isation* has happened, a kind of mega-cultural fusion spitting and splitting new forms and formations, new funding and support agencies, new intermediaries and professional types, new kinds of celebrity art and artist, locked into capitalist globali-zation and its shadow statist cultural policy incarnations, swallowing up the radicals, the dissidents, and the discontent, along with the rest – of-fering them space, place, to create and relate, engage and enrage, to ex-plain and disdain, within a new political-economy of contemporary art.

Painting is in there still, jostling for position, wondering where it stands within the hierarchy of artistic production (wondering if there is a hierarchy at all), and anxious about how it gets its own representations represented. John Updike calls his Lee Krasner Pollock character "Hope" in his 2002 novel *Seek My Face* – an extract from which I began my es-say with. Zack, of course, is make-believe son of Jack*son* Pollock and several of the other characters in the novel are spun fictional lives close, or not-so-close, to those Abstract Expressionists who themselves entered a mythological realm within art history and its popular representations after the 1950s. Updike suggests strongly that it was Pollock's *perform-ance* in Hans Namuth's film of 1950 that pushes the poor man back over the edge, robbing him of self-respect and the ability to work relatively sanely again: Pollock is made to portray, prostitute, himself on film, to parody and travesty his own body and psyche – and to produce 'Pollocks' in inverted commas, filmed from below a sheet of glass. A desperate kind of hard-core porn painting: spurt and posture this way, Jack (or Zack), come onto the glass. Let's do it again and again until you get it right – don't think about it, make the control automatic, for the camera.

Updike introduces other half-echoes of American artists after Pollock, but these are 'composites' or 'factions', confusing amalgamations of the 'real' – but also mythified – artists. After Zack dies, Hope marries an artist Updike calls "Guy Holloway", described as "Pop art's super-

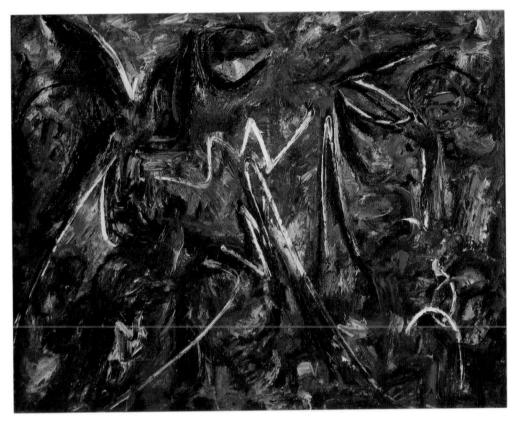

Lee Krasner:
Blue Painting, 1946.
Oil on canvas,
66 cm × 71 cm.
Pollock-Krasner
Foundation /
ARS New York.
Billedkunst.dk

successful boy wonder", suggesting aspects of Warhol, Rauschenberg, Lichtenstein, and Johns. Guy is portrayed as a closet bisexual. The 'reality-fiction' dichotomy is played on, and played up, throughout the novel: artist characters before the 1950s and 1960s are given the names of 'real' artists: so we hear of painters called "Kandinsky" and "Malevich" (good names those!) and the Americans "Grant Wood", "John Stuart Curry" and "the Soyer brothers". Are these names real or fictional? Are the referents for these names the same as the referents for these names when they appear in the art history books? A character called "Clem" is a fictional critic close for a time to "Zack", whose last name, by the way, is "McCoy" – Pollock's mother's maiden name, as well as some kind of joke name I imagine: maybe along the lines of 'Pollock was the real McCoy'? A character called "Bernie Nova" sounds like Barnett – "Barney" to his

friends – Newman. "Jarl Anders" may be Franz Kline. "Onno de Genoog" – very confusing one that! – is a figure with something to do with Willem de Kooning (though it's Updike's Guy Holloway who eventually develops Alzheimer's Disease – leaving Hope to marry a third man, not an artist this time, who dies (a bit like "Rabbit" in Updike's eponymous series), respectably, of a heart attack. "Hermann Hochmann" is a dead ringer for Hans Hofmann. My favourite, though, is a character Updike calls "Roger Merebien": can you guess? Robert Motherwell, of course!

Now: the theme of my essay is the problem of identity encountered as soon as we start to talk about painting, *now* – that term itself, 'now', is notoriously complicated, having a convoluted relation to both of the terms *contemporary* and *modern*. In its predominant sense, contemporary refers to 'now' – in strong opposition to a moment in some recognised past (over) or future (yet to come) time – but the term also contains within it the undertow of a late-nineteenth-century usage meaning 'modern' or 'ultra-modern'. This inheritance is at the root of the difficulty with 'contemporary': it confusingly has come to mean both 'now' *and* the modern, even though in art history 'the modern' has become, in some important ways, a distinctly *historical* notion. 'Modern art' usually refers to art from the time of Edouard Manet (the 1860s/'70s/'80s) to the 'end of modernism', a vanishing point usually located in the later 1960s or early 1970s – just before, that is, the rise of post-modernism.

Difficulties, however, equally plague the term 'now': it can not mean simply the 'immediate present' (literally this second) and therefore is ambiguously open and elastic itself – perhaps meaning anything from 'immediately' to 'this year' to 'the last ten years'. Who knows? Several further elements of confusion over *contemporary* involve significant issues to do with assumptions about the nature of art-historical research and the relations between this activity and the study of art and art institutions *in the present*. In one way, the resort to this phrase – 'in the present' – valuably indicates that 'contemporary' has no neutral or clear meaning, though it is often used precisely with the intention to *appear* neutral and clear. For instance, it became common about thirty years ago for new (don't ask!) galleries and museums of art, wishing to show artworks made more or less 'now' or 'in the present', to call themselves museums of 'Contemporary Art' (for example, the Museum of Contemporary Art in Los Angeles). This usage created a deliberate contrast with 'museums of *modern* art', whose collections were clearly associated with what was

believed now to be an *ended* or *concluded* past history: the modernist art, that is, of the twentieth century (roughly, let's say, from Cubism up to the work of the pop artists of the early 1960s). The exemplary institution concerned with this history is, of course, the Museum of Modern Art, New York, whose nickname 'MoMA' indicates its founding – and metaphorically maternal – status as the first such named museum, established in 1929.

Contemporary in this recent usage – since the 1970s – means more or less the same as 'now' or 'in the present', and, although the contrast with a past (completed, finished) modern moment is clear, the term contemporary remains highly ambiguous. In this ambiguity, contemporary shares a vagueness with that other term mentioned above used to describe art 'after modernism': postmodernism. The 'after' certainly suggests the 'overness' – the 'distinction from' – but also the active, if residual, influence or legacy of *that which came before*. For example, a painting identified in conventional art-historical terms as 'after' such-and-such an earlier artist demonstrates some observable connection to a work, or works, by that former artist. In the same way, contemporary paintings, though different from modernist paintings, will be, in all cases, shown to bear some relation to artworks that came before them. These two terms, then, *contemporary* and *modern*, are tortuously interconnected and confused, almost especially when the attempt is made to rigorously separate them out. Of course the difficulties are partly to do with assumptions about when certain things, events, processes, are supposed to have 'started' and 'finished'. You might think that when we've got beyond *modern* and *contemporary* we've reached *now*: but what about *recent* and *present*? Let me assure you that these problems are bound up, too, with *context* and *common*, and another term I will focus on here: *criticism*. Set all these to one side just for a moment, however, and then remember the other term that concerns us all: *painting*. In a collection of essays I edited in 2003 I suggested that we could usefully consider the fortunes of this word via its relations to three others that I shall invoke: these terms are *hybridity*, *hegemony*, and *historicism* – all with complex, disputed, interconnected histories themselves.

I chose to begin with Updike's novel, however, in order to suggest that his allegory allegorises the situation we are in when we begin to think and talk about *painting now*. My bold claim is that we have lost painting, and modern art, from an understanding that is anything other than

– for want of some better words! – tendentiously *fictionalised, made-up, far-fetched,* or what I will call *subjunctural.* All of these terms have their advantages and their pitfalls and are all usefully thought-of as 'exacerbated' and will, hopefully, productively 'exacerbate'. (This, incidentally, is a historical-materialist talking, and someone committed still to the ideal of forms of objective knowing, of knowing something *beyond* mere stipulation or subjective predilection!) Let me put some cards on the table, then: we have come terminally beyond the fantasies of modern painting's 'intrinsic purposes and drives', its 'internal regularities' and self-certain 'ontologies', pictured as these were most vividly, most successfully – influentially, hegemonically for the art world, that is – by Clement Greenberg and Michael Fried in the 1950s and 1960s. Well might "Clem" be a walk-on part in Updike's novel! Fried, to put it metaphorically, has been fried. He had the good sense to know so, and to have said so himself, in his Introduction to *Art and Objecthood,* his 1998 collection of essays on abstract art written in the 1960s. But that being true *doesn't* leave us in some 'post-space' of objective, sober-again, hung-over knowledge, some reflective moment when the rhetorical engine is merely ticking-over again, not racing the metaphoric revs. Criticism, I shall claim, has come to its last station-stop, and become a revealed *subjunctive*-grammatical construct – akin to science fiction or fantasy fiction writing: criticism is now a rather garish mode, that is, of presenting *simply what is imagined or wished or possible.* And in a way, of course, it always was. Criticism, especially modernist criticism, was a form of agitated, over-excited day-dreaming, of 'wishing X to be true', or 'desiring Y to be the case', or 'seeing Z as the desirable outcome'. 'High Modernist' criticism – I'm thinking here of Greenberg in his 1960 essay "Modernist Painting" and Fried in his 1965 essay "Three American Painters" – is as airless and breathless, as panting and delirious, as anything produced by Zack or Bernie (or Jackson or Barny); that is, as eccentrically hyper-individualistically solipsistic and absurdly hubristic as Modernist Painting itself.

Painting, Metaphorically

We *are* beyond all that, I'm saying (we know it in our bones), but *not* delivered, thereby, into some non-figurative, non-metaphoric elocutionary world: the strange creatures in painting since the 1970s (a world of pluralistic tolerance of difference, or is that rather *mere indifference*?)

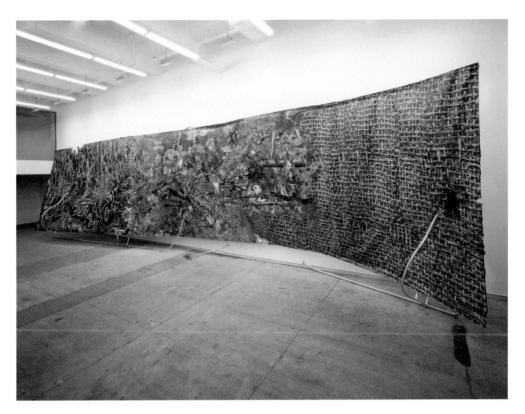

Fabian Marcaccio:
*Time Paintant: Image
Addiction Paintant*,
1999. Encad GO
inks on canvas with
silicon gel, oil, acrylic
and cast polyoptics,
2641 cm × variable
width × 609 cm.
Bravin Lee programs.
Photo: John Lee.

demonstrate the zoo of incommensurate language games that painting – that art *tout court* – has become. And criticism, too. Writings on painting, as much as painting *itselves*, have become a mad kind of incessant coupling and recoupling: electrical, digitalised, hypertextual, and hyped. Fried said it in his Introduction to *Art and Objecthood*: criticism since the 1960s has become "cultural commentary, 'oppositional' position taking, exercises in recycled French theory, and so on".[1] He doesn't add that even his own branch – what he calls "evaluative criticism" – didn't disappear either after 1970, but found continuities and legacies in many writers, including, for instance, John Berger and the reverend Peter Fuller in England, and Lucy Lippard and doomsday-monger Donald Kuspit in the USA. Fried, actually, had called his chosen path something a bit more specialised or reductive: that is, being "a formal art critic".[2] Now, whatever else you think of "cultural commentary", "oppositional

position-taking", "exercises in recycled French theory", most of this emphatically *was* evaluative: only the criteria and contexts and publics for evaluation had shifted, seismically and irreversibly, since Fried's day. Which is to say, apart from anything else, that painting, since the 1960s, has been 'commonized', in its original mid-nineteenth-century English sense: brought, that is, (sometimes rudely pushed) into a realm of shared public values and practices, made a fledgling citizen of the broad, and broadening, republic of contemporary art. Though judgements of 'vulgarization' still hover around the use of the term, painting, stripped of its elite pretensions since the High Modernism of the 1950s, *has* found a reduced though genuine niche in this contemporary art's 'common culture'.

And some of those writers associated with High Modernism's criticism are still panting, if not painting themselves. Greenberg, half-aware that the bubble had burst too, made what I think was a rather disingenuous claim in 1978 that his arguments in his essay "Modernist Painting" were – *at the time of him proposing them* – self-consciously *merely* subjunctive. Kant, Greenberg says (shall I say) was a lot of cant: "Many readers", Greenberg writes, "seem to have taken the 'rationale' of modernist art outlined ... as representing a position adopted by the writer himself: that is, that what he describes he also advocates. This may be a fault of the writing or the rhetoric... The writer is trying to account in part for how most of the best art of the hundred-odd years came about, but he's not implying that that's how it *had* to come about, much less that's how the best art still has to come about." "'Pure' art", Greenberg goes on, "was a useful illusion, but this doesn't make it any less of an illusion".3 Well, Well. Merebien!

What's the difference in a representation between an illusion and a fiction? It depends, surely, *only* on the context: at a fairground the magic tricks are called illusions, not fictions. In a novel the story is a fiction. In a painting the depiction of a person is achieved illusionistically. In a TV news broadcast the "War on Terror" is part illusion, part fiction, and partly – big part this! – *subjunctural*: that is, the threat may be wished, or imagined, or even possible. All bound up together. Criticism *after* modernist criticism, and painting after modernist painting, is a similar kind of agglomerate. It would take an *inhuman* amount of effort to construct what might stand as a plausible *theory* of painting these days – that is, it would literally have to come from another planet, be foisted upon us

in the manner that aliens are supposed to impregnate earthling women taken up into spaceships. No one is likely to believe anyone from *this* planet that either the painting we have now, or the paintings we have had in the last, say, fifty years, can, or should, make sense within *one* explanatory rubric, or that the bare bones of such accounts add up to anything now that is much more than a compendium of clichés: that painting is the residue of an authentic human (rather than superhuman) touch; that it is the phenomenal trace of embodied, materialised vision; that it is the sacred relic of some Heideggerian *geworfenheit* (the 'throwness' of human 'madeness-and-making' in the world), and other sundry hand-me-down neo-Merleau-Pontyisms. However simultaneously strangulating and intoxicating these gushings might remain, they all represent, finally, dying species of discounted, banal humanisms. They might be 'true' in the sense that the statement "President Bush is President" is true, but what of it?

In this post-space *after* 'painting theory-as-ideology' (since, say, the mid-1970s), these positions and their attendant philosophies, mostly deriving from one or another variant of phenomenology, have been unmasked as subjunctive constructs – one fantasy of seeing, or saying, or showing, with a tiny kernel perhaps of truth dotted with a very small 't'. But, since Abstract Expressionism – one last gasp of oxygen (pure individualism) Clark called it, before the "plane went down"[4] – painting has been revived again, and again, through an admixture, a hybrid, of gasses. These have cooled and heated, and cooled and heated, again, ever since, into a *game* of references, rather than constituting what painting was for Barny (or Bernie), or Robert (or Roger): that is, an artistic, Gramscian 'war of position' against consumer-capitalist culture; against "Clem's" *kitsch* and Michael's *theatricality*; against what Peter Fuller called the modern *mega-visual tradition* subsumed into advertising and spectacle – the horrors of what Donald Kuspit fulminates horrifically against in his horrific book *The End of Art*. Unfortunately, however, there will be no End to books about the End of Art.

Painting since the 1980s had promiscuously reinvented itself in virtually every possible position, including trying to pass itself off as hot and expressive again. (This intervening phase – now over I'd say – used to be called 'postmodernist'. Remember that?) Those artists and critics involved in the early 1980s 'hot' re-inventions, such as 'neo-expresssionism', may well have genuinely deluded themselves – so what? Is that necessarily any

better than being simply mendacious or working with an eye to the market? Painting has become experientially, rather than simply theoretically, ineffable: it can be found virtually *everywhere else* in the material fabric of contemporary art: in what used to be called 'sculpture', or 'installation', or 'video', or all, or none of these – all with inverted commas. And in none of these hybrids does it have any kind of *necessary* home any more, or meaning, or value. The same goes for 'criticism' – now as grossly inadequate and mis-representational a term as painting itself – meaning a vast range of kinds of writing and talking, much of it sponsored by, contextualised within, jargonized and depoliticized courtesy of, our academic institutions. No new problem this – can art be meaningfully *public* without a parallel public critical discourse intelligible and meaningful outside of academia? Cambridge-man William Empson told a Princeton audience many years ago that what was wrong with what he called the "horrible new American academic prose … was its failure to keep the normal living connection between the written language and the spoken one" (Empson, in Haffenden 2005: 265).

Discourse on art has grown so monstrously huge now that academics themselves find it hard to recognise specialisms nominally belonging within a single field. A visit to the bookshop at Tate Modern in London depressingly confirms this: *they simply don't know what to call a lot of the types of books they sell*: 'Visual theories' used to be my favourite, absolutely subjunctural to the core! Hoping! Wishing! So the situation exists now where there is no possible meaningful (that is, adequate or compelling) definition of painting and no consensus either about how people have been trying to make sense of this situation for ten years or so. The courses that we teach in universities entertain numerous titular fictions about this, for the sake of attracting students: dinosaurs like 'fine art' and 'art history' persist, with entertaining implied distinctions from notions such as 'applied' or 'commercial art', or, for that matter, 'social history' or 'cultural studies'. We are, then, to begin to sum up, living now within a heightened context of what could be called 'subjunctural supposition', bathed – as doomed Louis Althusser once had it – in the very dirty bathwater of ideological deformations, aware of them as such, but unable to escape out into some realm beyond this particular art world polluted goldfish bowl (to mix my metaphors!). To paraphrase Clark on Cubism, we are able to point to the figures and deceits in representation – able even to simulate a language that appears to lie outside this

structure of smoke and mirrors – but are finally *not* in a space or place outside of these inversions and mere tricks of appearance. What at least could be said in favour of this situation, I suppose, is that we are aware insomniacically of being in it. But are we happy? Does the insomniac not yearn to drop off, finally, into sweet, dreamless oblivion?

To recap: In the later 1960s the emergence of Minimalism and Conceptualism evidenced the arrival of diverse ideas and practices dialectically related to philosophical, political, and social analyses of a wide variety of kinds, many of them 'counter-cultural', connected to socialist, feminist, 'postcolonial', and ecological currents – pushing art *and* criticism into a new phase of existence and leading to these central terms themselves coming under serious and continuous strain. Painting lost out. But could the discourses of 'art' and 'criticism', so tied to the history of painting over many centuries, ever adequately offer to describe these new practices of making and thinking, representing and analyzing? When Painting returned (though it never really went away), its primary ideological and institutional place had vanished: like the fairy tale character off to seek his fortune, Dick Whittington, it had to seek a new life, with its bag of tricks cheerfully wrapped in a handkerchief on the end of a stick, and find a way of living with the other hungry creatures of the contemporary art world.

Painting in 'Post-criticism': from Work to Text

As Cindy Sherman's photographs suggest, artists 'after modernism' *continued* using traditional, new, and combined media, an investigation into the conventions of visual representation that Greenberg, Fried, and Clark all saw as a core element of the enterprise of modernist painting. Art writing, too, began reviews of its procedures of composition in so wide a variety of contexts and with aims so diverse that 'criticism', in any unitary or narrow sense, simply became an inadequate term for the activity. But evaluation in Fried's sense *remained* a key concern: what changed, as I've said, were the objects evaluated, the criteria of evaluation, and the purposes of judgement. Think of Sherman's photographs, then, as one attempt among many to encourage you to deliberate on conventions: in art (that is, on the history of painting and photography), on film and in film's relation to painting and photography in contemporary society, and on society as a whole. Images, narratives, and conventions-as-rituals

have come to constitute, one might conclude, a large part now of 'spec-
tacularized' social and political life. They are the mobile and ubiquitous
components of 'drama', as Raymond Williams once put it:

> in a dramatized society: these images and narratives challenged
> and engaged us, for once avant-garde paintings ... *were* images
> of dissent, of conscious dissent from fixed forms. But that other
> miming, the public dramatization, is so continuous, so insistent,
> that dissent, alone, has proved quite powerless against it ... A man I
> knew from France, a man who had learned, none better, the modes
> of perception that are critical dissent, said to me once, rather hap-
> pily: 'France, you know, is a bad bourgeois novel.' I could see how
> far he was right: the modes of dramatization, of fictionalization,
> which are active as social and cultural conventions, as ways not
> only of seeing but of organizing reality, are as he said: a bourgeois
> novel, its human types still fixed but losing some of their convic-
> tion; its human actions, its struggles for property and position, for
> careers and careering relationships, still as limited as ever but still
> bitterly holding the field, in an interactive public reality and public
> consciousness. 'Well, yes,' I said politely, 'England's a bad bourgeois
> novel too. And New York is a bad metropolitan novel. But there's
> one difficulty, at least I find it's a difficulty. You can't send them
> back to the library. You're stuck with them. You have to read them
> over and over.' 'But critically,' he said, with an engaging alertness.
> 'Still reading them'. I said. (Williams 1987: 19)

Over the past twenty years, since the term 'postmodernism' achieved
a relatively wide currency – though mainly still inside academic de-
bate and publishing – it was used rather more to refer to cultural and
artistic artefacts, practices, events, and developments than to explain
the character of broader contemporary economic and social structures
or transformations. Since the mid-1990s, however, the term has had to
compete with at least two others – 'globalization' and 'the postcolonial'
– that *have* been used to designate wholesale change within the organiza-
tion of societies and relations between nation-states, regions, and conti-
nents. On the whole, changes in artistic forms and practices deemed to
be 'postmodernist' were welcomed and celebrated in the 1980s and '90s
as evidence of a release from previously constraining 'modernist' codes

Cindy Sherman:
Untitled, 1990.
Chromogenic colour
print (ektacolour)
208 × 122 cm.
Courtesy of the Artist
and Metro Pictures,
New York.

and conventions, and held to be demonstrative of continuing innovation and creativity in the cultural sphere. This contrasts sharply with the connotations of both 'globalization' and 'postcolonial' which, although still suggesting liberation from inherited forms of social order and political oppression – restrictive or imposed national identities and direct forms of imperial domination – now also imply a generalization across the world of new insecurities based on, for example, the threat of terrorist attack or ecological disaster, and subtler, more insidious forms of economic and cultural subordination to predominant international forces and organizations.

Whatever painting's future – as 'theory', as 'practice', as 'artefact', as 'expressive trace' of its maker or makers' natures – it exists now within what appears to me to be an entirely novel discursive situation. This could be called the 'ideological' or 'apocalyptic subjunctive': our world of promised 'real threats' that bombard us daily: bird flu contagion, ecological catastrophe, terrorism, asteroid collision. The media seems addicted now to spreading these dark tales, episodes, of likely or less-than-likely deadly futures. Painting *might*, in this morbid regime, simply be re-invented as the kind of utopian 'dream of freedom' it represented to the Abstract Expressionists: this might be called, in contrast, the 'imaginative subjunctive'. Barney Newman – though it could be "Bernie Nova" – saying, to sum it all up, that if people could understand his paintings properly they would "mean the end of all state capitalism and totalitarianism".⁵

That paintings *could bring that about?*
That understanding could in itself *mean transformation?*
But as such, this re-invention of painting – as known or unwitting pastiche or parody – would simply, merely, be one *more* short story, an 'as-if' subjunctive, next to another and another and another, on a very long shelf (as long at least as the bookshelf in the Tate Modern bookshop) devoted to what painting 'might mean now'... And: "'You're stuck with them. You have to read the titles over and over.' 'But critically,'" said the Frenchman, with his engaging alertness. But *still only reading them.*

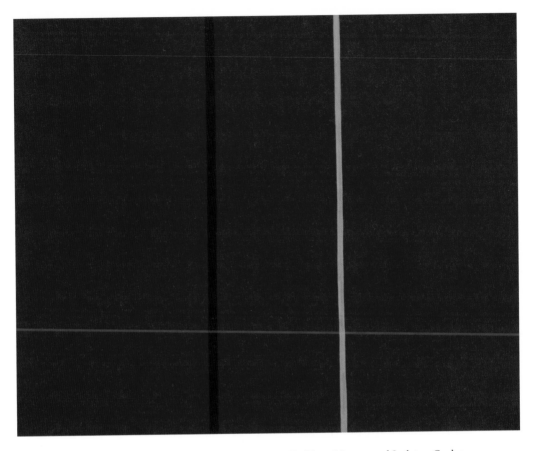

Barnett Newman: *Covenant,* 1949. Oil on canvas, 121 cm × 151 cm, Hirshhorn Museum and Sculpture Garden, Smithsonian Institution, Washington. Gift of Joseph H. Hirshhorn, 1972.

Notes

1 "An Introduction to My Art Criticism", *Art and Objecthood: Essays and Reviews*: 15.

2 "Three American Painters", in *Art and Objecthood: Essays and Reviews*: 219-220 and 262 n8.

3 Postscript to the 1978 reprint of "Modernist Painting", *Aesthetics Contemporary*, ed. Richard Kostelanetz.

4 "In Defense of Abstract Expressionism", *Farewell to an Idea*: 403.

5 Interview with Emile de Antonio (1970), *Barnett Newman: Selected Writings and Interviews*: 307-308.

Bibliography

Althusser, Louis (1971), *Lenin and Philosophy and Other Essays*, London and New York: New Left Books.

Berelowitz, Jo-Anne (1994), "The Museum of Contemporary Art, Los Angeles: An Account of the Collaboration between Artists, Trustees and an Architect", in *Art Apart: Art Institutions and Ideology Across England and North America*, ed. Marcia Pointon, Manchester and New York: Manchester University Press.

Clark, T.J. (1999a), *Farewell to an Idea: Episodes from a History of Modernism*, New Haven and London: Yale University Press.

Clark, T.J. (1999b), "Preface to the Revised Edition", *The Painting of Modern Life: Paris in the Art of Manet and his Followers*, New Jersey: Princeton University Press.

Clark, T.J. (2003), "Preface", in *The Painting of Modern Life: Paris in the Art of Manet and his Followers*, London and New York: Thames and Hudson.

Fried, Michael (1998), *Art and Objecthood: Essays and Reviews*, Chicago and London: University of Chicago Press.

Fuller, Peter (1979), *Beyond the Crisis in Art*, London and New York: Writers and Readers.

Haffenden, John (2005), *William Empson: Volume 1, Among the Mandarins*, Oxford and New York: Oxford University Press.

Harris, Jonathan, ed. (2003), *Critical Perspectives on Contemporary Painting: Hybridity, Hegemony, Historicism,* Liverpool: Liverpool University Press and Tate Liverpool.

Harris, Jonathan, ed. (2004), *Art, Money, Parties: New Institutions in the Political-Economy of Contemporary Art*, Liverpool: Liverpool University Press and Tate Liverpool.

Harris, Jonathan (2005), *Writing Back to Modern Art: After Greenberg, Fried, and Clark*, London and New York: Routledge.

Harris, Jonathan (2006), *Art History: The Key Concepts*, London and New York: Routledge.

Heidegger, Martin (1971), "The Origin of the Work of Art" (1935), in *Poetry, Language, Thought*. London and New York: Harper and Row.

Kuspit, Donald (2004), *The End of Art*, London and New York: Cambridge University Press.

Merleau-Ponty, Maurice (1964), *Sense and Non-Sense*, Evanston: Northwestern University Press.

Morgan, Robert C. ed. (2003), *Clement Greenberg: Late Writings*, Minneapolis: University of Minnesota Press.

O'Brian, John, ed. (1988-95), *Clement Greenberg: The Collected Essays and Criticism*, Chicago and London: University of Chicago Press, vol 1: 1988; vol 2: 1988; vol 3: 1995; vol 4: 1995.

O'Neil, John, ed. (1972), *Barnett Newman: Selected Writings and Interviews*, Berkeley: University of California Press.

Wallis, Brian, ed. (1984), *Art After Modernism: Rethinking Representation*, New York: New Museum of Contemporary Art.

Williams, Raymond (1987), "Drama in a Dramatized Society" (1974), in *Writing in Society*, London and New York: Verso.

Williams, Raymond (1988), *Keywords: A Vocabulary of Culture and Society*, London: Fontana.

PITTURA/IMMEDIA
Painting in the Nineties
between Mediated Visuality
and Visuality in Context

Peter Weibel

I (Ways and Problems in Abstraction)

The first phase of abstract art, the so-called rebellion of the abstract, emerged in Europe around 1910, during and after the First World War.[1] Subsequently, during and after the Second World War, the second phase set off, now predominantly in America, as a result of the fascist banishment of reason. Since it is not possible to review the history of art forms without also considering the history of ideology, we shall refer to this specific historical context, even if we are basically concerned with apparently free forms, i.e. forms liberated from things. Indeed, the life of forms and the forms of living are inevitably linked through a chain of cultural and social signifiers.

In the first phase of the abstract, the relation to the object was cut off, achieving the formal autonomy of colour, of shape and of surface amid loud declarations of independence. Significantly, the search for the pure forms in painting arose at the time as a mixed composition of rationality and feeling. Kandinsky hankered after forms that were purely emotionally motivated. By contrast, the Russian formalists and constructivists strove to attain a rational and analytic method to produce art forms.

Whether rational or irrational, whether considered analytic or synthetic, the forms that prevailed on the canvas were in both cases mainly

geometrical (squares, circles, lines, rectangles, spirals, pentagons, sticks, circular segments, triangles). Ornamental and geometrical forms, or at least weakened geometrical and ornamental figures, therefore belonged to the aesthetics of the first phase of abstraction (1910-1930). The second phase (1930-1960), on the other hand, was largely characterised by amorphous, organic structures, even by 'formless' forms. As a matter of fact, the conversion from geometrical to informal abstractionism had already been announced at an earlier date with Kandinsky's seminal question: What is there to take the place of the object? Of course, the substitution did actually take place, but the reference of forms on canvas to forms outside the canvas constituted a problem that still awaited solution. Instead of the relation of forms to the outside (the object world), the second phase would direct the attention to the inner world (the soul): the object was replaced by the soul. As for the representational and referential function in painting, it was not affected by this shift and remained unchanged. Having done away with the object, the painter's brushwork, to achieve legitimacy, was thrown upon the life of inner experience. In this new space, forms no longer deferred to the dictates of the object, and the link to the outside was replaced by an interior reference. According to Kandinsky, 'The beautiful is what expresses the inner necessity of the soul.' The obvious temptation was losing one's way in images of metaphysical landscapes, descriptions of vivid emotional travels, where colour provided the psychic equivalent. However, a reference of unspecified nature inevitably lingered on somewhere in order to justify the forms, however formless. Then, in 1929, Georges Bataille proposed the idea of the 'informe' to elude reference, and from 1940 and onwards the Informal constituted an aspect of modern art.

We may safely conclude, therefore, that the reference to the object was severed in the first phase of the abstract; then, in the second phase, the empty space left over from the vanished object was occupied by the psyche. However, as it happened, the referential validity of the forms was only marginally questioned as such in both phases. Nevertheless, the internal development, the gulf separating the different solutions to the problem of the abstract, was significantly widened in both phases, reaching antagonistic proportions (witness the contrasting positions of, say, Lohse's geometrical coloured surfaces vis-à-vis the lyric abstractions of Twombly's brush). In order to bypass the difficult question of the

referentiality of forms, 'De Stijl' had abandoned the problem altogether and introduced a universal programme of neo-plastic Gestalts instead. Problems of Gestalt replaced problems of form, showing an early way out of the crisis of the abstract, which artists in the third post-modern phase of the abstract were more than happy to avail themselves of.

In the third neo-modern phase of the abstract (around 1960), we come across the pluralistic attitude of 'anything goes'. All forms were allowed, whether geometric or informal, and the explicit emphasis on purity of method characteristic of the two earlier phases was no longer decisive. Not unlike what happened in the battle that raged from 1900 to 1930 in the elementary logico-mathematical sciences and their mutually differing schools (logicism, formalism, intuitionism), terminating in a purely technological idea of progress, a movement may be observed in abstract painting from a preoccupation with basic research to technology, wrapping up all pressing aesthetic issues and technicalities posed by the introduction of the abstract. This tendency may already be noticed in the second phase in the attempts to disregard the question of referentiality altogether. In a move to fully exploit the essential pictorial qualities, people tried to circumvent the problem of the reference of forms on the assumption that only material aspects signified. In fact, the question of abstract painting came to centre on a meta-linguistic interpretation, where the referential issue was argued by the historical abstract painting itself.

Contemporary neo-abstract painting habitually refers to the strategies of abstract painting as an object language; abstract painting has become a meta-language, inserting and elaborating the historical styles of abstract painting, whether constructivist or informal, now in a replacement of both the external object and of the psyche. By virtue of this meta-linguistic codification, recent abstract painting has been reduced to a reality of sheer signs, where abstract signifiers, like so many company signs (logos), are submerged in a free flow of polyphonic relations with the history of art and modernity itself. Paintings may now unfold in a free play of painterly signifiers. In a further reach, this third phase is also characterised by a translation of problems of form and method into problems of code. Indeed, the principle of codes pervades new abstract painting.

From conceptual art to Land Art, from avant-garde films to video productions, the 1960s and 1970s witnessed a development of aesthetic practices that were radically novel, resulting in an irreversible change of direction in the conditions for the production and reception of art. More

than anything else, these innovations would question the traditional concept of visuality and the notional status of pictures. On the one hand, there was a significant expansion of materials, methods and media in producing art; on the other hand, an analysis of various representational strategies emerged within the cultural institutions of the Modern itself. In both these developments, aesthetic ideas such as the unconditioned autonomy of the picture, or suggestions that the absolute play of form, colour and surface are pure expressions of the abstract, would be reduced to historical positions and conservative ideologies.

Of course, before this turn of events, a noticeable return to traditional positions took place in the 1980s, i.e. a return to cubism and expressionism or even to pre-modern trends. However, this development seems totally unmotivated by any interior logic and represents a deplorable return to naïve positions, pretentiousness and sheer historical convention. We shall therefore not follow this move any further.

Nevertheless, we still need to ask the question how art forms may operate in the 1990s without suffering a return to the positions before the irreversible change in the concept of the picture (during the 1960s and 1970s), but also, indeed, without succumbing to trends in neo-modern painting heading in the opposite direction, inviting a dissolution of the picture itself. How may we envisage the viable rationale of a third way? Two options, it appears, are workable – and they are both, in fact, firmly rooted in the provocations of the 1960s: mediated visuality and visuality in context.

Mediated visuality means posing the question of the nature of the visual in a new way (as for instance: why must visual art be visual and not textual? Why should 'visual' mean colour, form and surface and not text, form and surface?); and this is a question that is specifically raised in relation to the ubiquitous visual media. Today, we no longer confront the visual innocently, spontaneously, but recognise that it is invariably mediated; indeed, the visual is not only continually being mediated due to mass media like posters, newspapers, television and cinemas, etc., but also as cultural codes, thanks to the reproduction of art history in books and magazines. We live in a sea of mediated visuality.

Visuality in context implies the notion that art has actively constructed visual sites and visual media. A picture is a visual site in a museum. A photograph in a daily newspaper is another such site. A picture is a social construct, defined by conventions, rules of good taste, etc. Notably,

there exists a social consensus with respect to what art is, what a picture is, what a painting is. This social context or social consensus determines the visual. Thus, the frame of reference provided by art as an institution stands in a relation of exchange to the cultural code of the media; mediation and contextualisation mutually condition each other, leaving their stamp on painting in the 1990s, recreating it. This new type of painting enters a sea of mediated visuality and ponders anew the visual in a context of technical images.

In the 1980s, the crisis in abstractionism was sidestepped via a return to the conventional software; by contrast, the 1990s witnessed renewed attempts to tackle the problem of the abstract. In these efforts painting, as act and fact, was looked upon as a model and as a symptom. Hubert Damisch (*Fenêtre jaune cadmium, ou les dessous de la peinture*, Paris 1994)[2] asked what it means for a painter to think. More importantly, the very idea of the pictorial was reconsidered. Paying special attention to the underside of the painting, i.e. traces, drops, gradation of colour, size of canvas, texture, facture, coating, technology of brush, surface, etc., the act of painting was conceived as the production of a model, in the same way that the world of every painting is a model for painting as such. In a further perspective, painting created a model for life. The act of painting became a theoretical operation. The universalist demand of geometric abstraction was dissolved in the particular.

This approach invited the use of fuzzy logic, i.e. the logic of many values, to replace a binary logic. Instead of yes and no decisions you confront several layers, different levels and blurred borderlines, insinuating twilight zones between figure and ground, between layers of paint and painted form, between form and inform, between Gestalt and code. "Chaos can be structured as non chaos," Eva Hesse had said in 1970.

Painting as symptom originates in the visuality of the technical context. Here, in the symptom, a core of pure pleasure persists, disclaiming every attempt at analysis, despising all reduction to reality in an element of sheer *Schein* arising from the symbolic, the imaginary, that will not be defeated. Painting as symptom entails persistence of pleasure, a denial of reality, pleasure as real.

A *Pittura immedia* is a painting that, as symptom, generates pleasure. It will not be reduced to technical mediation, in spite of every surrender and analysis. It expresses absolute pleasure at whatever remains of painterly qualities able to resist mediation.

II (The Transformation of Visuality)

The primary place of the visual is visible nature. In the natural world of perception, visuality is universal. Present as nature, it seems to be without a medium to support it. As we know, the visual was only localised and contextualised and linked to a supportive vehicle with the advent of the imitative arts. Apart from certain early techniques, our oldest and most prominent imitative system is easel painting. As a result, we have falsely come to identify the idea of the visual with the shape of the easel painting. When people say that a picture is only, after all, a picture, what they have in mind is invariably an oil painting on a piece of canvas. However, as we have seen, visuality in its first form is really visible nature. As it happens, the easel painting in its finished form has already itself been mediated both by some sort of supportive vehicle as well as by a specific set of techniques, brush, oil of a particular colour, etc. Nevertheless, when narrating the history of our culture, we have come to accept the easel painting as second nature, as it were, linking it firmly to our idea of the visual. Then, with the advent of photography (around 1840) and later on also with the addition of new pictorial media like films, videos and computers, the visual would cut loose, travelling from picture-medium to picture-medium, in consequence of which the pictorial as such was separated from its exclusive medium. Evidently, the visual was not invariably linked to the easel painting after all; even in its incarnation as easel painting it was still only a passenger changing trains.

As it happens, we may detect an early awareness of this complex relationship between picture and visuality in Riegl's well-known summary of the three main purposes of the fine arts: 1) to embellish nature; 2) to inspire it; 3) to stand forth as a rival to it. The visual, allegedly, was inherent in nature, and the meaning of the picture was to improve it. In other words, the easel painting was supposedly even more beautiful than the visual in nature. In this respect, the gap between the picture and the visual had widened. To the extent that the picture managed to embellish the visual, the visual (i.e. nature) degenerated into something quite ordinary. With the arrival of aesthetics, the theory of beauty, as a discipline in the eighteenth century, the picture and the visual each went their separate ways. The visual became everyday, and the picture of the fine arts was elevated to a position as beauty's true site. Moreover, the spiritualisation of nature also led to a recharge of the picture, in a further promotion of

its triumph over the visual. Then, at the very moment of the clash between nature and picture, the confrontation between the visual and the pictorial, a decisive breach took place, driven on and completed by this rivalry, fuelling the drive towards the abstract.

Of course, the irreparable separation between the visual and the easel painting took place with the arrival of photography, films, videos and computer images. These new media-vehicles for the picture, these new pictorial forms, were in point of fact so novel that they were consistently referred to as audiovisual media, and for several years to come they were denied the function of pictorial art. The visual, as usual, was therefore left to the media, while the picture was claimed for the art of painting. Quite apart from the obscurantist backsliding of this classification, it only served to propel the picture's way through the different pictorial media so that, not surprisingly, the journey undertaken by the visual only whetted the edge of the questions surfacing in the wake of the above spiritualization .

In "La Rampe" from 1983, Serge Daney, the French film theoretician, analysed the function of the cinematographic picture, and like Riegl he proposed a three phase cinematic periodization. The first phase (the embellishment of nature) gave rise to the following question: What is there to see behind the picture? People want to see more, desire to see more, wish to see what is behind it. From this original surplus desire stems the first grand phase of the cinema: the art of montage. As it happens, we are particularly interested in the cinematic montage, since its techniques in the 1920s in pictorial art, i.e. in the classic pictorial medium, proved to be historically significant for the *Pittura Immedia*, which concerns us here. According to Daney, the cinematic picture also involved a second function, which we may express in the following question: What is actually there in the picture to be seen? Evidently, the relevant point was not what was there to see behind the picture, but rather: What may I retain from looking at a picture? What is taking place when I adjust my eye to the picture? From this point onwards, the importance of montage as an art form dwindled, giving way not only to the famous cinematic long take but to the development of pictures arranged on surfaces without depth. Influenced by this cinematic development, the surface without depth was also taken up by pictorial art, giving rise to the flat canvas of the 1950s and 1960s. This new cinematic form no longer showed an interest in embellishing or improving nature by the use of montage, but desired to intellectualise reality and invest it with greater intensity. However, it was

also increasingly plagued by the following question: What is it that I see in the picture? A certain doubt arose with respect to the reliability of the picture. What is it in the picture, or what is it on its surface, that catches my gaze? In this connection, Alfred Hitchcock's films were of particular interest, since they specifically addressed the question of the presence of gaze in the picture – which also explains the influence Hitchcock exerted on the question of form in contemporary painting (as may be seen in e.g. David Reed).

The first cinematic phase came to an end with the arrival of fascism. The second cinematic phase ended after the war as a result of what William S. Burroughs has termed the emergence of control and surveillance. The last phase, the rivalry between picture and nature, developed as a third function of the picture and may be expressed as follows: How make your way into the individual picture if it is invariably dissolved, sliding into a series of other pictures? It is no longer a question of what is there to see behind the picture, nor is it a question of how to see the picture itself, of what a picture is. The third question voices a query concerned with how we slide into the picture. Such an inquiry is not strictly technical in the way of interactive computer installations: the problem of sliding into the picture is raised because, by and large, pictures have in fact for quite some time been sliding into one another. Notably, the question originates in the discovery that the ground of a picture is itself a picture. For a very long period of time we have been working in a space beyond the natural horizon of the visual; the visual of today is already marked by mediation. On the one hand, this has led to the elimination of the ground, an emptying of the ground – even using the abstraction to create an empty picture, a white monochrome, in order to forestall this discovery. Or we are invited by the abstraction to reinterpret the conceptual structure of the painting.

Now, I have already reviewed the possible reactions to this discovery in two separate exhibitions, one of which was *The Picture after the Last Picture* (undertaken in cooperation with Kasper König and the Galerie Metropol in Vienna, 1991). In this exhibition I proposed an analysis of the continuous emptying of the picture. The first absolutely monochrome paintings by Alexander Rodtschenko from 1921, *Pure colour red, pure colour yellow, pure colour blue* (Rodtschenko Archives, Moscow), were so empty that the painter himself felt called upon to declare that they were indeed the last pictures. In fact, they were the last pictures based on

a specific conception of the picture. This had two consequences. Since other pictures followed the last picture, these pictures after the last picture could not be nourished by the illusion that there were no pictures before them; on the contrary, there were no pictures without origin, without ground, without history. The second reaction emerged as a new definition of the picture, in a three-step process, which I have described in the exhibition *Bildlicht* (together with Wolfgang Drechsler, Wiener Festwochen, 1991). The very moment the historical picture has lost its function, so that you may in fact speak of a last picture, a reaction in the form of a three-step development sets in: Firstly, a shift of accent, say, from perspective to colour; secondly, a generalisation, e.g. increasingly monochrome paintings; thirdly, a process of exchange and substitution of historical elements. The first two steps summarise the classical modern, the third addresses the present: the omission of historical elements (car paint instead of colour; concrete and wood instead of canvas, etc.).

Contemporary art, in the history of the picture, originates in this third reconstruction, which is secretly controlled by two notions: the concept of origin and the concept of the visual. The two notions go together. If I know that, at some time in the past, the visual was separated from the easel painting and that it subsequently moved on to the cinema, to television, to video, then I also know that there are no longer any pictures without origin, as Daney has phrased it. Consequently, we can claim that the true breach in modern painting should not be looked for in the disappearance of the object, but in the retraction of the idea of a lack of origin. This second breach also breaks with the illusions of modern painting itself, defining a radical post-modern painting, which itself originates in a cruel discovery: the ground of the picture is another picture. In other words, we move about in a pigeonholed but closed world of visuality; wherever we go, we are surrounded by a multitude of visual contexts; the visible world of things, the world of the media, posters, films, newspapers, including the world of the easel painting. In this universally contextualised visuality, one of the forms of contextualisation, spatialisation, has all of a sudden moved up front: in the shape of picturesque chromatic murals. Submerged in a universal contextualisation of visual life, we realise that this is the truth behind the terrifying statement that every picture has an origin. However, the picture does not originate in nature, but in another picture. This diagnosis, which may be new to painting, has in some sense already been introduced in cinematic

theory by people like Serge Daney or, indeed, by Pier Paolo Pasolini in his theoretical writings on film. In his thinking, Pasolini is preoccupied with the concept of code, repeatedly emphasising that the cinema is the written language of reality, claiming that the cinematic code is itself nothing but reality's own code. Thus, turning the nominalistic statement upside down, we get: "res sunt nomina" (things are names) instead of "nomina sunt res" (names are things). In the meantime, the permanent circling of codes around codes as described by Pasolini in the essay "Les Codes des Codes" (The Codes of Codes)[3] has not only made its impact on the cinema but, more importantly, also influenced the painting. It is by now clear that painting in its very operations is caught in a circulation of codes and also that, in its best efforts, it will try to escape from the control exercised by these codes.

The idea of pictures inscribing other pictures in circles in no way implies a loss of the world, but rather indicates that the rivalry between the artificially produced world of pictures created for the benefit of people and the picture worlds of the natural visible world has reached a climax. To claim that the ground of the picture is another picture is only another way of saying that we have now reached a climax in the rivalry between art and nature, between art and reality, between the code of art and the code of reality. Precisely because art is no longer called upon to embellish or spiritualize nature, but exists alongside it on the same level, it cannot, in the final analysis, presuppose nature; art can only take itself and its own pictures for granted. The fact of artists in the 1920s working with montage in photography was the first powerful signal of this change in perception. Montage, from John Heartfield to Hanna Höch, was not only a first step to what in the 1980s was termed the art of appropriation, but was also a signal of a new awareness of our dependence on pictures. Thus, we witness the beginning of a different awareness of our dependence on a source, on origin.

At the very moment when the last pictures in the history of art were painted, as claimed by Rodtschenko, the question was no longer directed towards the end, but backwards, towards the origin. The problem of origin was born, as the expression "pictures after the last pictures" indeed quite clearly states, the very moment in art history when the end of art was announced: the idea of the last pictures, the notion of pictures after pictures. The painting, while repressing the problem of visuality, had up until then naively assumed that there must be a primordial picture

without history – a painting that was original, but original in the sense of 'unmediated', 'devoid of context', 'pure'. Clearly, it had always been living on the fiction of the empty canvas. However, the word 'origin' has at least two meanings: When someone's painting is claimed as original, people generally assume that the painter created it without a model, according to the dictates of his feelings and intentions; the source is the exclusive ego itself, there is nothing else, the painting emerges from no other spring. 'Original' (*ursprünglich*) means 'close to the spring', and since the spring is equal to the painter, a promise of authenticity and conviction is implied. Generally, origin means 'presupposing nothing'. Something is original if it has no model, if it is not based on anything else. In fact, in common parlance the notion of origin drives away the idea of descent. Be that as it may, however, we here choose to interpret origin in a histori-cal sense. The painting that we discuss comes into being pregnant with the idea of the end – the end of a specific interpretation of painting. At the same time, this end is conceived as origin. The history of painting, the history of visuality, has itself become the origin of the new painting. Artists, clearly, have every right in the world to relate to the history of painting as exclusive origin, but by virtue of the same right others may choose to direct their attention to the history of the visual as such, not only to the history of the picture in painting, but to the entire history of the visual as manifest in all kinds of media. The painting in the 1990s is not circumscribed by an aura but invested with an historical idea of origin. Indeed, it does not deny that every individual picture has an origin in the same way that every picture presupposes another picture; every pictorial text also inhabits a context. If this is so, we may claim that visuality provides a context for the original painting. Insofar as it is a question of a technical reconstruction or a construction by other pictor-ial vehicles for the painting, I may freely speak of a mediated visuality. Some painters choose to paint on top of photocopies (Rappenecker) or they cover up fake paintings with plasticine (Arienti). In such cases, it is arguably relevant to speak of a painting as mediated visuality, even if a previous visual pictorial vehicle is once more subject to industrial, technical or digital manipulation. In any case, the result is a painting. In fact, the concept of visuality in context may direct itself to other works, as we may see in Lois Renner's sophisticated photographs of models of a painter's studio, or in Adrian Schiess's rearrangement of the vertical picture as horizontal.

What matters in connection with all these painters, however, is whether they approach mediated visuality or visuality in context; what matters is that, in producing their paintings, they are conscious of history: that their paintings originate somewhere, in some place, in some medium. The individual painting's origin or code may be found in the history of the painting or in the general history of the picture, in the way that it has developed through all the different media-vehicles from photography to that of the computer. Oil paintings invoke computers as props; Reed refers to films. In other words, the origin that the painting appeals to is its history and the visual context itself.

III (The Historical Origin of the Painting)

If we make an inventory of a historical easel painting, it all adds up to this: canvas, quoin chase, brush, oil colour – plus a certain mode of production: the hand of the painter gradually filling the empty canvas, a vertical hanging, etc. However, it is also clear to us that if a painter slavishly makes use of all these elements one after the other, he would hardly be present at the Pittura/Immedia Exhibition; had he been, he would have had to leave out at least one of the above commercial elements, codes and rules; in fact, often more than one, perhaps even almost all of them. What we get, then, is not oil, but industrial paint; or we face a picture placed horizontally, disclaiming its accustomed vertical position; or the painter doesn't paint, but kneads and pugs. Thus the choice of colour is not ordinary oil; instead we get polyester in a flat tub, the painter adding it to the canvas, as in the work of Herbert Hamak. The turbulence resulting from this violation of rules originates in the experimental exploration urged by the painter with a view to changing the visual in modern society. Obviously, such a visual transmutation will not take place within frames defined by the media, the place to which the visual has largely emigrated. Instead, the experiment is undertaken inside the pictorial frame itself, which means that at least some elements have to stay. Nevertheless, the return to easel painting does not take place before it has travelled through non-traditional, non-classical modes of production, shedding traditional means of production, grasping new ones, holding on to them, appropriating them. As a result, the new means and modes of production engendered novel pictorial forms, in which their history, their origin, i.e. the history of their visuality, could be perceived.

als sein Vor-
en Stelle er ge-
iat die Zeichen
1 bis 1500 ccm
gesenkt, dabei
auf 12 Monate

m 1100 D der
, England und
Einliter-Wagen
Cardinal, Mor-
M) begegnen.
für die Neu-
Fiat hat allen
n ausgereiftes,
blaren zur Zu-
ufendes Auto-

generellen Ex-
orgesehen und

Gerhard Richter:
Alfa Romeo (with text),
1965. Oil on canvas,
150 cm × 155 cm.
Museum Frieder Burda,
Baden-Baden.

After the introduction of this new viewpoint in photographic montage, artists who in the code of life had recognised the code of art were also the first to notice the law that behind every picture there is another picture. In the 1950s, working with *décollage* and *déchirage*, people like Vostell, Rotella, Hains would paste posters on top of each other, superimposing pictures on pictures, subsequently ripping the top poster or posters, creating new pictures. Evidently, a picture always covered another picture – all you had to do was subtract. If the historical painting avails itself of

addition, the painting of the 1990s, by contrast, was preoccupied with subtraction of historical similarities and historical elements or specific techniques, specific variables. The artists of the *décollage* and *déchirage* engaged in subtraction, lacerating posters in public places, freeing hidden layers of other pictures. Rauschenberg, Warhol, representatives of Pop art, took the next step, confronting public pictures, i.e. referring to mass media visuality, reincorporating it in their pictures. KP Bremer, Sigmar Polke and Gerhard Richter explicitly addressed mass media visuality in their works simply by copying newspaper-cuttings (a picture and a piece of text) or by reproducing the grid of mass media printing techniques. After these notable results in the 1960s, and not forgetting the advances made in conceptual painting, individual artists began to work with already existing pictures. Among others, this group included the Austrian painter Arnulf Rainer, who had already experimented with painting on top of pictures. However, Rainer's gesture was not primarily directed towards the presence of pictures in the history of visuality, but rather constituted an attempt at negating what was at hand, a negation of origin. By painting on existing pictures, whether photographs or paintings, Rainer did not liberate origin, but rather closed the door on it. While recognizing that origin constitutes a problem in contemporary painting, he nevertheless chose to disregard it, once more eliminating it, i.e. painting it over. In a certain sense, Rainer was not really part of the Pittura/Immedia Exhibition, since his field of interests and viewpoint are only distantly related to the other pictorial positions. However, it was surprising to see Günter Brus represented – first of all, since his important contribution to the renaissance of the painting is often overlooked, and, secondly, because Brus for more than ten years has produced more than a thousand pages that, like our theory of origin, stem from reworking other pictures. Brus selects pictures from the history of general visuality, be they papers on pedagogical questions or the history of the fine arts, and makes new pictures out of them. To the extent that he deals with a visuality mediated in context, Brus may be said to include these interests in his work. In 1979, I collaborated with Loys Egg in reworking hundreds of similar catalogues in different ways, naming them "peinture parole". With respect to predecessors I have concentrated on the women artists who resurfaced in the 1980s, adding their significant contribution to the movement of the painting in the 1990s. Several painters like Richard Prince and Christopher Wool may have appeared marginal in the

painting of the 1980s, but in the more advanced awareness typical of the next decade they came to occupy positions that have proved to be at the centre of a movement. Perhaps one may even speak of a type of classics in the 1980s. In other respects, I have done what I can to combine new names with the new subjects matter of the "immediated painting". Since more than eighty artists were present at the Pittura/Immedia Exhibition, I hope to have provided evidence that overcoming the media (immedia) by means of painting is a subject of universal importance, and that we have in fact here discovered a new way of thinking the pictorial beyond the picture, but at the same time within the horizon of the visual.

IV (Painting, Media, Immedia)

Traditional conceptions of art are based on the assumption of a direct relation between colour, canvas and the subjectivity of the artist as the sole mediator. The artist's approach to the canvas is blunt and forthright, and the elements constituting the painting are present without any middle terms – in the sense of Henri Bergson's *Essai sur les données immédiates de la conscience* from 1889. This type of painting as a spontaneous act without origin and without history of any kind dominated the first half of the twentieth century right up to the introduction of the Informel in the 1950s and 1960s. However, from the 1960s and onwards we have seen the development of an immediated painting that presupposes an origin, whether it be the picture world of the mass media or of art history. Nevertheless, this reaction on the part of the painting to the media world of photography (in the nineteenth century) and the video (the twentieth century) still took place within the framework of representation. The outbreak of the wild and violently gesticulating painting of the transavant-garde and of the neo-expressionists of the 1980s signified a regression to the illusion of spontaneity, a falling back on already established positions of modern and modernist painting. However, in the 1990s, in painting and elsewhere, the link to already achieved positions of complexity was reinstalled with a view to subjecting the representational horizon to critical self-examination. Notably, these paintings were not a reaction to the surrounding pictorial world of the mass media or to art history as mediated by this world (as in the printed media), but an attempt to take their effects on painting for granted and overcome them in the very act of painting. These paintings therefore no longer, as in the

Albert Oehlen: *Untitled*, 1993. Silk screen print (Computer Drawing), Acrylic on canvas, 250 × 210 cm.
Courtesy and photo: Galerie Max Hetzler, Berlin.

nineteenth century, study nature, but choose instead to explore a medi-
ated world reflecting a techno-transformed environment dominated by
abstract codes and mass media effects. The technical picture-world is
presupposed as second nature, and painting, once more, is claimed as
a convincing individual activity in the midst of an anonymous display
of public pictures. Significantly, this is a development brought about by
entering the pictorial world of the media, not by rejecting or negating
it. Since the technical media, in their function as storehouses, reproduce
art history everywhere and at all times, the history of art itself becomes a
kind of second nature, to contextualise the painting.

Thus, the new painting of the 1990s is the outcome of a dialectical
process. A phase characterised by spontaneity is followed by a phase of
mediation and subsequently by a phase of de-mediation or immediation.
The concept of "Immedia" has been designed to express the ambivalence
of a post-medial painting caught between historical spontaneity (imme-
diate) and non-media (im-media). I designate the process of travelling
through a number of different media "immediasation", if it results in a
"painting" that poses the question of the visual in a new way; not painting
as underbidding the media, but as outbidding them, moving beyond. This
post-medial painting, which represents a form of reflection on painting as
mediated technically as well as by art history, gives rise to a transformed
spontaneity of the second order. It reacts immediately to the media in
an expression of an observational model of the second order of the type
known from cybernetics and systems theory as the observation of the
observer. The painting of the second order therefore also includes obser-
vations of changes in painting resulting from the media and their effects.
Significantly, it does not propose to build a counter-world to the media,
but – as pictorial immedia – to induce a pictorial transformation of the
world of the media. It is not a question of an ontological painting encir-
cling a spontaneous or auratic world of things. Rather, it is a painting of
the second order that pervades and explores the mass media multi-world
of surrogates, substitutions and simulations, building an ontology of the
second order. Hence, the pictorial world must be interpreted on many
levels. It may be technical or conceptual, semantic or pragmatic. Notably,
it is not a question of any formal convention, i.e. we are not witnessing
a confrontation between abstractionism and realism, but approach the
new painting as an assembly of procedures and practices derived from
cultural and technical processes used the electronic media, in mechanical

production and reproduction and the world of industry. What we see is a painting that is affected by technology and media. However, since art history is itself reproduced by the media, it partakes of that very same world. Thus, art history displays a kind of ready-made consisting of codes which lend themselves to new interpretations. The ready-made painting of the 1990s is therefore not only related to the ready-mades of the world of the media, but also to those of the spiritual world. Consequently, the indexical nature of the photography inherited an important function, and the question of indexicality came to play a decisive role in post-modern painting (from Art & Language to Donegan).

The question of representation is solved in new ways. The crisis in representation gives way to the problem of mediation. The painting is not related to reality in any direct way, but mediated through the media. It is no longer important to cut the moorings to reality as in abstract painting, but to cut the link to the media. The point of departure is not the observation of a subjective feeling for the reality of the senses, but the observation of the cultural production of artefacts, i.e. an already mediated, simulated reality, a makeshift-reality. The representation of the real is translated into the surrogate form of representation. From this point on, we may notice an inevitable development towards a surrogate form of painting. A social and philosophical self-reflection in painting is expressed in technical, material and formal manipulations or experiments. The separation between the code of the message and the body of the messenger, between the idea of the picture and the medium supporting it, which has existed ever since the invention of the telegraph, has resulted in a situation where the picture-screens of machines have been admitted as material media-vehicles underneath the easel painting. The painting of the 1990s demonstrates that this separation between messenger and message, between vehicle and code, has also reached the painting itself, depriving it of the innocence of immediacy. The painting has become a subject supposed to know. A knowing painting knows its own history, just as it knows its artificial surroundings. The change of code also affects painting. The painting changes codes immediately. The idea of the picture has journeyed from easel painting via photography and the film screen to the screens of television and computers. These journeys through the different material vehicles have also effected a change in the notion of the picture. What takes place now is a return of the idea of the picture to its point of departure. Liberated by the media,

Ghada Amer: *Untitled*, 1994. Embroidery on canvas, 180 × 150 cm. Courtesy: Galerie Martina Detterer, Frankfurt.
© Ghada Amer. Image courtesy of Deitch Projects.

Art & Language: *Index V: (Now They Are)*, 1992. Oil on canvas on wood with enamel/ glass, 190.6 × 163 cm. Courtesy: Art & Language and Lisson Gallery, London. Photo: Gareth Winters.

the picture doubles back to its origin in the easel painting – however, this time without denying the trail left behind its exodus. This move not only permits the pictures to travel from one medium to the other, between oil paintings and photography, but also serves to strengthen the free play between the media and the codes. And this, in a further move, results in new forms of influence and gives rise to new transformations, so that the painted picture not only steps forth as a child of the pictorial tradition, but appears as a product of the technical history of the visual media. Liberated from all reference, the painting's abstract code floats about in a free movement, adapting itself, metamorphosing into a play of differences inside a formal system, constantly enhancing its capacity for

innovation and experiment. The new painting evinces an awareness of the way the picture is situated between and transformed by historical and contemporary media-vehicles. According to Gerhard Richter (1966): "All painters, in fact everybody, should paint photographs." Or David Reed: "We see paintings in a different way now because of film and video." The place of the visual has been cut loose and become variable, changing. The place of the visual is displaced. The visual finds new contexts, technical, urban, cognitive contexts.

By virtue of the dialogic structure between picture and picture, the painting is transformed into an open play based on the elements that constitute it, a 'language game'. However, as Wittgenstein remarked, such a game is not based on language only, i.e. on the painting, but also on context. Hence the pictorial urge to migrate to the spatial surroundings and to enter the world of objects. The abstract painting not only secures its environment abstractly, but also insures the reality of its surroundings, the sphere of its life, in a very specific and highly concrete manner. Consequently, the spatial and object-related context of the painting does not result in arbitrary generalisation, but interconnects with the reality of peoples' lives. The variability of visuality, the variety of visual places, corresponds to the variable rules of the game and the specific character of the cultural context, since, as Wittgenstein noted, "different places have entirely different games". Thus, the painting in this expanded field initiates an open dialogue between the various games and, in a further perspective, between different ways of living and different cultures in a multifaceted implementation of the visual. And, as it happens, this connection between formal grammar and the manifestations of life instituted by 'language games' very precisely manifests the interconnection between art and reality, between illusion and life, which is traditionally expected of good art.

Thus, the new painting of the 1990s may be located as a position between mediated visuality and visuality in context. Intersecting with the media, the painting at the end of the twentieth century, as manifest in the new pictorial Immedia, outlines a future horizon of expansive openness. The analysis of the development of the painting in the twentieth century between materiality and immateriality (*Bildlicht*, Wiener Festwochen) and between Origin and End (*The Picture after the Last Picture*, Galerie Metropol, Vienna 1991) will be followed by taking stock of the present and risking a forecast of the painting of the twentyfirst century. As we

have seen, the status of the object and the question of representation determining the painting in the first part of the century was exhausted in the opposition between abstraction and concern for the object in the second half of the century; subsequently, this phase was replaced by a discourse on materiality and immateriality determining the painting in the second half of the century. As in the two previous exhibitions, we also intend, in the present exhibition, to explore the shift in discourse defining the above two-phase development. In the present analysis, the opposition between abstraction and figuration, between the material and the immaterial, will give way to the contrast between the mediated and the immediate. The discourse between the media and the immedia will expand the previous opposition, and it will add a historical dimension.[4] At the end of this century, the representational crisis in art in the beginning of this century emerges as a crisis of the visual.

Translated by Claus Bratt Østergaard

Notes

1 The present essay was written for the catalogue of the exhibition *Pittura/Immedia. Painting in the 90s* which was also curated by Peter Weibel. Peter Weibel, ed., *Pittura/ Immedia. Malerei in den 90er Jahren,* Graz: Neue Galerie am Landesmuseum Joanneum and Klagenfurt: Verlag Ritter, 1995.

2 [Cadmium yellow window or the under side of painting].

3 Pier Paolo Pasolini, "L'experiénce hérétique cinema", Payot Paris, 1976; 134-142.

4 In this connection, we propose to revaluate the pictorial work of David Salle, Jack Goldstein (cf. David Salle's essay, "Distance Equal Control", Buffalo NY: Halways, Nov. 3-26, 1978), Troy Brauntuch, Robert Longo, Peter Nagy, Ian McKeever, Fausto Bertasa, Mitchell Syrop, Franz Gertz, Walter Robinson and others. In addition, I would like to refer the reader to three books that are highly relevant for our subject matter: John A. Walker, *Art in the Age of Mass Media*, London: Pluto Press, 1983, *Endgame: Reference and Simulation in Recent Painting and Sculpture*, Boston: Institute of Contemporary Art, 1986, and Ann Goldstein and Mary Jane Jacob (eds.), *A Forest of Signs: Art in the Crisis of Representation*, Cambridge, Mass.: The MIT Press, 1989.

Part Two: Rethinking the Ontology of Painting

Object or Project? A Critic's Reflections on the Ontology of Painting

Barry Schwabsky

One and Three Chairs

Our topic is the ontology of painting and I have to begin by admitting that I am somewhat embarrassed by the fact that I am not entirely sure how to go about approaching it. To put it in the simplest possible way, I am concerned about whether the word I should be taking most seriously is 'ontology' or 'painting.' That's not to say that my concern is somehow one about emphasis, about whether I should concentrate more on the ontology aspect of the topic or on the painting aspect. If that were the biggest problem I'm sure I could deal with it, at least in some sort of rough and ready way. No, what worries me is rather that there might be a sort of contradiction between the two terms – that there really is no "ontology of painting" and that therefore it is strictly speaking impossible to talk about it, even though one might separately talk about ontology or about painting.

But how can that be? Why would I think that? Since paintings certainly exist, it ought to be possible to say something about the nature of their being.

Well, yes, of course. But that's not yet sufficient for there to be an ontology of painting. In order for us to be able to talk about such a thing, there would need to be something particular about painting – and nothing else but painting – with regard to being. Painting would have to be a particular category of being. To clarify this, let's go back to a classic

philosophical example that I remember from my freshman year at college. Plato, as we all know, taught that what is real is a 'form' or idea, and to illustrate this he said that when a carpenter makes a chair, he constructs an object out of wood in accordance with its idea. The wooden chair is merely a representation of the idea. Further, he ventured, if a painter were to paint a picture of the chair, the painted chair would be a representation of a representation – something at two removes from real being. In this case, we can see that ideas have a certain ontological status which, according to Plato is, so to speak, fully vested, whereas objects such as chairs, being at one remove from ideas, possess an ontological status that is subordinate; and then images, at two removes from the fully-fledged reality of the ideas, possess an even lesser ontological status than objects.

Obviously we're not concerned here with the possible validity of Plato's ontological rankings, which after a few thousand years may seem rather dubious. And I'm not interested in the arguments of certain Platonists or Neoplatonists who believed they could finesse the master's condemnation of painting on the grounds that the image might in reality be closer to the idea than the object is. Nor does my problem lie mainly in the fact that, after the invention, first of printing, then of photography and – last but not least – of digital technology, the word 'painting' can hardly be equated in any simple way with the words 'picture' or 'image.' Unlike ancient times, there is now a multitude of ways to convey an image, and the implicit synonymy of 'painting' and 'image' has been prized open. Rather, I want to point out simply that in illustrating his theory of being, Plato used chairs and paintings as examples but could hardly be said to have been offering an ontology of painting any more than he was offering an ontology of carpentry. Instead, one can speak of the distinctive ontologies of ideas, objects, and images. That is to say, kinds of being can be differentiated only at a much more general categorical level than that of painting, at least in a philosophical setting like that offered by Plato. That is not to say that painting may not have a character that is distinctive from other modes of artmaking – just that its difference would not reside at this level of generality.

Would this still be the case according to modern and contemporary theories of being? Not being a philosopher, it's hard for me to say for sure, but I suspect something similar would be the case. However, my concern comes not from contemporary debates in philosophy but rather from discussions about art – from qualms about the categorical status of

painting as distinguished from other artistic practices as these are understood by contemporary artists as well as critics, historians, and theorists of art. Simply put, such discussions make it hard to see how – given a desire to speak of ontology at all – one could speak of an ontology of painting rather than, more generally, of an ontology of art.

This goes back to issues I've discussed before, particularly in my introduction to the book *Vitamin P*, which was a survey of recently emerging work in the field of painting. In writing that text I had to wonder "why – above all today – do we need a book about painting and not simply a book about art?" In order to give myself a satisfactory answer to the question – in order to justify my hunch that after all, and despite everything, there was a particularity to painting that did finally justify its being separated out from other kinds of art – I had to examine the notion, quite common in today's art world – really a sort of shibboleth – according to which "contemporary painting – or at least contemporary painting of any significance – is essentially conceptual." After all, I continued, as long ago as the late 1950s certain artists, as Thierry de Duve has put it, felt it necessary "to produce *generic* art, that is, art that has severed its ties with the *specific* crafts and traditions of either painting or sculpture" (de Duve 1996: 203, quoted in Schwabsky 2002: 6). The artists who began producing Happenings and "environments" around the end of the 1950s (Allan Kaprow, George Brecht, Robert Whitman, etc.) were among the first of these, soon to be followed by the practitioners of Minimalism and Conceptual Art (Donald Judd and Joseph Kosuth, both of whom have been known to have their own questions about the status of a chair, among others); but today this desire for an art not limited to any particular *métier* or medium has become general. This can be seen, for instance, in the fact that fewer and fewer art schools require their students to enroll in departments of painting, sculpture, or printmaking; in the new "deskilled" academy, there is typically one overarching department of, say, visual arts, whose students are expected to apply ad hoc whichever techniques happen to be most appropriate to a given project.

Four Needful Things

It must be admitted that all works of art do have certain things in common – certain minimal attributes without which an object cannot be (received as) a work of art. It seems to me that these are at least four: In

order to count as an artwork, an object must be endowed with a title, a date, and an enumeration of materials. And of course, above all, it must have the name of an artist associated with it, whose role may in part be to supply the other three. If you go to any museum or gallery in the world, the things you see will have these, or else they will be things that just happen to be there without being artworks – the benches sometimes provided for viewers to sit on while contemplating a painting will not typically have a title, date, list of materials, or artist. The fact that title, date, and materials are unavoidable demands placed on any object that might be considered an artwork means that the provision of these has become as much a part of the artist's job description, so to speak, as anything else. No artist can avoid giving a title to her work, and even 'untitled' counts as a title – often a most informative one, for instance when it clues the viewer in to the formalist underpinnings of the artist's project.

Perhaps more interesting because less noticed is the way certain artists formulate descriptions of the materials they use. One might have expected to read that the materials of Joseph Marioni's monochrome paintings consist of "acrylic on canvas," but his insistence that they be described instead as "acrylic on canvas on stretcher" alerts us to the fact that our materialism will have to go deeper than usual if we are to engage with his work most attentively and rewardingly. Likewise, to realize that Lawrence Weiner's text works are not described as, say, "vinyl lettering on wall," but rather as "language and the materials referred to," is to learn something about, indeed, the work's ontological location (and the specular *mise en abîme* generated by 'materials' being used as a key word in the inventory of materials is altogether to the point). Michelangelo Pistoletto has exhibited works made of "anonymous materials." It has been similarly possible for artists to play with the dating of works, though apparently it takes more daring – or perhaps desperation – on an artist's part to avail oneself of those possibilities. The fact that McDermott and McGough would date paintings and photographs produced in the 1980s and '90s back to the 1890s is perhaps the clearest example. And of course, that the artist's name is part of his or her plastic material is so obvious that it need only be pointed out. Whose mother ever gave her son a name like Assume Vivid Astro Focus?

In the Renaissance, artists had to produce works in accordance with iconographic programs laid down by churchmen and humanists. Under the market conditions of modernity, they became required to invent

their own subjects. In contrast to conventional accounts whereby subject matter becomes more and more expendable as the twentieth century approaches and abstraction becomes a possibility, it really becomes more and more crucially a part of the artist's task to arrive at a subject – all the more so if the work is abstract, and that is why, when some of the New York Abstract Expressionists contemplated founding a school, the name they chose for it was, precisely, The Subjects of the Artist. Finally, with postmodernity, the artist has to produce, not so much the work itself (as we'll see, there exist artists whose every effort is to reduce the work to its vanishing point) or even its subject – its 'myth,' as we will see that it can be called – as its cataloguability, if there is such a word. But in any case, these minimal attributes of the artwork are so indispensable precisely because they are requisite to any attempt to understand the work's relation to the project that generated it.

"What look like paintings"

The October 2005 issue of *Artforum*, the magazine with which I work closely, devoted no less than three articles to the work of the German painter – but perhaps we should be very tentative in using that word here – Michael Krebber (*Artforum,* 2005). I'd like to take a look at these three essays, to use them as examples, because they represent a certain range and quantity of consensus opinion on the same subject in a concentrated dose, and from an authoritative source. Let's look at how the three critics talk about Krebber's work. I'm not going to try and summarize what each one says – in any case their modes of discourse are not necessarily based on the presentation of structured arguments that can easily be reduced to a precis – but simply to quote certain value-loaded passages and expressions that seem significant and in some way typical.

According to Daniel Birnbaum, director of the Städelschule in Frankfurt, "Krebber's art is a zone of contagion, a space for conversation rather than a mode of producing objects." Birnbaum also relays what he refers to as Krebber's "often-repeated claim that he was working on his myth long before his paintings." Although after some early work based on the readymade, Krebber "has systematically turned to painting," Birnbaum says, "this is not to suggest that he has finally found a technique or subject matter with which he feels authentically at home." Instead, "What look like paintings are often in fact altered readymades,

Artforum, October 2005
[cover].

as in the case of some naively exotic-looking cheetah pictures from 2003, which are actually found pieces of fabric put on a stretcher." (Although Birnbaum dutifully notes Krebber's propensity for making works that resemble or quote other German painters, such as Sigmar Polke, Martin Kippenberger, or Albert Oehlen, he neglects to mention that this appropriation of found textiles is a move that goes back to Blinky Palermo's work in the '70s, with the difference that Palermo never used fabrics with images, only monochromatic fields.)

The New York-based critic John Kelsey begins by contrasting Krebber with other painters based on a difference in the sheer quantity of paint that their practices entail: "All the paint in Krebber's last two shows here" – that is, in New York – "couldn't fill one small canvas by Dana Schutz or John Currin." Thus, "Krebber demonstrated," by contrast, "that the proof is not in the paint job but in the idea that puts it at a fresh

distance." I don't suppose the name of Maynard G. Krebs means anything to anyone in Europe – he was a character in a well-known American television series of the late '50s and early '60s, a bongo-playing beatnik who would run like hell whenever anyone mentioned the word "work" – but (aside from the happy resemblance between their names) Kelsey portrays Krebber as a sort of Maynard G. Krebs of painting, a man motivated by his aversion to labor: "he uses painting as a strategy for extricating himself from the wrong kind of work – both the bad works that surround him and the bad works he, like anybody, is capable of – or from the demands of work, period." This is the typically Duchampian strategic detachment, not so much of art from labor, as it might seem, but rather of intellectual from manual labor. Thus the importance to Kelsey of the phrase "paint job," which he uses more than once: It suggests that merely depositing paint on a surface is a menial, manual task, the toil of a common laborer. And it seems that it is when "work" turns into "works" – when ideas or at least activity become embodied in objects – that the results are liable to turn out "bad". Kelsey suggests that Krebber goes a step further than Duchamp: "Krebber's approach underlines the fact that artists are readymades too, and that readymades can be unmade." As a result of this self-consciousness about the contingent status, not so much of painting, as of being a painter, "Krebber is less a painter than a strategist, and ... his strategy is to repeat and stop painting in order to go to work on the wider system that makes painting what it is today." And as for the objects, the paintings, in quotes, that result from these strategies, they are hardly to be dwelt on for long; as Kelsey says, "It is probably less interesting to interpret the meaning of a readymade checkered bedsheet or one depicting a moonlit, galloping horse than to realize that this throwaway image – in its very meaninglessness – is here being reclaimed as pure means. In other words, such a gesture doesn't care to fulfill any particular end, to succeed in accomplishing some ultimate significance or work." What matters to an art like this – or rather, to an artist like this – is a sort of virtuosity at escaping everyone's grasp.

It is precisely this talent for "diversion and lack of fixity," according to the third contributor to *Artforum*'s discussion of Krebber, that has made him an important reference point for younger artists both in Europe and the U.S. For all that, however, this writer, Jessica Morgan, a curator of contemporary art at the Tate Modern in London, is somewhat more measured in her praise for Krebber than are her two colleagues.

She sees his work as a repertoire of endgame maneuvers, and for that reason as a possibly unsuitable model for young artists: "While a consummate knowledge of his immediate cultural context protects him from any accusations of naïveté or misguided notions of originality, the weight of his inheritance leaves room for just the slightest of activities." While Morgan's understated yearning for an art practice that might still be just sufficiently naïve or misguided enough to risk something more than Alexandrian tinkering with the edges of one's context is a desire I'll admit to sharing, it's not exactly something that can be urged on a young artist in so many words: The very act of warning someone to maintain their innocence is a significant step toward taking that innocence away by converting it into a self-conscious strategy.

If I've spent so much time on these readings of Krebber's work, this is not – as you may possibly have gathered already – because he is an artist who evokes any deep sympathy in me. But he and the interpretations his work provokes seem representative to me – not so much of artistic work in general today, as of certain commonly, though not exclusively, held values. I think that what all those accounts of Krebber's work agree on, and what they either praise him for, or else at least see as accounting for his widespread influence, is the way the objects he produces systematically evade definition – they seem to be paintings but they have not been painted or carry very little paint; they present images but the images are essentially insignificant, and so on – and then the way Krebber himself embodies the role of painter by evading identification as such, so that he is said to be a producer of strategies rather than works, conversations rather than objects, legends and rumors more than of anything the viewer can easily grasp. Above all, and despite all talk of the death of the author that continues to echo back to us from the days of Barthes and Foucault, the reception of Krebber's work consists of a constant swerve away from an attention to the character of the things he produces as an artist to his manner of behaviorally manifesting an idea of the artist – a manifestation of which the exhibited works are only a very small part.

With regard to the ontology of the art object, painted or otherwise, this has to serve as a warning to us: It is not necessarily by looking at the object itself that we are going to learn very much about its ontology. For this reason, most of the contemporary philosophical writing on the subject seems fundamentally misguided. Even those accounts that might at first appear to shift the focus to another level, for instance George

Dickie's institutional theory, do so only in order to account, in the end, for the object – in order to explain why certain objects are "baptized," as it's sometimes put, as artworks while others are not. The title of Arthur Danto's classic essay sums up this entire problematic: "Works of Art and Mere Real Things."

But if we look attentively at how art is discussed within the contemporary art world, it soon becomes clear, as I think I showed with the essays on Krebber, that for all the energy expended on the description and evaluation and interpretation of objects, paintings among others, the object is not considered the ultimate ground of its own justification. Instead, the real point of the artistic enterprise, the thing that one really wants to pinpoint and to construe, is what might be called the artistic *project*. This focus on the project has been intermittently articulated at least since the early days of Romanticism – in 1798 Friedrich von Schlegel wrote, "A project is the subjective embryo of a developing object" – but it is as relevant as ever today, if not more so. If you are an admirer of Michael Krebber's work then what you are admiring is above all his project, his redefinition of artistic activity. If you are an admirer of John Currin, the American painter whom John Kelsey implicitly contrasted to Krebber on the ostensible ground that the former used too much paint (such inefficiency!), and if you believe that Currin "paints well" – a controversial assertion but one that would surely be affirmed by most of Currin's admirers; or rather, if you think that Currin paints well *and* count yourself a sophisticated viewer of contemporary art, then you ought to be able to see how Currin's painterly virtuosity is justified by his project, and not vice versa.

Maybe this is why we think we have a particular ontological problem about painting – an ontological problem that is also a critical problem: because whenever we look at a painting we think we are looking at an object. And if the unit of artistic evaluation and analysis is the project rather than the object, then we might feel that in this painting/object we are facing something of lesser status, like a Platonist looking at a mere chair when what he really wants to do is contemplate an idea. Someone who thinks this way might even suspect, as Kelsey seems to do, that the physical beefing-up of the painting/object (that mass of paint he derides in Schutz's or Currin's work) is a purely compensatory reaction against the object's ontological inadequacy as such – a sort of aesthetic Napoleon Complex.

But there's another way to look at it. Maybe the Platonic idea could be contemplated in its purity – maybe; but if so, that's because it was held to be perfect and eternal. A project, by definition, is nothing like that. Its very nature is to be in progress, in development – to be incomplete and unfolding, and above all to be subject to revision. (A project is not a program, which can simply be executed.) And that, in turn, means that you never get to look at it straight on. Rather, it's something you only catch glimpses of, something you descry by way of its various manifestations. If those manifestations happen to be paintings, they are at no greater (or lesser) remove from the project itself than would be the case if they were texts, or performances, or what have you. With a painting, like any other work of contemporary art, what you really have to ask yourself is, "Does the artist have a project? And if so, what can I learn about it from this particular work?"

"The intention to produce"

In the essay whose paradigmatic title I've already mentioned, "Works of Art and Mere Real Things," Danto seems to point in this direction with his fable of six identical red monochrome paintings, each of which has a different title – *Kierkegaard's Mood* being an abstract psychological portrait, *Nirvana*, "a metaphysical painting based on the artist's knowledge that the Nirvanic and Samsara orders are identical, and that the Samsara world is fondly called the Red Dust by its deprecators," and so on (Danto 1981b: 1). But I don't think that Danto quite arrives at the sense of how the artistic project underlies the diverse practices of titling because all the titles in his story are essentially captions, which function to turn the seemingly nonobjective monochromes into representations of one sort or another. Danto is implicitly cognizant of what I called the importance of 'cataloguability' for contemporary art, but he mistakes the reason for its import – he mistakes it, I mean, when he writes as a philosopher, but not, I think, when he writes as a critic. It is not what the painting represents that counts in the real world of art. What the painting represents, when it does represent, is only one more clue to the all-important sense of the underlying project, and this is the primary focus of our aesthetic attention.

To get a better sense of the force of the project, we might turn, not to a philosopher, but to a creative artist, albeit a literary artist. In his famous story "Pierre Menard, Author of the *Quixote*," as I hope you all know,

Jorge Luis Borges presents the idea that a late Symbolist poet in France, a friend and contemporary of Paul Valéry, had set himself the project of writing the great novel of the Spanish Golden Age. "Pierre Menard did not want to compose *another* Quixote," Borges' narrator specifies, "he wanted to compose *the* Quixote. Nor, surely, need one have to say that his goal was never a mechanical transcription of the original." He did not propose to copy Cervantes – unlike the appropriation artists of the '80s, though like them, Menard's inventor was fascinated by the theme of the copy and the original, which has been inseparable from any discourse on art since Plato. Instead, Menard's "admirable intention was to produce a number of pages which coincides – word for word and line for line – with those of Miguel de Cervantes" (Borges 1998: 91).

This is the essence of the issue: The artist, above all, has the "intention to produce" something. Normally, the desideratum is that this something produced should not resemble a work already existing, or at least not too closely, because this nonresemblance might be seen as a sort of indirect sign that the work is not a copy (whatever that is) but really a production. Menard, anomalously, had elected to take on a more formidable challenge. Yet, "The task I have undertaken is not *in essence* difficult," Menard is said to have explained, "If I could just be immortal, I could do it" (Borges 1998: 91-92). (His project would therefore be, perhaps, less demanding than that of Contantin Brancusi, who said of the art of which he dreamed that "one must be a god to conceive it, a king to commission it, and a slave to make it" – assuming that to be immortal is not necessarily to be a god.) In the end, Menard does manage to produce a few fragments of the novel he has in mind. These lead the tale's narrator to declare that while "The Cervantes text and the Menard text are verbally identical ... the second" – that is, Menard's – "is almost infinitely richer" (Borges 1998: 94). Of course, it is the nature of Menard's project, not the "visible" features of his text, which makes it so.

Curiously, Danto himself cites Menard, but in a different essay, and he draws different conclusions from the story than I do, although we agree that "Borges' contribution to the ontology of art is stupendous" (Danto 1981a: 36). If we were to imagine a project similar to Menard's in the domain of painting, it would presumably be an artist of today attempting to paint – not to copy but somehow to "produce" – a masterpiece by Velázquez. Of course, after Borges, that might still be a form of copying – copying an idea rather than an image. Naturally, there

exist today painters who self-consciously employ antiquated styles, and sometimes their works are of genuine interest, yet their projects never seem quite as ambitious as we can imagine Menard's to have been, or as that of Borges in reaching the point of being able to imagine a Menard. And while the work of appropriationists like Elaine Sturtevant or Sherrie Levine serves to show how tenuous the distinction between copying and production may become, insofar as the act of copying itself can at least in some instances produce differences sufficient to distance the original, their projects as well seem narrow enough to give some of us a sort of aesthetic claustrophobia. But in any case, as always, the distinction lies in the act and not in the copy – in the project, not the object.

Bibliography

Artforum International (2005), vol. XLIV, no. 2.

Borges, Jorge Luis (1998), "Pierre Menard, Author of the *Quixote*," *Collected Fictions*, trans. Andrew Hurley, New York: Viking.

Danto, Arthur C. (1981a), "Content and Causation", in *The Transfiguration of the Commonplace: A Philosophy of Art*, Cambridge, Mass.: Harvard University Press.

Danto, Arthur C. (1981b), "Works of Art and Mere Real Things", in *The Transfiguration of the Commonplace: A Philosophy of Art*, Cambridge, Mass.: Harvard University Press.

de Duve, Thierry (1998), *Kant after Duchamp*, Cambridge, Mass.: MIT Press.

Schwabsky, Barry (2002), "Painting in the Interrogative Mode", in *Vitamin P: New Perspectives in Painting*, London: Phaidon Press.

Painting: Ontology and Experience

Stephen Melville

A Problem

Let me begin with two remarks by Michael Fried about the work of two very different artists:

> It is as though Caro's sculptures essentialize meaning *as such*—as though the possibility of meaning what we say and do *alone* makes his sculpture possible.
>
> (Fried 1998: 162)

> [P]erhaps the best that can be said is that Demand seeks to make pictures that *thematize or indeed allegorize intendedness as such*, not simply assert the intendedness of the representation ...
>
> (Fried 2005: 203)

The first of these will be familiar since it figures importantly in one of the most read pieces of post-war American art criticism, Fried's controversial 1967 essay "Art and Objecthood." The second may be less familiar; it appears in a recent essay for *Artforum* on the work of the photographer Thomas Demand. I take the strong echo of the first in the second to be entirely deliberate and indeed to be underlined by the inclusion of the first in a footnote to the article in which the remark about Demand appears.

My sense – for what it's worth – is that the remark about Caro is fully at home in the closely carpentered and tightly jointed text of "Art and Objecthood," which is to say it strikes most readers as fully secure – at

least within that essay's ambit – both as a remark about Caro and as an element of the text's larger argument. I don't find myself feeling equally satisfied by the remark about Demand: without actually disagreeing with Fried's account of the work, I nonetheless find myself unwilling to come to rest there. While I accept, I think, his major point about the peculiar constraints under which photography engages matters of intention (as Fried quotes Walter Benn Michaels, "It has always been recognized that in the making of photographs, there is 'an irreducible discrepancy between intention and effect' "),[1] I find myself obscurely unhappy with the apparent, more general, carry of this invocation of intention. I should probably add that this is not because I have any general theoretical problem with the notion of intention: however various strands of recent theory may have complicated our grasp of intention, I don't see any arguments that simply rule it out of our accounts.

Unquestionably, a part of what bothers me here is that way in which Fried's account of Demand is wrapped around a rereading of "Art and Objecthood" 's critique of minimalism. That rereading gets a particular notion of intention before us that seems to me fundamentally alien to the actual argument of the earlier essay. Here's how Fried puts this point:

> A further contrast, which in "Art and Objecthood" remains largely implicit, concerns the fact that, whereas in modernist paintings and sculptures the constituent relationships were intended to be what they are by the artist, the relationship between the literalist [for which we now of course say "minimalist"] work and the beholder, although conditioned in a general way by the circumstances of exhibition, was understood by the literalists themselves as emphatically not determined by the work itself and therefore as not intended as such by its maker. On the contrary, the primacy of experience in the sense stated above meant that meaning in literalism was essentially indeterminate, every subject's necessarily unique response to a given work-in-a-situation standing on an equal footing with every other's. (Fried 2005: 202)

"Experience in the sense stated above" is in fact less stated above than, so to speak, profiled, as for example in a sentence that reads, in part: "What mattered, in other words, was the beholder's experience of the work, or rather of the situation in which the work was encountered, a situation

that, as I put it [in "Art and Objecthood'], 'virtually by definition *includes the beholder* ...'" It's in a footnote to this that we get the explicit statement of the relevant sense of "experience." Here Fried quotes Walter Benn Michaels commenting on the phrase Fried has just quoted:

> [I]n Fried's account of Minimalism, the object exists on its own all right; what depends on the beholder is only the experience. But, of course, the experience is everything—it is the *experience* instead of the *object* that Minimalism values. (Fried 2005: 262, citing Michaels 2004: 89)

And Fried goes on to characterize the book from which this passage is taken as "a wide-ranging critique of recent theoretical and fictional texts, all of which make the analogous error of [again citing Michaels's formulation] 'think[ing] of literature in terms of the experience of the reader rather than the intention of the author, and [of substituting] the question of who people are for the question of what they believe.'"

You may know Michaels as the co-author, with Steven Knapp, of an essay entitled "Against Theory" that played a notable role in US arguments about "theory" in the early 1980s, and so also will have recognized this particular argument about "experience" as an extension of the more general argument of that essay (Knapp and Michaels 1982). The particular opposition between "who people are" and "what they believe" is deeply responsive to the political shape of literary theory as it emerges in the US from the 1980s on, so it's perhaps worth adding that the argument I have with Michaels is not, to the best of my knowledge, significantly political. But I do think that, for all its plausibility, Michaels's account gets something very importantly wrong, and that Fried is thus also wrong in endorsing it.

I apologize for leading you so slowly through a fairly dense thicket of texts and citations, but I think it's necessary to seeing the nexus of the questions I'm trying to get at. On the one hand, there is a question about how "experience" figures in the argument of "Art and Objecthood" and so might continue to figure in whatever accounts of art we might devise in its wake. And on the other hand, there is also a question about how our general sense here might be inflected by the particular art or practice we are considering. These two presumably intersect in a particular way as a question about painting and experience.

Experience

Let me start on all this by noting two major features of the argument of "Art and Objecthood":

1 Fried characterizes the work he is attacking as "literalist" for a number of reasons. The most obvious is that he sees it as following a peculiar literal reading of Clement Greenberg on the underlying impulse of modernist painting (the essay also more quietly charges Greenberg with participating in this same literal reading). The idea here is that Greenberg seems to be saying that the essential logic of modernist painting is to reduce itself to its underlying, essential core. Greenberg claims that this core is flatness and the delimitation of flatness; his literalist followers see this as stopping arbitrarily short of painting's fullest reduction, which is to the condition of an object. Against both Greenberg and the Minimalists, Fried means to argue for an understanding of modernist painting that is not reductive, and so evidently also has a different view from them about the ontological depth of the conventions that sustain painting as an art; this view presses strongly toward considering a painting as something like a subject.[2]

2 "Art and Objecthood" is essentially an account of Fried's experience of certain works. The numerous remarks cited from both artists and other critics are adduced less as evidence for an 'objective' argument than as illuminating glosses on that experience. And just as the essay does not proceed by amassing evidence in the service of an argument, it draws no separate conclusion as if based on such evidence. Fried clearly feels that the judgment is simply and deeply embedded in the experience itself, so laying out the experience just is making the judgment as well. Fried's many critics who have wanted to say that he gets the experience right but the judgment wrong are working with a distinction that is utterly foreign to Fried.

This second feature comes most fully into view in one of the essay's most well-known passages. Here Fried quotes at some length from Tony Smith's recollection of an episode he takes to have had a fundamental effect on his work.[3] It is perhaps too little noted that Fried rejects nothing of this passage: he accepts that these things happened to Smith and accepts that they are of real relevance to his subsequent work. He doesn't

– it seems – have any argument with Smith. But he clearly thinks that reading this passage ought to lead one to reject Smith's work. So what actually is the argument? What is going on here?

Here's Fried's commentary:

> What seems to have been revealed to Smith that night was the pictorial nature of painting – even, one might say, the conventional nature of art. And *that* Smith seems to have understood not as laying bare the essence of art, but as announcing its end ... There was, he seems to have felt, no way to "frame" his experience on the road, no way to make sense of it in terms of art, to make art of it, at least as art then was. Rather, "you just have to experience it" – as it happens, as it merely is. (The experience alone is what matters.) There is no suggestion that this is problematic in any way. The experience is clearly regarded by Smith as wholly accessible to everyone, not just in principle but in fact, and the question of whether or not one has really had it does not arise. (Fried 1998: 158)

Smith, Fried says, saw something true – that painting is pictorial, that art is conventional – and registered that not as a truth but as something else, and the words with which he frames this disavow any capacity to frame it, as if Smith does not know that he is using words or does not know what it is to use words. The commentary thus sets out to trace a peculiar and repeated twisting of Smith's passage against itself. Part of the reason why Smith's passage needs this kind of commentary and part of the reason why the force of the commentary itself is often not seen is that we are evidently comfortable with this kind of twisting ourselves. We know – or think we know – what people mean when they say things like, "you just have to experience it."[4] Fried is suggesting that we, in fact, mostly don't know what we or they mean. And when he goes on to say that "the question of whether or not one has really had it does not arise" – and clearly does not mean by this to suggest that the events Smith recounts did not in fact happen – he must mean that experience cannot be a matter of events alone, of what merely happens or merely is. The argument between Fried and Smith is about what experience is, and more particularly about whether there can be experience apart from its having. Fried is presenting this argument as a matter of, above all, what disorganizes Smith's story and his work from within, amounting, in both cases, to the

having of an experience only in and as its disavowal. It's worth noticing that Fried's next paragraph begins by re-asking the question Smith has in fact not asked himself: What *was* Smith's experience on the turnpike? And it's equally if not in fact more notable that Fried takes himself to be in as good a position as anyone – and certainly better than Smith – to both ask and answer this question: experience is in this sense a public and not a private matter (anyone can *read* Smith's account; that's in fact all Fried has done here).

The art-specific moral is presumably this: Painting does not exist outside the experience of painting. When I put it this way, you should be able to hear Smith drawing the conclusion that this means painting is merely conventional, and you should also be able to hear Fried replying that this is to get the ontological depth of convention badly wrong, in thrall to some image of a world that would not be built from the ground up out of our conventions.

There's a very hard picture lurking within this.[5] Tony Smith, as Fried understands him, is like someone who goes through a museum, sees that people have found various ways of putting pigment on a surface and so thinks that if he does that too he will have done what they've done. Fried will say that the museum and its works have been lost on him – that he may have seen all the things on the walls but that he hasn't yet seen a painting, thus has no idea what it is to make a painting and so is bound to end up making nothing, at least nothing that matters to painting. It's perhaps worth puzzling a bit over what he has seen: images, perhaps, and relations of reference and self-reference that pass through them. There are days – at least days – when this looks to me like a good description of vast stretches of the contemporary art world (think, for example, of the ways in which 'self-reference' has come to occupy the place once apparently held by 'self-criticism').

If we let the sharper cutting edge of history shape our picture, we will see Tony Smith and Michael Fried both standing in front of one of Frank Stella's *Black Paintings*, both noting pretty much the same set of material features – say, the unusual depth of the stretchers and the intimacy of the surface pattern with the shape of the support. The literalist will say, "How clever – he's derived the painting from its support" while Fried will say, "How extraordinary – the painting has found a way to take possession of its support," as if the two of them are reading Stella's stripes in different directions and so also drawing their conclusions in different directions,

on the one hand toward the support that would justify the stripes (they derive from it) and on the other hand toward the shapes that might justify or redeem their support. (Fried himself only becomes fully explicit about this in the face of Stella's somewhat later paintings.)[6]

If painting does not exist except as the experience of painting, how are we to imagine its coming into existence? Here's an answer that fits well, I think, with Fried's argument. It comes from Jean-Luc Nancy:

> Let us imagine the unimaginable, the gesture of the first imager. He proceeds neither at random nor according to a project. His hand advances into a void, hollowed out at the very instant, which separates him from himself instead of prolonging his being in his act. But this separation is the act of his being, or his birth. Here he is outside of himself even before having been his own self, before having been a self ...
>
> For the first time he touches the wall not as a support, nor as obstacle or something to lean on, but as a place, if one can touch a place. Only as a place in which to let something of its interrupted being, of its estrangement, come about. The rock wall makes itself merely spacious: the event of dimension and of the line, of the setting aside and isolation of a zone that is neither a territory of life nor a region of the universe, but a spacing in which to let come – coming from nowhere and turned toward nowhere – all the presence of the world. (Nancy 1996: 74-75)

It helps us to get at the force of this imagination if we flesh it out a bit beyond what Nancy offers. We're in a cave, and we are talking about the making of a handprint. People have been living in this cave a long time and the print we are talking about is far from the first to be left on its walls; this wall is perhaps more or less covered with the same accidental marks that show up on all our walls. Seeing this, we can almost invert Nancy's little scene, "the first imager" might be less the maker of some special print that somehow comes to stand out as a print than the mere seer of the standing out of a print that has not theretofore stood out. However we turn this scene, we wind up with the same point: the first image, made or seen, transforms the whole; the first imager is that only on the condition that the image appear as already participating in – and breaking with – a prior practice. As Nancy writes in a related essay:

> [T]he history of art is a history that withdraws at the outset and always from the history or the historicity that is represented as a process or as 'progress.' One could say: art is each time radically another art (not only another form, another style, but another 'essence' of art), according to its 'response' to another world, to another polis; but it is at the same time each time all that it is, all art such as in itself finally ... (Nancy 1996: 87)

The fact that painting does not exist outside the experience of painting means that its practice is at once immemorial and radically originary, the first painter appearing at every moment of its history. As if, to quote from "Art and Objecthood"'s notoriously obscure epigraph, "the existence of things every moment ceases and is every moment renewed."

Caravaggio, for example, and perhaps more than mere example. Surely there was painting before this. We can point to it easily enough: there was, for example, the Renaissance and its artists, and evidently there was something before that, including Lascaux where we stood alongside Nancy a moment ago. And yet we might also have good reason to say that there was not; what was there was a certain odd conjunction of sculpture and architecture, an exercise of relief, *relievo*, that did not quite have any terms of its own. (I should note that I'm following here, at a certain oblique distance, the argument of Thomas Puttfarken's very interesting recent book on the discovery of pictorial composition [Puttfarken 2000]). In Caravaggio, something, one might say, comes into its own and so also reveals the history to which it belongs as being, newly, of painting. If one is inclined to accept this example – I know that I haven't given you any particularly good reason to do so, but I hope it's at least plausible – it may strike you that Caravaggio is able to do this because he makes explicit a relation between painting and experience that had not been explicit that way before, forging for painting a space essentially open to experience, and in doing so he opens for a practice of the image the actual possibility of painting, the space of its experience.

And now of course the proposition that painting does not exist outside the experience of painting has unfolded into a slightly different thought: that painting exists only so long as experience persists as a crucial dimension of human being and more particularly as something that needs to be had and is not simply given. As Hegel puts it: "Painting ... opens the way for the first time to the principle of finite and inherently infinite subjectivity,

the principle of our own life and existence, and in paintings we see what is effective and active in ourselves" (Hegel 1975: 797).

Medium and System

What may be interesting here is that the argument as it has emerged is evidently specific to painting. We don't, I think, have much idea of what it would be like to try to speak of, for example, sculpture, the experience of sculpture, or sculpture's intimacy with experience in this way, and we may be tempted to connect up our uncertainties here with a sense that sculpture doesn't have a history in the sense that painting does, or doesn't have its history, whatever it is, the way painting has its ('experientially', we might say, or 'self-critically').

I'm turning this way in conclusion because I'm still worried by those quotations I started with.

I noted then that these remarks are made about two very different artists. I'm noticing now that neither Caro nor Demand is a painter and asking (1) what it means that these remarks emerge on the occasions offered by their work, and, I suppose, especially why "Art and Objecthood," driven as it is by questions of painting, turns this way in its closing pages, and (2) why or how such a turn opens into something that looks like a deep misconstrual of Fried's own core argument. The answer to which I am tempted, and which I will quickly sketch, seems to assume that Caro and Demand are both, in some sense, sculptors. I think I can defend that a bit, but I admit that it's highly arguable.

What I want to suggest is both that sculpture is deeply different from painting and that the two are intimately linked in what one might as well call 'the system of the arts'.[7] It's Hegel – this whole paper has at a certain level been about nothing but Hegel – who has come to seem to me most useful here. What I take from him now are two thoughts: first, that where painting thinks experience, sculpture thinks identity, and, second, that the moments of thinking these things are historically disparate, one modern or, as Hegel says, Romantic, and the other Classical. The Classical and sculptural moment is in a strong sense normative for art – it's notable that Hegel uses the Kantian phrase "beauty free and necessary" here and nowhere else in his *Lectures on Fine Art*. It is also permanently prior to art's emergence as such; from the moment one has 'art,' sculpture is 'a thing of the past' (this is the somewhat peculiar sense I give to Hegel's

famous claim about the end of art; I think it is the only serious sense one can give to it). Art is, on this account, oddly out of synch with itself, emerging as art only after its highest achievement – life and death thus continuous in it. "Art and Objecthood" is written in the midst of a difficult turning where the complex grammar that binds 'art' both to its mediums and to their necessary distinction is bottomlessly at stake and so cannot be addressed without also enacting the shifts and discontinuities proper to it. With minimalism and with Fried's response to it, something like sculpture emerges then just where the 'as such' of painting cannot be said because painting-as-such is not; at the same time, it emerges in the place of painting, in a place where the of-ness of experience – the fact of what happens – demands registration despite everything.[8] It is in these displacements that "Art and Objecthood" opens the possibility, both within and beyond the essay, of a problematic rewriting of the argument they also anchor.

That is quickly – too quickly – said, but saying it perhaps helps to make visible an odd hidden symmetry between Tony Smith and Michael Fried – a strange logic according to which the assertion of painting will always be doubled by the end of art that sculpture marks. That will not dissolve the argument between, or within, them, but it may help in making that argument more fully our own (that is, may help us make out the present dimensions and prospects of painting).

A part, certainly, of what I would want to say about the generation of American artists who follow on minimalism – I have in mind particularly Eva Hesse and Robert Smithson, and, in a slightly different way, Richard Serra – is that they do make something very much like this argument their own, taking on the difficulties of the complex grammar and tense shifts that bind painting and sculpture and architecture into the odd, fissured unity of what we call 'art.' It would then be crucial to maintain the distinction between practices of this sort and other practices – installation would be one major example – that claim to have freed themselves from this grammar altogether (this would be one place where the fault line "Art and Objecthood" charted appears now to pass).

If the word "contemporary" is to pick out anything other than a continuously vanishing present, perhaps we should learn to hear in it a claim about how art can no longer be adequately addressed in terms of the punctual modernity of a simple now but makes itself out of a radical finitude that obliges it to grammar, tense, and medium. If we take this

to be the hallmark of the contemporary, then we will be obliged also to take that term as marking out not – or at least not simply – a period within time but as a key to registering how art's presence is itself at every moment a play of temporalities. Hearing the word this way, we would, of course, not know where contemporary painting begins or ends; we might take that as a measure of the term's promise.

Notes

1 Fried 2005: 202. The original remark by Michaels can be found in Michaels 1987: 236-237.

2 See particularly that essay's note 15: "In a discussion of this claim with Stanley Cavell it emerged that he once remarked in a seminar that for Kant in the *Critique of Judgment* a work of art is not an object" (Fried 1998: 170).

3 The passage by Tony Smith reads, in large part, as follows: "When I was teaching at Cooper Union in the first year or two of the fifties, someone told me how I could get onto the unfinished New Jersey Turnpike. I took three students and drove from somewhere in the Meadows to New Brunswick. It was a dark night and there were no lights or shoulder markers, lines, railings, or anything at all except the dark pavement moving through the landscape of the flats, rimmed by hills in the distance, but punctuated by stacks, towers, fumes, and colored lights. This drive was a revealing experience. The road and much of the landscape was artificial, and yet it couldn't be called a work of art. On the other hand, it did something for me that art had never done. At first I didn't know what it was, but its effect was to liberate me from many of the views I had had about art. It seemed that there had been a reality there that had not had any expression in art.

"The experience on the road was something mapped out but not socially recognized. I thought to myself, it ought to be clear that's the end of art. Most painting looks pretty pictorial after that. There is no way you can frame it, you just have to experience it" (see Fried 1998: 157-158).

4 This is perhaps a useful place to recall Jonathan Harris's remark in the conference to the effect that painting has now become experientially ineffable.

5 It's "hard," first of all, as a judgment on Smith. But it's also hard on the reader, since the reader cannot make it through the argument without making sense of his or her own experience of such things.

6 On this, see "Shape as Form: Frank Stella's Irregular Polygons," in Fried 1998.

7 The phrase may sound somewhat old-fashioned; the thought is not all that different from the notion of a medium's relational existence within an "expanded field" as first advanced by Rosalind Krauss and subsequently taken up, with more or less of its initial rigor, in a variety of contexts. See Rosalind Krauss, "Sculpture in the Expanded Field" in Krauss 1985.

8 I take this to be no small part of what is compelling in Smithson's acute insistence, in "A Sedimentation of the Mind: Earth Projects," on the irreducibility and undeniability of Tony Smith's "sensation." Smithson's final attitude toward Smith's work seems to me complex (see Smithson 1996: 102-103).

Bibliography

Fried, Michael (1998), *Art and Objecthood: Essays and Reviews*, Chicago: University of Chicago Press.

Fried, Michael (2005), "Without a Trace," *Artforum,* March 2005: 198-203, 262.

Hegel, G. W. F. (1975), *Hegel's Aesthetics: Lectures on Fine Art*, Oxford: Oxford University Press.

Knapp, Steven and Walter Benn Michaels (1982), "Against Theory," *Critical Inquiry* 8, 4: 723-742.

Krauss, Rosalind (1985), *The Originality of the Avant-Garde and Other Modernist Myths*, Cambridge, MA: The MIT Press.

Michaels, Walter Benn (1987), *The Gold Standard and the Logic of Naturalism*, Berkeley: University of California Press.

Michaels, Walter Benn (2004), *The Shape of the Signifier: 1967 to the End of History*, Princeton: Princeton University Press.

Nancy, Jean-Luc (1996), *The Muses*, Stanford: Stanford University Press.

Puttfarken, Thomas (2000), *The Discovery of Pictorial Composition: Theories of Visual Order in Painting, 1400-1800*, London: Yale University Press.

Smithson, Robert (1996), *The Collected Writings*, ed. Jack Flam, Berkeley: University of California Press.

Part Three: The Expanded Field

The Poise of the Head und die anderen folgen

by Katharina Grosse

In 2005 I was invited to do an in-situ piece for Solvent space of Richmond University, Virginia. While waiting for all the prep work to be done, I decided to spend half the day in the vast collections of the Museum of Fine Arts. ¶ Amongst the people that happened to arrive with me, a little eight-year-old boy stood out wearing yellow rubber boots, jeans, a big yellow t-shirt and a black cowboy hat. ¶ After I had purchased the ticket I went to the loo and all of a sudden there was a yellow rubber boot poking through from under the other booth, showing a ball pen drawing on its lower part. ¶ It was after viewing the Chinese and Indian collections that I realized I could not get this drawing from the ladies' toilet out of my head. So I went back looking for the boy to take a shot of the boot. ¶ It then dawned upon me that this little boy ensemble contained a lot of features crucial to painting that interests me most: The piece moved through public space, but was connected to the frame-work of the museum. The support for the drawing expanded from boot to the whole boy, drama-tically shifting the scale relationship from drawing and boot via drawing and boy to drawing and the whole environment of the boy and so forth. ¶ Questions, such as who was the author of the drawing, opened up. Did the boy wear the boot when the drawing was made? Was it made by himself or somebody much smaller than himself? ¶ From his carefully chosen clothes I deduced he was showing the drawing deliberately. It was shown, during this afternoon, not only in the museum's toilet but also in most of the museum's collections, causing a continuous contextual shift from private to public or to other artists' work. ¶ A ball pen is normally used for writing on a piece of paper. Its un-orthodox usage, in this case, changed the meaning of the boot from waterproof footwear to a yellow three-dimensional pictorial surface. The blue lines established a relation to the yellow, dissolving the connection between the yellow and the rubber and setting the surface free to be a colored unfathomable space.

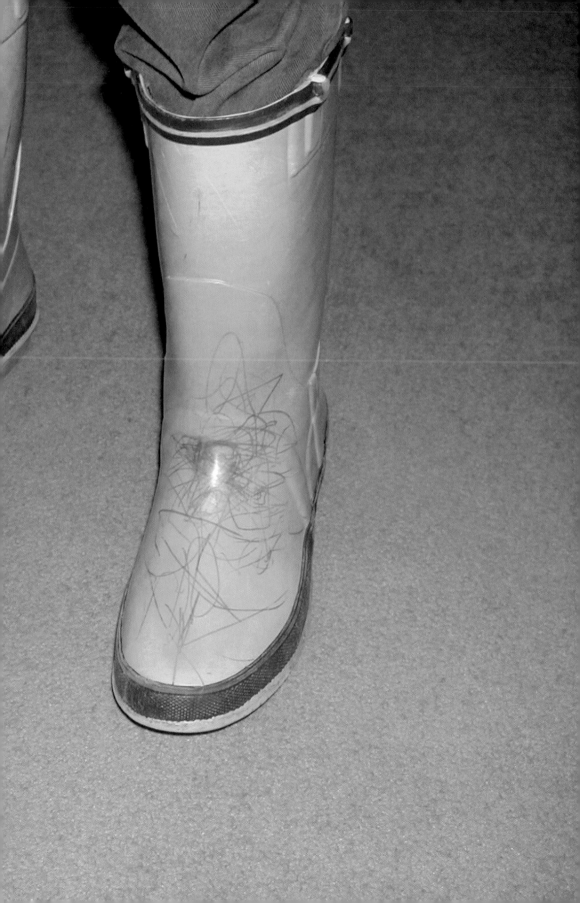

Painted Egg, Düsseldorf 1973

I probably painted this Easter egg at the age of ten. My mother must have kept it all those years. She gave it to me around 2003 with a big laugh telling me how much she thought it was connected to what I was doing now. The egg shape provided an endless surface (no beginning/no end), giving the egg and its drawing an expanding and difficult to determine scale. Similar to the boot drawing it is only by adopting a drifting point of view that the whole image unfolds to the spectator. ¶ As it cannot be seen as a whole, at once, the egg has to be turned in your fingers to reveal the complete drawing. The fingers always covering some of it relate to another order of scale and let the egg swing back to small. In this way the egg is always viewed through various shifting temporal and spatial perspectives. ¶ It is the image that disconnects the egg further from its daily use and expected function. ¶ Both boot and egg matrix reflect crucial issues of my work: the drifting point of view, the transformation of the support's meaning through painting, the arbitrariness of the context, size and scale shifts within the work's structure and the temporal and performative quality of it.

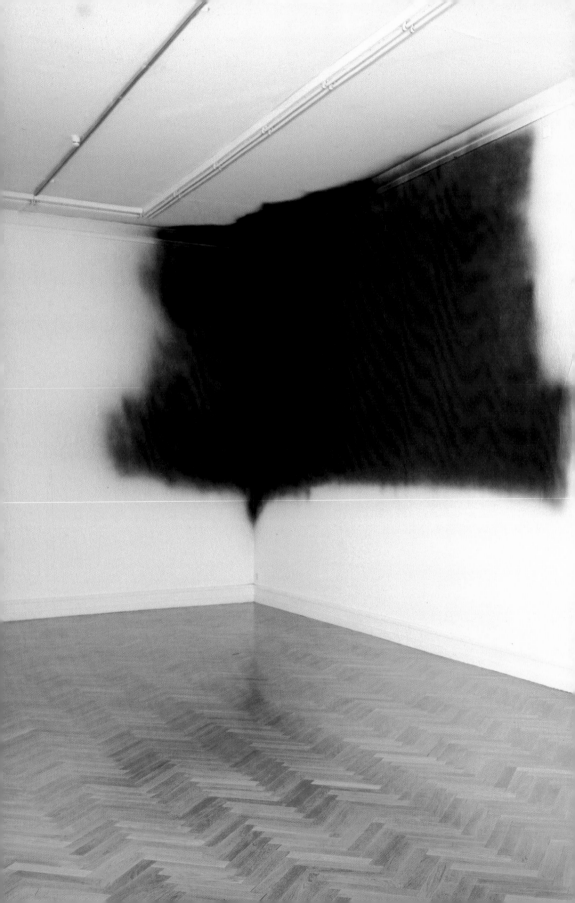

This was the first time I used a spray gun to make a painting in relationship to space and its volume. Until then I had used paintbrushes to cover the full wall space, going in regular movements from left to right or up and down thus creating different overlaying color segments.¶ When showing canvases I also used to make them correspond to the given wall dimensions until I thought, that this was a too sculptural interpretation of the situation. ¶ Painting evokes illusionistic space that follows different rules than built space; that's why it should make different use of the space it is shown in and display its independence from the surrounding set-up by under-scoring an incongruent relationship to it. ¶ The painting optically destabilized the corner of the room, letting it appear soft or even dissolved. I intended to show painting's independence of the support's coherence, i.e. the archi-tectural structure. ¶ In Bern I decided to show a painting sitting up in the right corner; that was where my gaze ended up when entering the room for the first time. ¶ The light came through windows in the opposite wall, filtered by the green of pine trees. The phthalo green of my pain-ting reflected in a very artificial way the outside context and despite its monochrome nature developed a poly-chrome character. ¶ Spraying paint on a wall has a very different effect on the working method than using a paintbrush. There is no physical contact with the wall anymore. The brush not only feeds back the disposition of the surface linking the painter more strongly to the sur-face's construction, but it also covers what is being painted that very moment. The painter only sees a little later what they did a moment before. The spray gun's move-ment is less related to body or support but it allows the activity of painting and looking to happen at the same time and to coincide. The movement of the spray gun is more related to the movement of the eyes than to the movement of the body in space. In a way it dematerializes the painter. The body-size/painting-size relationship is given up. The eye movement places painted areas in out-of-body-size relationships. This is why the artificial enlargement of the painter's body (ladders, scissor lifts) goes along with the continuous development and expansion of the work.

Whereas Bern was just slightly different in size from my studio work, the São Paulo piece refocused the relationship of scale and distance. From far away the painting in Niemeyer's large biennale building looked like nothing but a crayon scribble made by a giant. From close up it reduced the spectator to a little figure barely able to take in a small section. ¶ The viewing angles significantly altered the appearance of the piece. Coming down the ramp one would first see the wall, whereas from the lower ramp or the side wings the ceiling became the prominent view. ¶ Corrugated iron roller doors and two toilet entries were part of the painting. You could get to the men's and ladies' bathroom by walking through my work.

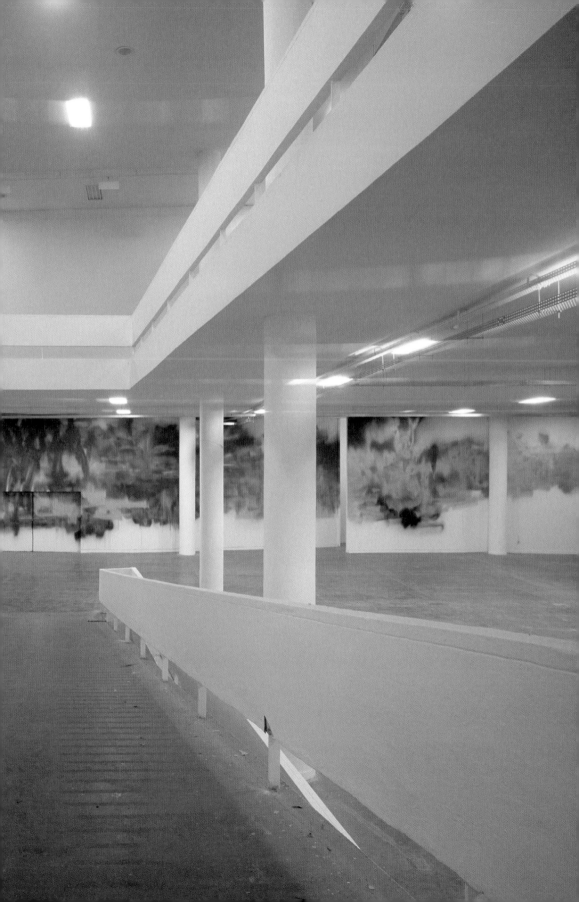

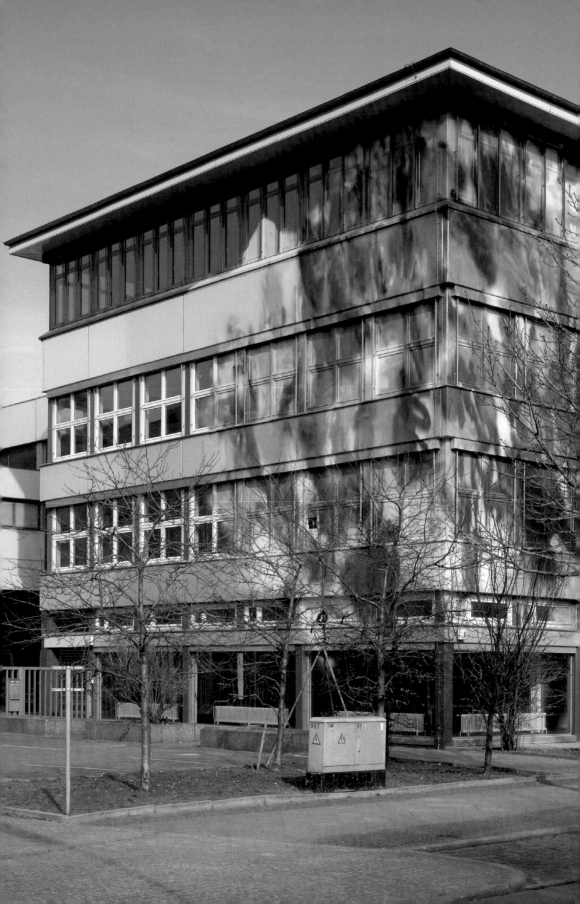

Untitled, Berlin 2003

This was the office building of an old glass factory before it was turned into Berlin's city museum. I selected the site as an exhibition venue having decided to make an outdoor work. It was included in the city structure and life, exposed to all weather, to the dark and to daylight mode. ¶ The viewing distance of the painting in the open city could be endlessly expanded. ¶ The building was used as a complete object offering a complex structure comprising a number of components such as windows, doors, blind racks or drainpipes. The paint covered and transformed these components in various ways, dislocating and inverting the presence of drainpipes, etc., as if the building was turned inside out, also inverting the function of aspects of the building, most noticeably blinding the windows with an opaque paint-skin. ¶ We were working from a five storey scaffolding fully wrapped in tarpaulins. While we were working, the piece could never be looked at as a whole from afar. ¶ I had no sketched out plan or preconceived idea according to which I would then evolve the work. First, we coated large parts with white to get brilliant colours and to delineate the maximum size of the painting. Then I worked in large overlapping movements reaching often over 2-3 storeys. I painted the following sequences from my memory of the previous moments, not aiming at an envisioned optical result but making decisions in relation to the detailed close-up experience. I stopped when the structure started to lose the transparency of its own making. ¶ What I had in mind was to give part of the building's static functional appearance an absurd metamorphic meaning similar to a gigantic bruise.

I had made quite a few in-situ paintings just prior to this work, all of them connected to set exhibition time frames. I wanted to see whether scale shifts could also be achieved in normal-sized rooms with an everyday use. In order to understand the function of different sized objects and to analyze their figurative or narrative quality I made this painting in my bedroom. ¶ Deliberately choosing a very private space of small scale filled with personal possessions and with no public access, I took it the way I had left it the day before. Nothing got specially arranged. ¶ The bed added a powerful metaphoric layer to the piece. In a more formal sense it introduced a discussion between horizontal and vertical planes. When we stand with our feet on the ground, we are placed in measurable relation to our environment, whereas our understanding of space and volume is shifted and unlimited when in bed. ¶ The books, the clothes, the money, the little paintings and photographs on my writing desk embedded references of fiction and the anecdotal into the painted field. ¶ Spraying over door, walls, cardboard boxes, books, clothes, the bed and on the floor in one unbroken spray gun movement, the objects gave up their individual contours to share the painted structure of the image. ¶ At times, the paint was absorbed and swallowed by soft velvety clothes or the cotton of the sheets. In places the painted-over objects gave a lot of volume to the thin layer of acrylic paint evoking the effect of body in oil paintings. In this way the movements of the paint took up different densities and intensities as if different time units were linked to one another. ¶ The dis-congruency of the painting towards the environmental set-up was now visible on a more detailed level.

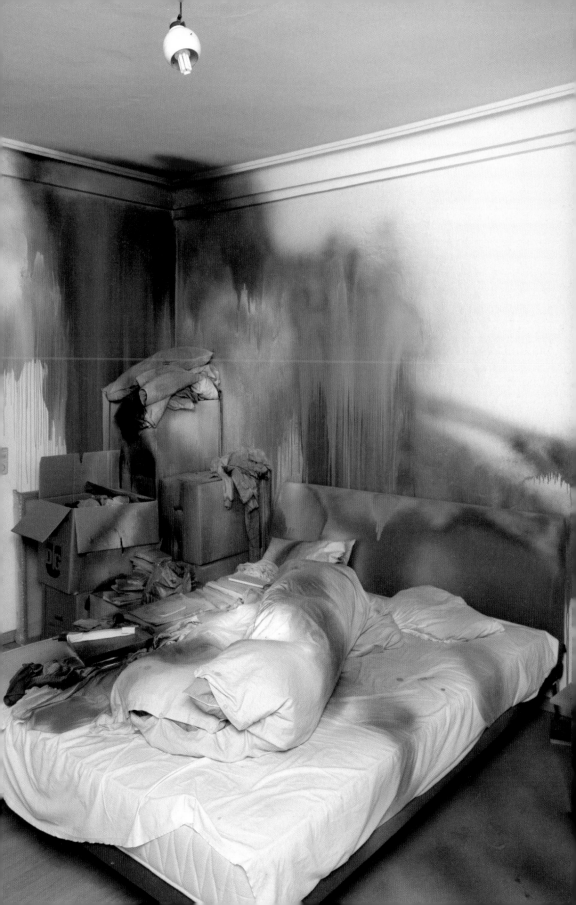

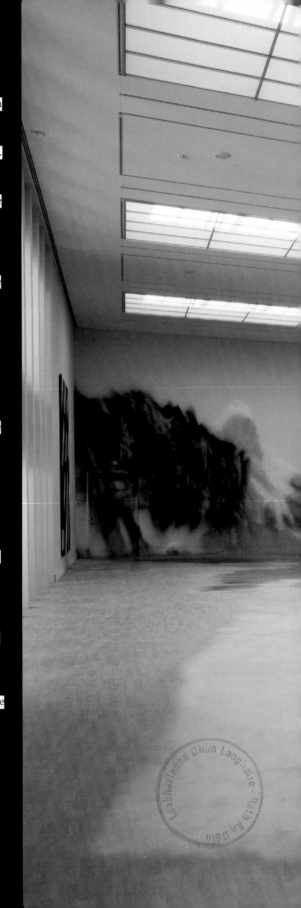

In Odense the bedroom experience was expanded to fit a large-scale room including a 4 x 15 m Montana bookshelf, three very large paintings, the doors of the museum and an imported fake oak floor that covered the original one. The Double Floor Painting. ¶ The bookshelf was completely filled with second-hand books leaving no gaps. It sat on the same wall as two large canvases coming from my studio, mimicking the qualities of a pictorial support on the one hand, and just looking like a very large bookshelf on the other. It linked the museum space to the atmosphere of a private living room that came out a little too big. Only the books would allow the visitor to rescale the experience and to recognize an object of a familiar size from close by. ¶ For larger works like this one I made a model beforehand to think about the size of the canvases or the bookshelf. The 4 x 8 m net structured painting existed already but I had to paint it again for the show, as I did not own it anymore. The one next to it I made specially for the installation, 6 x 3 m; it shows a large centered oval-shaped form; on the white canvas it looked like a large pancake leaning against the wall. I wanted to exaggerate the object to ground relationship and to accentuate the height of the space. ¶ The shelf, the canvases and the floor were camouflaged by the painted film and became unified. ¶ The combination of wall and floor painting turned out to be very surprising. Painting on the two different planes united them into a seamless continuity setting up one coherent movement running along the wall and then sliding down onto the floor stretching into the last corner of the room. This made the whole painting take on an enormous dimension, rescaling the already large canvases and bookshelf to a fraction of their original size. ¶ Looking at the wall and standing on the painted floor at the same time you would discover yourself in the work and on top of it triggering off a sensation of being above it or even distanced from it. The contrasts of being wrapped and separated seemed to dissolve into each other and generate another state of being. ¶ The all over painting constituted an image value, i.e. the activity of painting does not merely produce traces of its own action but it clearly is the result of the mental capacity to understand and generate structures according to painting's pictorial logic.

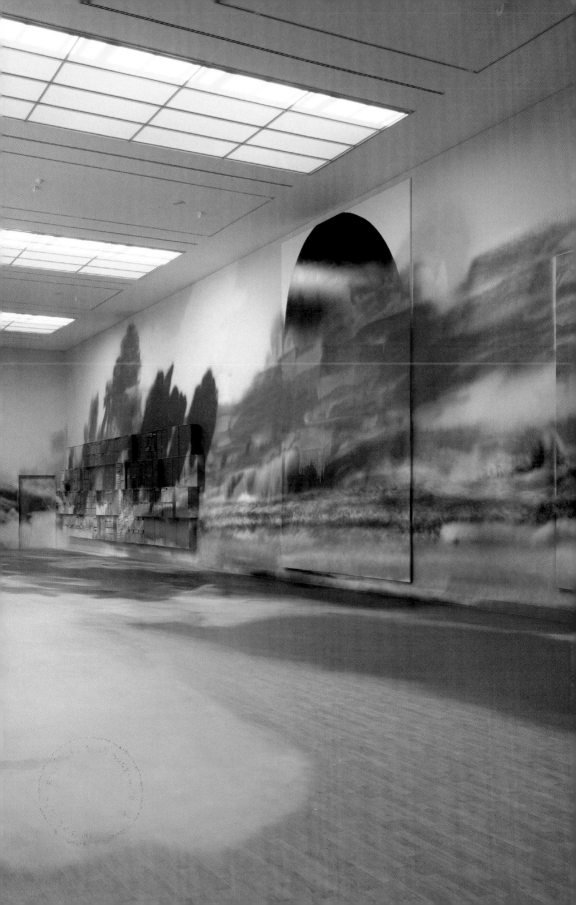

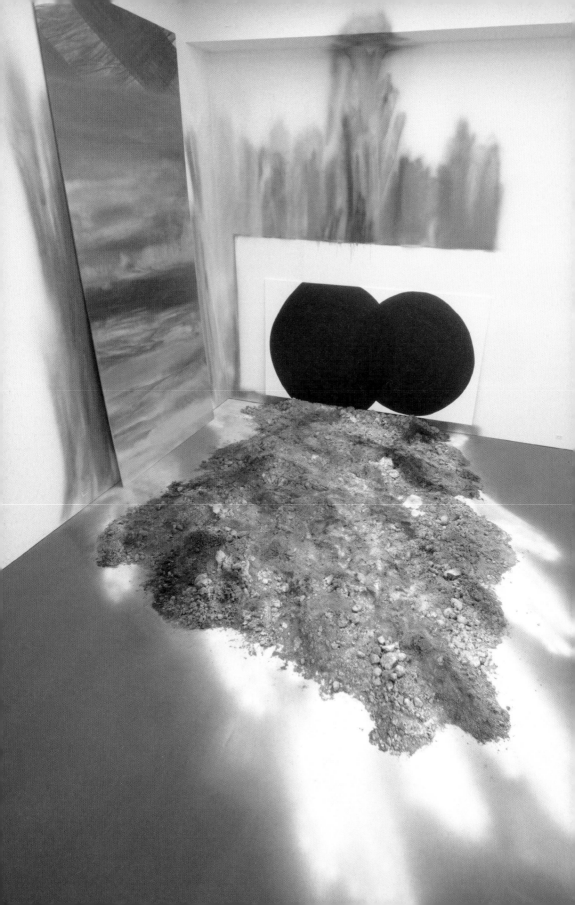

In this work I introduced a new element replacing the numerable objects by an uncountable mass, the soil. The painted soil referred to pigment as the basic ingredient of paint; it could also be read as colored earth, contaminated nature or thickened paint. The color on the soil could be looked at as mere light reflections coming from the colored walls or as being artificially lit from above as the space had skylights. ¶ The soil connected the wall and floor planes establishing a new space on which the canvas sits. ¶ In this group I started a feedback loop structure to integrate studio work into a flexible in-situ process, where different time modes and scale definitions were intertwined. ¶ I painted the soil, floor, the empty canvas and the walls at the same time, and then shifted the canvas from the right wall to the left, turning it from a horizontal to a vertical position. This movement both exposed the unpainted space behind it and covered some of the painted parts of the other wall. ¶ The inserted canvas was smaller than the shifted one. Surrounding the inserted canvas the white field appeared like a flat well-lit showcase. I painted the two-spiraled turquoise dots on gessoed canvas to make them look like two objects on a white sheet sitting in a specific white field. The dots were an image of the smallest unit in a spray finish. ¶ The piece could be seen from above; the soil seemed to look like a landscape seen from a bird's eye view. In this context the size of the canvases was hard to understand. A white spray movement on the floor took up the soil's outline so that the earthen mass seemed to sit on a white field floating on the grey floor. ¶ The activity of the work took up a relatively small area of the whole gallery. In most cases I aimed at making the smallest version of the biggest possible piece for the given space. That often meant the painting's size would not be much bigger than half of the unpainted parts. In Düsseldorf instead I compressed all the information. The corner seemed to contain the plot from where the pictorial energy expanded into the whole room giving the whole space what I called image value earlier on.

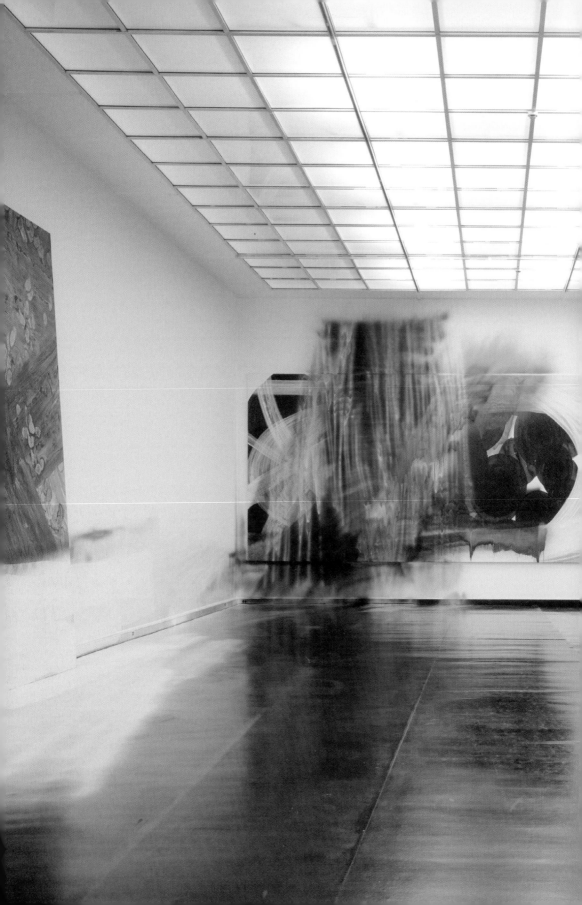

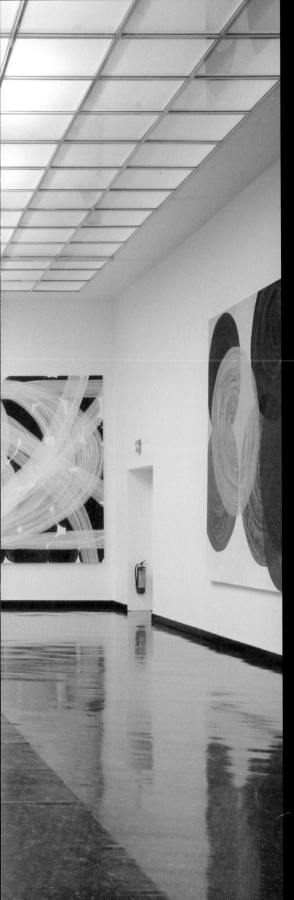

Something Leadlight, Bergen 2005

Here two of the large paintings were partly painted over without being fully integrated into a wall painting. ¶ The left one was leaning against the wall. Its structure was painted wet in wet, the unstretched canvas lying on the floor. I walked into the wet, newly painted areas undoing with the dot like footprints what was being built up. When hung in the space I painted the lower third white with a roller to connect it optically to the wall and dematerialize its physicality. ¶ The painting in the middle, which was three by nine meters, took up an image type I had used earlier in the year for the Palais de Tokyo show. It consisted of two spatial systems: a broken surface constituted by large turquoise dots that became smaller towards the right end of the canvas. I had painted a line structure on top of it walking from the right upper corner back to the right lower corner covering the largest possible distance, i.e. describing a parabolic form towards the far left of the canvas. All these movements added up to a centrist twisted space figure. When hanging, I sprayed into it to add a third movement to the two systems of the painting. This spraying added a soft excentric movement running from top to the bottom down the floor along the whole room. ¶ A new kind of feedback loop was set up through the painting, installing and over-painting of these works. The paintings can be taken into another context and possibly be painted over again, collecting different definitions resulting from their presence in various show constellations.

This was the most complex loop of integrated studio work, soil structure, canvas shifting and painted objects I had generated so far. It spread over four larger and three smaller spaces on two levels, some artificially lit others in daylight. The appearance of various light sources existing alongside the painted illusionistic light was one of my main interests in the show. ¶ Another intention was to develop one room out of the other. A thought would unfold during the painting process and take on another appearance in each room. ¶ Theatre spotlights directed strong light out of the semi-opaque window glass. A big heap of soil was mixed with thick Styrofoam boards and colorful circles cut from antique stained glass were placed on a light wire grid under a skylight. In the third room you could walk on painted Dutch clay that pushed two large dot canvases towards the walls. In the fourth room I painted the floor as white as the walls, put seven circular canvases on top, all of them different in size, spray-painted the floor and then I took the tondi upstairs to the next room to put them on the walls in an irregular rhythm. This space looked like the inversion of the previous one. ¶ The tondi could be understood as single works or as small sections of a larger coherent invisible surface. The large white circles left on the floor when the tondi were removed were disturbing to walk on, evoking holes in the floor or the sensation of a spotlight on the painting itself. ¶ From the upper level you could look down into the second room, catching a glimpse of some of the foothills made out of soil and appearing as enlarged floating spray dots. ¶ The remaining small rooms displayed a heap of white wooden boxes that I thought of as a schematic three-dimensional enlarged model of canvas microstructure. The boxes were sitting in loose stacks on a very low pedestal in front of a canvas that was propped up with another two boxes. ¶ I painted very lightly over the whole set-up, approaching it from all sides and creating spray shadows from every direction. Then the canvas was moved to close the next space off, creating a one meter wide corridor between the windows and the painting. Some light traces were left behind the box stacks as if a magician had caused the evaporation of the objects. ¶ The most important features genuinely inherent in painting are for me synopsis and non-causal structure: the first annihilating linear time flow and the latter letting cause and effect coincide to the extent that the vision of the world constantly turns out to be ambiguous and relative. Both break down hierarchic order and challenge western societies' dualistic and causal foundations. This is why painting is so interesting today. Its medium is non-affirmative and anarchic. Its political potential is rooted here. ¶ This potential unfolds when outside information is imported into the medium's specific loop. This import needs to be transformed and its mental content to be made the blue-print of the working method bringing forth the medium's new conventions. ¶ This is where the differences are between site-specific work and autonomous work. The first introducing "life" into the art loop thus shifting "life's" meaning via the context, the latter expanding the work's condition even into theatricality to provide the transformational liquid to fuel the act of transcendence opening up the experience of the spiritual core of the work.

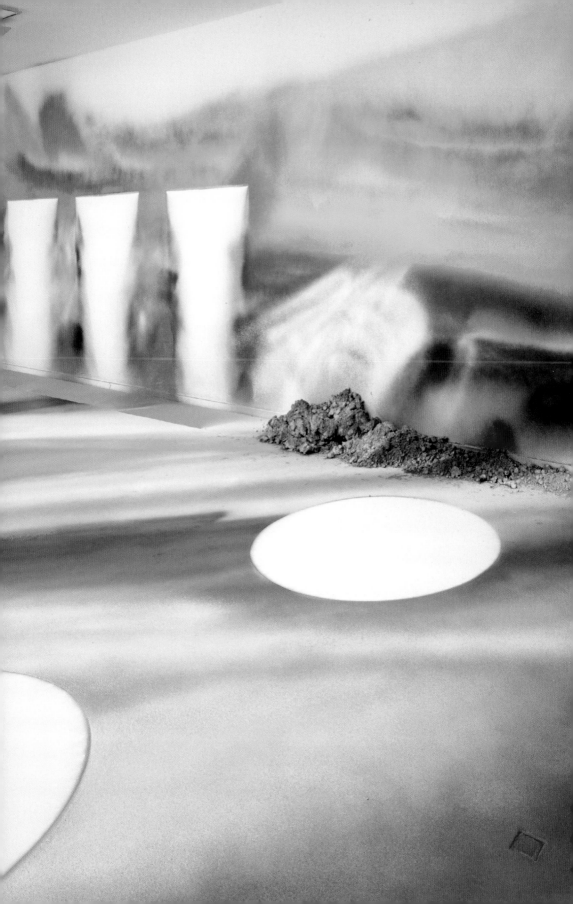

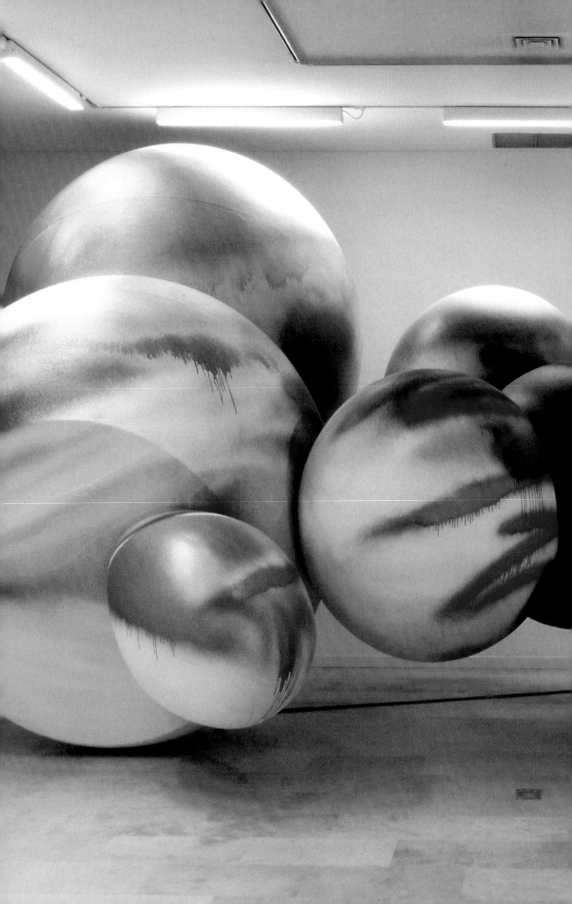

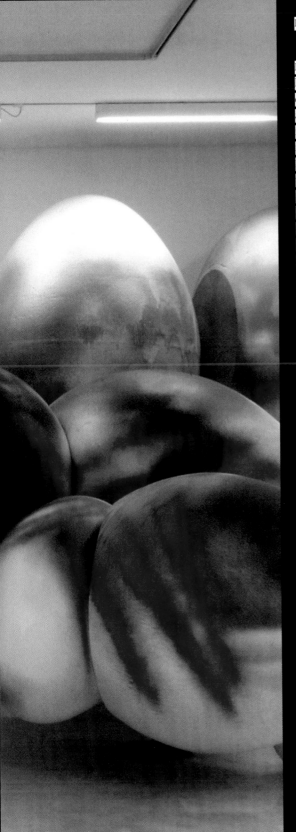

I had been working on different sculptural units for a little while alongside my usage of found materials. Some consisted of more or less mathematical elements such as spheres or ovoids, some of them were rooted in organic forms coming from stones or boulders. I was curious to find out how to substitute the soil, clothes, furniture, etc., I had used so far to dramatize the various aspects of paint's volume. ¶ Faux Rocks was made for Helga de Alvear's gallery space in Madrid. ¶ I had a mobile sculptural structure built and I painted it in situ. ¶ My main interest was to create an artificial sculptural surface that would carry the image into the volume of the architecture. ¶ I do not consider painting as extending its structure into the surrounding field, understood as the given architectural context, nor as deliberately opening up to associative subject matters "created" by the recipient. ¶ I rather understand it as a small visible part of an agglomeration of independently inter-relating organisms that exist in invisible information pools. The connection between the painting and its invisible reservoir is comparable to the way the ball pen drawing refers to the little boy wearing the yellow boot or, put in another way, to the relation of a footprint and the body that caused it. ¶ Nevertheless I believe we cannot deduce the appearance of the invisible mass the painting is made of, since I read a painting as a side product of the existing whole rather than an abstract of the whole that con-tinuously refers to its infinite structure. ¶ This reasoning made me investigate possible support features existing independently from architecture. I blew them up to construct a simultaneous view of the image's evocation in volume on the one hand and its reliance on a projection plane for visibility on the other.

Town and Country, Copenhagen 2006

This is the largest earthwork I have been able to realize so far. Nearly two thirds of the Art & Design Factory in Copenhagen was covered with soil, damaged furniture, steel containers and paint. ¶ This old factory built at the beginning of the 20th century provided an ambiguous setting for the work. It is used for workshop and preparation activities as well as to stage shows. ¶ The provisional condition of the space permitted me to explore, more extremely than previously, transitional qualities inherent in the work. The piece looked very much like a building site, loosely organized and yet on its way to a meaningful cohesive structure. ¶ Rather than achieving a finished self-sufficient work, the situation allowed the surrounding set-up to subversively infiltrate the different semantic layers of one's thought process. ¶ The provisional structure of the space's usage accentuated the temporal, unifixed qualities in the work. ¶ There is a continual coming-into-being in the work. The potentiality for change and emergence and the potential for the elements used to assume various semantic identities. ¶ For example the containers may become little huts or jewel boxes or frames revealing slanted doors leading into hidden underground hide aways. ¶ This leaves us with the question: Is what you see what you see?

Impressum

1. Katharina Grosse, untitled (boot), 2005, Richmond,
Photo: Katharina Grosse
© Katharina Grosse and VG Bild-Kunst, Bonn 2007

2. Katharina Grosse, untitled (painted egg), 1973,
felt pen on empty chicken's egg, appr. 6,2 x 4,8 cm,
Düsseldorf,
Photo: Olaf Bergmann
© Katharina Grosse and VG Bild-Kunst, Bonn 2007

3. Katharina Grosse, untitled, 1998, acrylic on wall,
450 x 1250 x 400 cm, Kunsthalle Bern,
Photo: Michael Fontana, Basel
© Katharina Grosse and VG Bild-Kunst, Bonn 2007

4. Katharina Grosse, untitled, 2002, acrylic on wall,
500 x 5000 cm, "Cidades/Cities",
25. Bienal de São Paulo, Iconografias Metropolitanas,
São Paulo 2002,
Photo: Nelson Kon
© Katharina Grosse and VG Bild-Kunst, Bonn 2007

5. Katharina Grosse, untitled, 2003,
acrylic on aluminium, concrete, glass and plastic,
1300 x 1000 x 1000 cm, Berlinische Galerie,
Fred-Thieler-Preis für Malerei 2003,
Photo: Olaf Bergmann
© Katharina Grosse and VG Bild-Kunst, Bonn 2007

6. Katharina Grosse, untitled (the bedroom), 2004,
acrylic on wall, floor and various objects,
280 x 450 x 400 cm, Düsseldorf,
Photo: Nic Tenwiggenhorn

7. Katharina Grosse, "Double Floor Painting", 2004,
acrylic on canvas, bookshelves, wall and floor,
680 x 3800 x 1100 cm,
Kunsthallen Brandts Klædefabrik, Odense,
Photo: Torben Eskerod
© Katharina Grosse and VG Bild-Kunst, Bonn 2007

8. Katharina Grosse, "The Poise of the Head
und die anderen folgen", 2004,
acrylic on wall, floor, soil and 2 canvases,
900 x 900 x 1100 cm, "raumfürraum",
Kunsthalle Düsseldorf/Kunstverein für die Rheinlande
und Westfalen, Düsseldorf 2004,
Photo: Nic Tenwiggenhorn
© Katharina Grosse and VG Bild-Kunst, Bonn 2007

9. Katharina Grosse, "Something leadlight", 2005,
acrylic on wall, PVC-floor and canvas,
480 x 2020 x 939,5 cm, Kunsthall Bergen,
Photo: Torben Eskerod
© Katharina Grosse and VG Bild-Kunst, Bonn 2007

10. Katharina Grosse, "Holey Residue", 2006,
acrylic on wall, floor and soil,
371,5 x 1430 x 646 cm (partial view), De Appel, Amsterdam,
Photo: Johannes Schwartz
© Katharina Grosse and VG Bild-Kunst, Bonn 2007

11. Katharina Grosse, "Faux Rocks", 2006,
acrylic on styrofoam on polyurethane on wood,
320 x 700 x 440 cm,
Galería Helga de Alvear, Madrid,
Photo: Joaquin Cortés

Painting Spaces

Anne Ring Petersen

> What I would really like to do is make a painting
> and then walk into it.
>
> (Julian Opie, in Bogh and Brandt 2000: 49)

The story of how artists of the 1960s and the 1970s broke new ground by means of media like photography, video, ready-mades, installation, performance and different kinds of mixed media has been told so often that it has almost become a 'myth'; that is, it has become an art historical orthodoxy, a naturalised 'truth' of how the age-old demarcation dispute between the fine arts was eventually closed. According to this myth, the experiments of the 1960s and the 1970s moved art into a "post-medium condition" (Krauss 1999) in which the classical art historical categories had been dissolved by new interdisciplinary crossovers, and the modernist discourse on the specificity of disciplines had been overtaken by 'the new media' and their seemingly inexhaustible potential for readjustment, technological updating and the generation of new hybrids. Topicality is often believed to be part and parcel of these media hybrids, irrespective of the subject of the individual artwork, because the material organisation of the hybrid *as hybrid* seems to mirror the hybridisation that characterises the era of globalisation and multiculturalism on a higher level of identity politics and cultural, economical and informational exchange.

This correlation of the new media with topicality, expansion and hybridity is also part and parcel of the myth of the victorious new media. In the mythological narrative of how art entered the "post-medium condition", the new media had to conquer an enemy: painting. Predictably, the opposite qualities of the heroes are ascribed to the enemy: The new media

are believed to be allied with the future because they assimilate and blend the very latest technologies. Painting, on the other hand, is assumed to be restricted by its simple and old fashioned materials, and it is thought to be chained to the traditions of the past because its origin is lost in Palaeolithic caves and ancient legends. And whereas the new media are busy breaking down traditions and strengthening the commitment of art to social and political issues, painting is regarded as conservative, aloof and absorbed in self-reflection. In the 1960s it was widely agreed that the cul-de-sac of painting was caused by the Modernist attempt to preserve the discipline from contamination by other kinds of art and culture and restrict its activities to what the formalists regarded as its primary task: to explore the formal aspects of painting, on the theory that all painting is basically about painting.[1]

In the 1960s and 1970s artists and critics generally had much more faith in sculpture despite the fact that sculpture had until then been ranked below painting in the hierarchy of fine arts. During that period radical sculptors succeeded in rethinking the work's relationship to site and to space. They began to treat the materials and structures of the work with an unprecedented freedom which placed sculpture in what Rosalind Krauss has called "the expanded field" (Krauss 1987). In the late 1970s and the 1980s a wave of figurative, neo-expressionist painting swept over Europe and the US, but critics such as Hal Foster were quick to dismiss this revival of painting as "the use of kitschy historicist references to commodify the usual painting", that is, as a return to tradition that sided with the political neo-conservatism of that decade, and whose principal objective was to increase the turnover of the art market (Foster 1985: 122, 124).

It seems that a genuine change of attitude did not occur until the 1990s. It was not a change in the sense that painting reclaimed its historical position as the leading artistic discipline, or that the critique of painting ceased. But attention shifted from the limitations of painting to its possibilities, when people recognised that painting could function as a flexible medium in keeping with the times and on a par with 'the new media.' This change paved the way for a recognition that painting since at least the late 1960s has extended its repertoire so much that one has to acknowledge that it, too, has developed from a fairly well-defined discipline into an expanded field in which 'painting' can merge with the above-mentioned media of photography, video, ready-made, installation and performance, but also with the older disciplines of sculpture, architecture and drawing.

Today, artists do not limit themselves to the traditional materials and means of painting. They move beyond the framed surface and its bounded physicality. As Jonathan Harris has put it, "'Painting' ... has become the name for an exploration and extension of these implicated conceptual and physical resources" (Harris 2003b: 238). Artists today are less preoccupied with the formal types of demarcation than with investigating *the painterly* as an effect resulting from the use of colours or the modes of construction, representation and display traditionally associated with the discipline of painting (Wallenstein 1996: 30).

When contemporary painting is compared to modernist painting it becomes obvious that the range of *content* has also been expanded. Painting has indeed become an outward-looking forum. Its practitioners do not only investigate the language and history of painting itself, but also wider social, ideological and political issues and questions of the formation of gender and national and ethnic identities – just as the 'the new media' do. Hence, if you want to identify some of the features that distinguish the painting of today from other media you will have to take a closer look at its formal aspects.

Exploring the Spatiality of Painting

Generally speaking, the expansion of painting can be described as a *hybridisation* – a notion whose pertinence to contemporary painting has been thoroughly discussed by British and American scholars in the anthology *Critical Perspectives on Contemporary Painting: Hybridity, Hegemony, Historicism* (Harris 2003a). With respect to cultural forms, hybridisation can be defined as "the ways in which forms become separated from existing practices and recombine with new forms in new practices" (Pieterse 1994: 165). However, with respect to the visual arts it still makes sense to consider some of the new hybrids as a continuation of the traditions of painting as long as you keep in mind that they are not only related to painting.

There is all the more reason to consider them as continuations, because the expansion of painting is not a historical novelty. On the contrary, it has been the very impetus of modern painting. Every new avant-garde movement wanted to reinvent painting. Until the 1970s painters usually extended the traditional domain of figurative painting by exploring *abstraction* or by assimilating images from popular culture and the mass media, that is, by working with and reflecting on the *mediation*

of images in modern society (Weibel 1995). Both ways of extending the vocabulary of painting have established a long and rich tradition that continues to this day. The argument of this essay is that a major change has taken place in the field of painting within the last fifteen years. A remarkable number of painters have begun to explore the possibility of developing painting in a third direction and redefining what 'space' is in relation to painting. Today, much of the experimental energy is put into exploring the *spatiality* of painting, not as a product of illusionism, but as something physical and tangible. Artists are investigating painting's relations to objects, space, place, and the 'everyday', and in doing so they are expanding 'painting' physically as well as conceptually. In many cases one can hardly say that the artist is painting pictures; he or she is rather painting or creating spaces. This rethinking of space in painting, or of painting *as* space, brings about changes in the relationship of painting to the viewer, the exhibition space, the art institutions, the market, and the other contexts of the artwork.

Let us take a closer look at some of the techniques that artists use to transform 'a painting' into a three-dimensional object or a spatial entity and to explore the connections between the work of art and its physical and social contexts. A good place to start is with installational exhibitions of paintings, e.g. by the Danish painter Peter Bonde. Peter Bonde has often used the techniques of installation art to emphasise the interrelations between the individual paintings in an exhibition. When exhibiting at Galerie Brigitte March in Stuttgart in 2000, Bonde placed a large canvas directly on the floor, leaning it against the wall. He hung medium-sized canvases densely on the wall in a syncopated rhythm and sent a series of smaller and visually lighter canvases up under the ceiling by placing them on long poles cast in plastic buckets, thus approximating his paintings to the political boards of a protest demonstration and throwing a cloak of subversive radicalism over them. Because the luminous colour of the buckets matched the orange colour of the paintings, they enhanced the coherence of the display – almost turning the exhibition into a work of art in its own right.

Peter Bonde:
Installation view from
Galerie Brigitte March,
Stuttgart, 2000. Photo:
Uwe H. Seyl. Courtesy
Galerie Brigitte March.

Obviously, Peter Bonde's exhibition does not fit neatly into the category of modern easel painting made for anonymous costumers; neither does it fit into the category of installation art proper, whose target group consists of museums, galleries and rich private collectors. Contrary to installation art proper, installational exhibitions of paintings are generally

dismantled and the paintings sold separately. In other words, these exhibitions are hotbeds of conflicting interests. As installations they have been made for a specific site, they are ephemeral and practically impossible to sell; as independent easel paintings they are durable, transportable and extremely well-adjusted to the market economy. On top of that, the installational exhibition of paintings has a double appeal to the viewer: It invites the viewer to experience and read it as a spatial environment, an installation with countless cross-references among its elements and a multiplicity of vistas that overturns traditional pictorial perspective. But at the same time it also urges the viewer to contemplate and read each painting as an individual image. It goes without saying that this requires multitasking and thus a greater effort than the usual oscillation between the details and the whole of a single picture. To conclude, the installational display of paintings turns painting into something more complex, intertextual, contradictory and – last but not least – more *spatial* than we have been used to.

The Interstice between Painting and Design

Minimal art has been a major source of inspiration for the exploration of spatiality, thanks to its use of modules and emphasis on objecthood. Some of the abstract painters of the 1990s have resumed Donald Judd's attempt to create artworks that are neither painting nor sculpture, but something in between an artwork and a thing. A case in point is some of the recent works by the Danish painter Torgny Wilcke. They are constructed out of modules made of painted laths and have standard measures so that they can be mounted, or rather stacked, in aluminium bands. Their colours, however, are endlessly variable and can be tailored to meet the wishes of the costumer. Torgny Wilcke himself stresses the flexibility of his modular paintings and their potential for creating different places and spaces. He even compares them to the modular furniture for homes and offices by one of Scandinavia's largest furniture stores, IKEA:

> I like painting because it is simple and direct. I want to build paintings directly like moulding concrete and bricks, like building walls and houses. I want fragments with a factual clarity to combine into a painterly and elemental quality. Fragmented structures and series that are flexible and open to place and time and persons. Flexibility

Torgny Wilcke: *Length
– that's beat. Multi color
version*, 2003. Timber,
aluminium, oil paint,
300 × 400 cm. Artist's
collection. Photo:
Anders Sune Berg.

gives space to the viewer just like the very different possible spaces,
homes, persons that can fit within the modular set up of the
Swedish IKEA home/office solutions. And modules, bricks, blocks,
and lengths of lumber, or similar materials are flexible to building
many kinds of walls and spaces. (Wilcke 2005: unpaged)

Wilcke's works can be viewed as an investigation of the potential of
painting to *create* interiors. However, when the artist is working in the
interstice between painting and design he is, of course, running the
risk of reducing painting to wallpaper in a posh interior decoration.
Wilcke's paintings function perfectly as a decoration of a room, albeit his
enhancement of the irregularities of the wood and the paint dissociates
them from the smooth laminated surfaces of IKEA furniture. But it is
this crudeness, together with his studied willingness to make paintings
that are *nothing but* decorations, that turns his works into comments on
the very function of 'decorating' and the late modern "aestheticization of
everyday life" (Featherstone 1996).

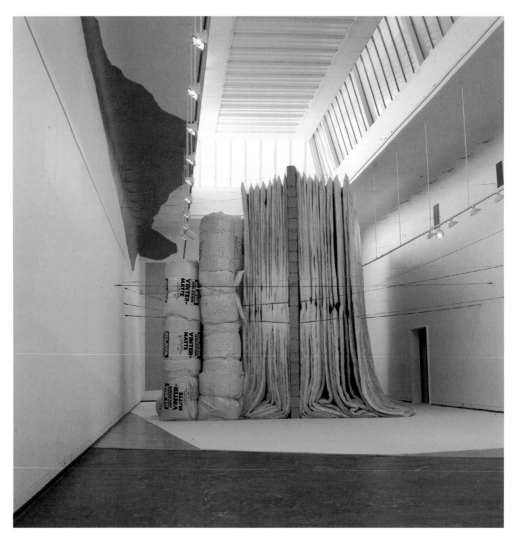

Jessica Stockholder: *Slab of Skinned Water, Cubed Chicken & White Sauce*, 1997. Paint, yellow Glava road insulation, Leca building blocks, plaster, carpet, linoleum, metal cables, hardware, hay bales covered in white and black plastic, green rope, two rooms of 32 × 8.8 m each. Installation view, Kunstnernes Hus, Oslo, Norway. Courtesy of Michell-Innes & Nash. Photo: Jamie Parslow.

Paintings to Walk Into

Other artists have turned to the techniques of installation to reinterpret the genres of landscape painting, cityscape and cartography – obvious forums for the exploration of space. The German painter Franz Ackermann, for instance, has created complex mental maps of overlapping images by combining easel painting with wall painting, and the British painter Julian Opie has used installation art's spatial distribution of objects to explore the idea of landscape painting as a space that the viewer can walk into.

The techniques of installation art have also added a wide range of expressions to the palette of artists working with the effects of colours and non-figurative forms, artists such as Katharina Grosse and Jessica Stockholder. The latter creates assemblages and builds huge installations out of mass produced everyday objects and building materials: wooden planks, insulating material, textiles, carpets, refrigerator doors, bulbs, lamps, wires, toys, plastic bags and boxes, ventilators, etc. Contrary to most installation artists, e.g. Jason Roades who also exploits the colour effects produced by the juxtaposition of different objects, Jessica Stockholder adopts a specifically painterly approach. She often covers the objects partly or entirely with paint, and she combines them with compositional counterparts of pure colour that transform the articles for everyday use into independent forms. When she puts things together to create an installation, she often places them along diagonals as if she were constructing a linear perspective in a picture, thus stressing the similarity between her three-dimensional construction and the construction of pictorial perspective. Stockholder uses the spatiality of installation art to transfer, or rather translate, painting from plane to space and wrap the work around the viewer as a three-dimensional environment. Hence, her works elicit the more bodily and performative type of response typical of installation art. One could say that she creates a usually temporary stage-like event, and that this event or spatial situation gives substance to the dream that illusionistic paintings have always played on, and that many commentaries pick up on, from the art criticism of Diderot to reviews of Stockholder's installations (Fried 1980: 109-131; Schumacher 1996: 393): The dream of literally walking into the painting in order to explore it more thoroughly and empathise more deeply with it.

Something similar can be observed in the case of Katharina Grosse who treats the exhibition space as if it were a surface to be painted on. To Grosse everything is a potential ground for her paintings: walls, ceilings, windows, doors and the everyday objects and materials that she sometimes brings into the room. As opposed to Stockholder who uses objects and titles to lay down traces of a narrative in her works, Grosse's normally untitled installations are more closely connected to abstract painting, and they do not present themselves to the viewer as a construction of mainly solid forms based on architectural and perspectival principles. On the contrary, they enhance the fluid and formless consistency of the paint itself and convey a sense of movement and expansion to the viewer.

Grosse often spray-paints her works spontaneously and without preliminary sketches (Bepler 2004: 74). She uses a standard tool of house painters and graffiti artists, the 'mechanised brush' of the spray gun. Contrary to house painters and graffiti artists, she paints with very good pigments, thus bringing together the sphere of fine arts and the everyday. Or, as Grosse has put it, she brings together "Rembrandt's colour theory and the everyday method of applying paint" (Grosse, in Bepler 2004: 72). She uses the spray gun as a mediating device that introduces a distance between the hand of the artist and the surfaces she paints on. Nevertheless, the huge traces of colour that she applies to the surfaces of the room without touching them with a brush do bring the Abstract Expressionist Jackson Pollock and the colour field painter Morris Louis to mind, as they won fame for being the first artists to use dripping techniques to create large scale paintings. By using a spray gun Grosse does not only establish a cool distance to Abstract Expressionism and the modernist myth of painting as an authentic 'imprint' of the artist's hand and a direct expression of his inner life. She also enlarges the gestures of the hand, making them bigger and more powerful than the physique of the human body allows. The spray gun enables the artist to make one single 'brush stroke' that reaches from the floor, across the wall, and up to the ceiling. Mechanical or not, what the spray gun leaves is more than life-size traces of a body moving in space and time. It is macro-imprints of a painter's performance. In that sense, one could say that Katharina Grosse uses the spray gun as a technical means to transcend the limitations that the human body has imposed upon Abstract Expressionism. As regards Grosse's approach to painting, it is reminiscent of Jackson Pollock's – think of the famous photos of Pollock taken by Hans Namuth

in 1950 while Pollock was performing what looks like a ritualistic dance around the canvas on the floor, spraying and dripping paint all over its surface (Schimmel 1998: 16ff.). As Grosse has explained in an interview, "The most important thing for me is to present actions as if they were performances. There isn't really a story, but there's a sequence of actions and a plot" (Grosse, in Bepler 2004: 64).

Katharina Grosse considers painting as the material trace of an act to be a crucial part of her installation. Thus, one could say that there is a performative dimension to her work although the audience never gets to watch her perform. Before she takes action, Grosse puts on a white protective suit that not only transforms her from an artist personality into an anonymous and mysterious figure, but also moves her into another sphere – that of painting: White is, among other things, the colour of the untouched canvas, of the painting before it is painted, so to speak. Grosse's approach to painting and the vibrant traces of colour that her movements and gestures leave in the exhibition space invest her flowing, floating and trickling landscapes of colour with a strong sense of transitoriness: Her macro-imprints speak strongly of the presence and physical activity of a body now absent from the room. They provide the viewer's gaze and body with a powerful stimulus for tracing the progression of the artist's work which is also the coming into existence of a painterly space. Unlike conventional easel paintings, Grosse's in situ works are not objects. There is no canvas to endow her work with permanence, only the surfaces of and the objects in the exhibition space that temporarily lend her improvised abstract compositions the necessary material support. Hence, Grosse creates fugitive spaces. As such, her works are impossible to fix, except in memory or as documentation in another medium.

Just like Stockholder, Grosse wraps her installational works around the audience, more or less immersing the viewer in colours. By doing so, Grosse and Stockholder substantially alter the conventional casting of the audience as rather immobile spectators positioned in an ideal position in front of and at a distance from an artwork that is clearly delimited as an object. This casting is particularly persistent in the case of easel paintings presented in art galleries and museums. This explains why painting, more than any other discipline, has nourished the idealistic notions of the autonomy of the work of art and its correlate: the notion of the spectator as an all-seeing and detached, even disembodied, eye that gazes upon the artwork from a centred consciousness. Nobody has explained

the part assigned to the modern viewer better than artist and critic Brian O'Doherty in his institutional critique of "the white cube" of the modern gallery space:

> The ideal gallery subtracts from the artwork all cues that interfere with the fact that it is 'art'. The work is isolated from everything that would detract from its own evaluation of itself. … Indeed the presence of that odd piece of furniture, your own body, seems superfluous, an intrusion. The space offers the thought that while eyes and minds are welcome, space-occupying bodies are not – or are tolerated only as kinaesthetic mannequins for further study. This Cartesian paradox is reinforced by one of the icons of our visual culture: the installation shot, *sans* figures. Here at last the spectator, oneself, is eliminated. You are there without being there …
>
> (O'Doherty 1999: 14-15)

Stockholder and Grosse establish very different conditions for the reception of their works. Just like the phenomenologists, they emphasise the entanglement of the subject's body and mind with the world and its phenomena. By locating the viewer at the centre of the work and creating the impression that he or she has walked right into the painting, by submerging the viewer in colours (Grosse), or by surrounding the viewer with brightly coloured objects (Stockholder), they point to the fact that, in principle, there is no distance between work and viewer; they are connected parts of a whole, a total *situation* which the viewer cannot transcend or step out of, but only experience from different viewpoints that are always viewpoints defined from 'within' the situation.

What makes these works into something special? By combining painting with installation and giving substance to the dream of physically entering a picture, artists like Stockholder, Grosse, Ackermann and Opie produce an ambivalent intensity that distances their works from most installation art as well as easel painting. This intensity of experience seems to originate in a tension between two kinds of presence. On one hand, the viewer experiences a phenomenological and situational presence related to his or her direct involvement in the 'here and now' of the work. This kind of involvement is a dominant mode of reception in installation art as it is usually based on an ambition to awaken the viewer's awareness of embodied perception.[2] Involvement in the 'here

and now' of the work directs the viewer's attention to his or her bodily and performative navigation through the space of the installation. On the other hand, the viewer also experiences a sense of absorption, of being embraced by a fictitious world that introduces other time-space relations, and pushes corporeal gravity and navigation through space to the back of the viewer's mind (Bogh 2000: 20). This is the mode of reception that viewers usually adopt when contemplating a painting or pictures in general. Painterly installations impose this conflict between the feeling of loss of self and a heightened awareness of self on the viewer with a greater intensity than most installation art and any easel painting, even more so than colour field painting that is usually considered to be capable of producing an intensified awareness of the phenomenological relations between viewer and work.

The Limits of Painting

What do my examples tell us about the expansion and limitations of painting today? They have demonstrated that 'painting' which moves in the 'third direction' of exploring the spatiality of painting can take the shape of an installation, an object, or design. It can be overtly "theatrical", as Michael Fried would call it, and it can engage the viewer in a more bodily and dynamic manner. But it can also recede into the background to find a more humble position among ordinary things, subtly changing the environment in a way that designer furniture and wall paper can never do.

As to the painterly installations, these spectacular works are very dependent on the spaces of museums and galleries as opposed to paintings that have been designed as 'public art'. Paintings made as public art and the grand fresco decorations of the Renaissance and Baroque integrate painting into a social context. They are placed so that they do not obstruct the normal functions of the rooms for which they are made. An installation, on the other hand, requires a room of its own, a space that people do not enter in order to *use* it for a specific purpose. People enter an installation as viewers. Their only reason for being in that space is their desire to experience the installation.

On the face of it, installations based on painting seem to break down the barrier between the painting and the surrounding world, leaving the borders of the work of art wide open so that social reality can pour into the work while the work itself seizes control of the surrounding space. The

fact that the viewer physically enters into the work to experience it also seems to give evidence of a free passage between the work and its contexts. However, this fusion of spheres is paradoxical, because it opens and closes the work to the surrounding world at one and the same time. The integration of techniques of installation art extends painting into physical space, but this extension is normally dependent on a withdrawal into the reclusive spaces of museums and galleries. Accordingly, the fusion of painting and installation does not necessarily entail an opening of painting towards the social and political world of everyday life, not to mention a critical engagement with social, political and historical issues. Subversion and critique is not something inherent, and as opposed to other kinds of installation art it is not obvious for the audience that some of these 'painterly' installations could or should be read as art with a critical edge.

The majority of viewers are probably not aware that the formal heterogeneity of Ackermann's paintings and installations amount to more than a delirious sampling of styles and citations from the history of painting, namely, a critical reflection on the impossibility of creating a coherent, clear and stable image of the world in an age of informational overload and heightened intensity of travel and exchange. Nor is it obvious to the audience that Stockholder's aestheticisation of everyday objects involves a reflection on the relationship between different economic systems, that of mass production and that of high art (Bonde 2005), and on what it means to live in a consumer society where your lifestyle and identity is abundantly determined by your relationship to all the objects and services you buy. As the art historian Katy Siegel has observed, Stockholder does not emphasise the uniformity and anonymity of mass produced goods like the minimalists did. She renders visible the very personal feelings that objects, even impersonal mass produced objects, inspire. Stockholder points to the allure of individual ownership or control of things by enhancing their sensuousness or "sex appeal", the way they respond to handling and awaken our desire to consume or to have them. Moreover, her uneasy marriage between incommensurable objects can be seen as a blown-up version of what people do with things in their everyday lives, how we put things together in highly idiosyncratic ways, and how leaving our marks on material objects and stuff contributes to defining ourselves as individuals (Siegel 2005: 41-42).

It is not that the art audience is ignorant, but contemporary painting is received in a context of new artistic media and strategies that

are often misleadingly promoted as critical or subversive art forms be-cause the artists using them have explicit political and social agendas. Compared to this kind of engaged art, most viewers are likely to experi-ence Ackermann's and especially Stockholder's understated works as po-litically and socially disengaged 'affirmative art' and associate them with the tradition of modernist painting, and hence also with such disputed notions as 'autonomy', 'beauty', 'style', 'originality', 'abstraction' and 'pure form'. Instead of regarding installations based on painting as a defensive pull-out – a retreat to the white cube as a formalist laboratory and a shel-ter from the world – we should perhaps try to look for the limitations of painting elsewhere than in 'painting' itself. Perhaps the most serious restriction that 'the expanded field of painting' still has to overcome is the rather fixed expectations of its audience.

Notes

1 An earlier version of this essay with a more thorough discussion of specific works of art was published in Danish in the art journal *Passepartout*: "Maleri, ting, rum", special issue on " 'Nyt' 'Dansk' 'Maleri' " vol. 26, 2005, 2006: 7-25.

2 For an in-depth discussion of the reception aesthetics of installation art, see Bishop 2005.

Bibliography

Bepler, Cecilie (2004), "Interview", in *Katharina Grosse: Double Floor Painting*, ed. Lene Burkard and Katharina Grosse, Odense: Kunsthallen Brandts Klædefabrik: 62-77.

Bishop, Claire (2005), *Installation Art: A Critical History*, London: Tate Publishing.

Bogh, Mikkel (2000), "Fact as Value, Value as Fact: Some Current Trends in Painting and Sculpture", *Fact & Value: nye positioner i skulptur og maleri/new positions in sculpture and painting*, ed. Mikkel Bogh and Charlotte Brandt, Copenhagen: Charlottenborg Udstillingsbygning: 16-22.

Bogh, Mikkel and Charlotte Brandt, eds. (2000), *Fact & Value: nye positioner i skulptur og maleri/new positions in sculpture and painting*, Copenhagen: Charlottenborg Udstillingsbygning.

Bonde, Lisbeth (2005), "Rebellen, der blev klassiker (interview)", *Weekendavisen*, 14-20 October, sec. 2: 6.

Featherstone, Mike (1996), "Postmodernism and the aestheticization of everyday life", in *Modernity & Identity*, ed. Scott Lash and Jonathan Friedman, Oxford and Cambridge, Mass.: Blackwell: 265-290.

Foster, Hal (1985), *Recodings: Art, Spectacle, Cultural Politics*, Seattle, Washington: Bay Press.

Fried, Michael (1980), *Absorption and Theatricality: Painting and Beholder in the Age of Diderot*, Berkeley, Los Angeles and London: University of California Press.

Harris, Jonathan, ed. (2003a), *Critical Perspectives on Contemporary Painting: Hybridity, Hegemony, Historicism*, Liverpool: Liverpool University Press and Tate Liverpool.

Harris, Jonathan (2003b), "Hybridity versus Tradition: Contemporary Art and Cultural Politics", in *Critical Perspectives on Contemporary Painting: Hybridity, Hegemony, Historicism*, ed. Jonathan Harris, Liverpool: Liverpool University Press and Tate Liverpool: 233-246.

Krauss, Rosalind (1987), "Sculpture in the Expanded Field", in *The Originality of the Avant-Garde and Other Modernist Myths*, Cambridge, Mass. and London: The MIT Press: 276-290.

Krauss, Rosalind (1999), *"A Voyage on the North Sea": Art in the Age of the Post-Medium Condition*, London: Thames & Hudson.

O'Doherty, Brian (1999), *Inside the White Cube: The Ideology of the Gallery Space*, Berkeley, Los Angeles, London: University of California Press.

Pieterse, Jan Nederveen (1994), "Globalisation as Hybridisation", *International Sociology* vol. 9, no. 2: 161-184.

Schimmel, Paul (1998), "Leap into the Void: Performance and the Object", in *Out of Actions: Between Performance and the Object 1949-1979*, ed. Russell Ferguson, London, New York: Thames and Hudson.

Schumacher, Rainald (1996), "Jessica Stockholder", *Kunstforum International* vol. 133: 393.

Siegel, Katy (2005), "Both Sides Now", in *Jessica Stockholder: White Light Laid Frozen – Bright Longing and Soggy Up The Hill*, ed. Jessica Stockholder, Lene Burkard and Birte Westing, Odense: Kunsthallen Brandts Klædefabrik: 29-59.

Wallenstein, Sven-Olov (1996), "Måleri det utvidgade fältet", *Måleri det utvidgade fältet*, ed. Ulrika Levén, Stockholm and Malmö: Magasin 3 Stockholm Konsthall and Rooseum: 11-31.

Weibel, Peter (1995), "Pittura/Immedia: Die Malerei in den 90er Jahren zwischen mediatisierter Visualität und Visualität im Kontext", in *Pittura/Immedia*, ed. Peter Weibel, Klagenfurt: Verlag Ritter: 13-26.

Wilcke, Torgny (2005), *Length to Blocks – that's beat*, New York: DCA Gallery.

Part Four: Painting and the Question of Gender-Specificity

Claims for a Feminist Politics in Painting

Katy Deepwell

What is the context now for a feminist politics in painting? While I had an ambitious plan in mind to construct an overview of some of the debates in the last thirty years around this question, I quickly hit upon the difficulties of such a project. So what follows are a series of examples, problems and questions around the subject itself. I have periodically written about the relationships between painting practices and feminist politics (Deepwell 1987, 1994 and 2000) and attempted to make interventions which would argue for feminist practices in painting which were not divorced from but a part of other feminist strategies in contemporary art. In the context of this book, I wondered if there was any value in a reinvestment in painting as a practice if it were seen as distinct from other forms of contemporary art. Perhaps a better strategy for subverting the problem which discussions of painting always seem to raise would be to blur the lines of any claim to medium-specificity as this is the claim which is so clearly aligned to reinstating or trying to maintain a late modernist perspective and holds onto painting as a category (Verwoert 2005; Roberts 1984-1985). Arguments highlighting the death of painting (which are always also simultaneously its rediscovery and celebration in new forms) in recent exhibitions and in the art market circulate primarily around whether this is a return to or a rejection of modernism's claim to the importance of painting as medium. Examples here include: *Unbound: Possibilities in Painting* (London: Hayward Gallery, 1994), *Urgent Painting* (Paris: Musee de L'Art Moderne de la Ville, 2002), and *The Triumph of Painting* (London: Saatchi Gallery, 2005). This is especially problematic

for feminists – and for any claims to a feminist politics in art production/art practices – given that feminism, in Lucy Lippard's words, defines itself by its lack of contribution to modernism and as a break from and a transformation of modernist practices to other ends (Lippard 1980). Mary Kelly's useful description of the feminist problematic as the intersection between modernism/modernity, sociality and sexuality rests on precisely this shift in definition and practice away from modernism and towards an engagement with modernity (Kelly 1981). Feminism has had a vested interest in challenging modernism, especially for its masculinist biases but also for its separation of art from politics. It is here that painting itself is always doubly-identified as both a conservative and a male-dominated practice, first in the sense of reproducing the bias in which men paint and women appear as objects within the frame and second as a studio-based practice which breeds forms of ivory-tower isolationism and produces *the* primary commodity in the art market (Lippard 1981; Rosler 1977). As John Roberts has suggested, painting practice is frequently either fetishised as a release from the cognitive and political or dematerialised as being outside the possibilities for any form of cultural intervention (Roberts 1984-1985).

Painting's pretensions to singularity as a practice rest on a specific modernist trajectory. Painting exists here as *the* model of art practice, a category whose tropes nevertheless embrace many different types of painting styles and approaches, both figurative and abstract, laid out as a series of inheritances and breaks from previous forms. Acknowledging this may also be the start of dissolving painting's claims for its *raison dêtre* as defined either by figure to ground relationships (Krauss 1985), or by painting's absolutist reduction to either a piece of canvas on a support ([late] Greenberg cited by Fried 1968 and Greenberg 1965). Alternatively painting has been repositioned by the new art history as a complex signifying system generated by the relationships between the social space of art's production; the symbolic space of the art object and its statement; and, finally, as a space of representation in which social and sexual hierarchies are figured (Pollock 1992). Griselda Pollock's construction, for example, positions painting as:

> [the] ideology of art [which] services bourgeois mythologies of
> the self-possessing and self-realizing individual in this imaginary
> form, [and] we must recognise that its function is also decisively on

the side of the Symbolic: that is the cultural-social-political order.
The imaginary individual ... is a man, empowered by his privileged
place on the symbolic side of the division theorized as 'sexual
difference'. (Pollock 1992: 144)

This model, she suggests, is one in which women can

> share the fantasy of the creative self, desire that privileged space of
> imaginary freedom called the studio. Feminism and the discourses
> of art are, however, locked in a profound contradiction at the site
> of the expression of the creative self. Feminist theory problematizes
> notions of the self, of woman, of the subject, arguing that these
> are not essences, the pre-social sources of meaning but intricate
> constructions in social and psychic space. (Pollock 1992: 145)

In spite of this retrospective analysis of the appeal of painting, painting
acknowledged as an ideological socio-cultural model – particularly the
tropes of modernist painting – did act as a significant reference point for
many early feminist practices and as the object of women artists' critique
of formalist practices.

Women Artists' Critiques of Modernist Painting

Kristine Stiles in her essay on Carolee Schneemann, "The Painter as an
Instrument of Real Time" (Schneemann 2001), points to the significance
of the artist's installation *Eye Body* (1963) in terms of the politics of
painting. *Eye Body* is an installation, a loft environment, an assemblage
– a setting for performance or rather performative actions to camera.
Schneemann's project is, for her, devoted to exploring the painterly is-
sues of relationality, figure-ground and similitude: all prominent tropes
in painting in the early 1960s when the work was made (and the territory
on which the debate between Rosenberg and Greenberg was staged in
the late 1950s). Citing Schneemann's own correspondence, Stiles's ar-
gument underlines the artist's refusal to identify her work with action
painting. She was not interested in the mark as redolent of an expressive
subject. Instead the works are an exploration of the techniques of vision,
manifest in the gap between outer representation and inner experiences/
consciousness. Arguing that her contribution as a painter to art history

remains unseen, or confused, Stiles locates Schneemann's strategy as an "aesthetic of the transitive eye" moving between a "bodily eye" (which dominates over actual things) and a "body-as-eye" (which thinks its domination in the mind), citing Goethe's argument that to resolve this dilemma was the true measure of an artist. This relationship between eye-body and consciousness she positions as "one of the essential functions of painting" (Schneemann 2001: 4-5).

Stiles's reading opens up the territory for a gendered reading, but in the interests of making a case for Schneemann's importance to art history she bypasses or refuses its implications. She does not want Schneemann to be positioned as the Other again, the marginal figure of the woman artist insisting on her centrality to cultural production. Schneemann's own description, also presented in *Imaging Her Erotics*, is more candid, describing *Eye Body* as a work in which she "established [her] body as visual territory" and in which the "extension of my painting-constructions challenged and threatened the psychic territorial power lines by which women, in 1963, were admitted to the Art Stud Club, so long as they behaved enough like the men" (Schneemann 2001: 55).

Schneeman's work and such statements reinforce her strategy in undertaking one of the primary feminist shifts in cultural politics: the move from object to subject through a revaluation of female experiences/perspectives in art. Recognition of the negative place women occupy culturally provided the motivation, the inspiration for re-thinking the politics of sexual and cultural differences: the models of inner/outer experiences. Schneemann, occupying the place of *Olympia*, the model in Robert Morris's performance *Site*, is just one example of how her body was frequently used in other people's performance as the perfect object – the nude. In her own works, she describes the use of herself as nude, or rather naked, as no longer this object but as a "primal archaic force which could unify the energies I discovered as visual information." And she adds in the same piece, "Not only am I an image-maker, but I explore the image values of flesh as material [I choose to work with]. The body may remain erotic, sexual, desired, desiring, and yet still be votive – marked and written over in a text of stroke and gesture discovered by my creative female will" (Schneemann 2001: 55-56).

Stiles interestingly describes the artist's strategy of using her body as a material as one of similitude, but is forced to recognise how frequently the artist's body is mistakenly often read or collapsed onto the 'real'

Schneemann. Similitude produces a counterpart or double to the real, and through this means Stiles argues that the artist "draws the observer's attention to the connection between actual things and conceptual representations through the material of the body. Because Schneemann has so convincingly animated the space between the eye and the body as if it were real, the formal and aesthetic developments she has made to the history of painting have largely been overlooked" (Schneemann 2001: 8). Stiles highlights how this mistaken reading of self as the "ideal" body through her physicality has blocked the reception of the work or resulted primarily in it becoming seen as narcissistic. The collapse of a distinction between "The natural work where she lives her life as a person and the work she invents and represents as an artist who sometimes also presents herself in her representations" has meant that her body is too often conceived as a 'real' object and the work is seen only as an extension of autobiography – a reaction to her position in other's work or relations between the artist and other colleagues. In this way, Schneemann's aesthetic strategy is lost, collapsed into the detection of a real 'woman' or a problem, circumscribed and limited to the ideal female body.

Stiles's arguments which locate such practices in relation to painting constitute a useful starting point to reconsider the articulation of a feminist politics in painting and how an engagement with painting practices can be seen to mark feminism's move away from painting and into performance, film, media – which is usually the way feminist art practices are described as emerging, through a rejection of traditional media. However, here and in other examples, it is relatively easy to demonstrate how a critical relationship to painting informed early feminist performances and installations. However, a full assessment of what painting may have contributed to feminist art practices is not my ambition here. Instead I wish just to highlight that there are overlaps and continuities which the frequently announced critique of painting in the 1970s and 1980s did not acknowledge even though feminist paintings continued to be shown in many feminist art and women's art exhibitions since the early 1970s.

Shigeko Kubota's radical *Vaginal Painting* performance in the context of Fluxus's critique of action painting is another example. Kubota simulated painting from her vagina, painting red lines across a page: referencing not only women's menstruation and a critique of what it might mean to paint directly from a sexual organ; but also referencing a low-

class Geisha trick called Hanadensha ("flower train"). Midori Yoshimoto, discusses the ambivalent reception of this work by both men and women in the Fluxus group, with the exception of a strong verbal defence from Schneemann. "Kubota may have intended to intersect the divisions between geisha and performance artist, pornography and avant-garde art, low art and high art", but Yoshimoto argues that Kubota underestimated the shock produced in her Western audience to the image of the "courteous and subservient" Japanese woman that her performance as an artistic agent and not an object of desire provoked (Yoshimoto 2005; 179-183, quote 183).

Taking another tack on this question of what relation painting has to early feminist work in other media, there are many other references to the redeployment of 'ideals' of Woman from the history of painting in the work of performance artists as diverse as Orlan and Ulrike Rosenbach to produce subversive feminist readings of mythic women and Western concepts of beauty (O'Bryan 2005; Orlan 2003 and 2002-2003; Rosenbach 1989).

In Bobby Baker's much later performance *Drawing on a Mother's Experience* (1988), the performance progresses through a parody of action-based painting performed with food on a white domestic sheet, while the artist recounts the experiences of motherhood. The synergy between creativity, the mess of young children as well as the oral narrative of the mother's experiences reproduces some of the 'infantile' or 'faeces-like' aspects of action painting, but here the discourses of life, art and women's experiences of childcare, creativity and mothering are merged in a distinctly witty and critical synthesis (Baker 2000). Here the painting gesture itself can represent a protest, a marking out of a different territory of subjecthood and subjectivity through that other residue of painting as modernist practice, the mark. Other works like Janine Antoni's performances washing the gallery with her hair dipped in dye (*Loving Care*, 1993-1995) could also be read as a re-enactment of the all-too-familiar 'in/appropriate' positioning of an abject feminine in the white cube of the gallery space (Antoni 1995).

If painting can be defined or identified as a mark-making process establishing human existence in feminist works, it has also been used performatively as process to mark different times and establish a different relationship between 'being' and contemporary art. Miriam Cahn's more recent work in response to the Gulf War is a good example of how

the duration of the creative process marks periods of time, and her im-
agery represents the processing of the 'overload' of images which human
subjects are exposed to in life, through the media, through the recording
and learning about events (Schweizer 2004). Another example would
be Irina Nakhova's transition from painting to conceptual installations,
such as *Rooms* in Moscow (1984), "breaking out of the confines of paint-
ing" and destroying visual borders or perceptions of spatial boundaries.
Covering her apartment with cutouts (ranging from abstract shapes to
reproductions from fashion magazines), the artist changed the lighting
to create an avalanche of visual information which disturbs the percep-
tion of the space itself (Tupitsyn 1990).

Criticism and the Woman Painter

So far I have mentioned the strategies of these women artists as if the
feminism within them were self-evident. The problem of criticism itself,
its tropes for the discussion of painting and/or feminism(s) and for its
silence or failure to acknowledge the practices of women artists, whether
in painting or other art practices, has not yet been fully discussed. The
readings constructed around the woman painter in relation to traditional
painting practices by "traditional" art historians, male and female, have
often positioned them primarily as subjective expressive objects and
rarely as full or whole subjects. This is especially true when a woman art-
ist uses herself as the model within her works. In these cases, discussion
of a conscious self-representing subject manipulating and mastering the
means of representation is frequently disavowed. Donald Kuspit's read-
ing of Maria Lassnig is a case in point (see Deepwell 2000), where his
analysis attempts to name a motivating force, an identifiable psychologi-
cal dilemma, which will provide the clue to understanding what he con-
siders to be a remarkable object, an impressive body of work by a woman
painter. His understanding of her subjectivity – since it is this which
the actions of expressionist gestures and taschist marks must reveal – is
identified through her "failure to objectify" her own body, to recognise it
internally but not to externalise it (Kuspit 1993: 206).

In Kuspit's reading Lassnig is a subject without history – a reinven-
tion of the eternal woman albeit mediated by a psycho-biographical
reading of the artist via psychology and modernism. History – but
particularly Lassnig's own history as an avant-garde artist, a participant

in many different kinds of exhibitions – is what has disappeared in this reading along with any broader grasp of the artists' specific education and historically changing experience. Kuspit's reading reinforces some of the most typical qualities of femininity in male-defined desire, elusiveness, unknowability, "in touch with their feelings", inchoate, prioritising touch over sight and the effect of texture/tachisme over vision. This reduction to an ageless 'eternal' feminine body – messy, chaotic and disorganised, lacking in coherence – is a product of one kind of reading where, mistaking the personal as political, the writer jumps from the particular to the eternal in order to reinvent over a woman's body the classic 'modernist' fight between canvas and maker. Transcendent experience is not possible except in so far as we may or may not subjectively grasp her struggle. For Kuspit, Lassnig is "as a permanent invalid" stereotyped by "Slavic colour" and interest (but not involvement) in "Austrian modernism" (Kuspit 1993: 211). Lassnig's childhood and convent upbringing, her ability to feel but not to objectify, has resulted in a "feminism" within her work as "a subjective fantasy of wholeness of being not an activist critique of patriarchal society" and "she is stuck in a narcissistic plight" (Kuspit 1993: 211).

The parallels with Schneemann I hope are transparent, but perhaps both allegations of narcissism are closely related to a reading of painting as expressive subjectivity and a judgement that for a woman this is a self-indulgent activity – since woman in philosophy since the Enlightenment lack transcendence and are burdened by their association with matter, material and nature. Attempts to reverse the value systems associated with this burden, however temporarily satisfying when recognised, are doomed to failure because they cannot shift the weight of this tradition, nor the limited and often stereotyped ways in which their work is read (Lee 1987; Betterton 1996 and 2004; Warped 2001). The feminist critique of 'painting' as a category from the late 1970s has also been centred around two key ideas. The first is based on a conceptual critique of painting as a 'fetishised' commodity (in art market terms) and the second, a critique of modernism's expressive subject as reflected in the paint mark: a unity between subject and mark which is always assumed in criticism in spite of existing 'theoretical' knowledge that visual language always operates through learned codes and conventions. These key ideas represent two very narrow aspects of what painting is and can signify. The former developed out of Marxist critiques of the circulation of commodities, the latter from a re-evaluation of the potential for the

expressive subject represented by Abstract Expressionism but mediated through French feminist ideas of a position for a female subject position in "écriture feminine"/"peinture feminine". For women, schooled and invested in modernist abstraction, alternative routes emerged through a problematic embrace of the 'feminine' and the reassertion of the importance of speaking with a feminine voice or language:

> [The] subtle misreadings of French feminism provide an updated alibi for the model of the artist in the studio producing a singular, individual practice, whose traces define the painting and give spectators access back to the artistic subject [...] because it so confidently affirms, a fundamental difference of the feminine, or femininity only as fundamental difference. (Pollock 1992: 157)

If the body of the painter and the body of woman form a binary opposition through which to track contradictory placements and significations, then, as Griselda Pollock suggests, any triangulation of the field can only be secured by attention to history (histories) (Pollock 1992: 160) and signifying systems which result in the contestation of both sides of the binary through feminist critiques of cultural hierarchies and normative forms of femininity. Such proposals make it impossible to mount a critique of femininity through the gestural marks of painting. Nevertheless, this is a project which has engaged several women artists recently producing parodies of modernist abstraction or the dissolution of the space of the support in which their feminist intent is apparent – e.g. Fiona Rae, Jessica Stockholder, Beatrice Milhazes, Marianne Uutinen and Mira Schor (see Schor: 1997). Could it be argued that this work has succeeded in shifting the terrain away from the body, from the feminine, rather than representing again the feminine Other, as this is constantly the trap in which women artists are caught?

The Question of Women Painting

Paintings have been produced by women artists in large numbers since the nineteenth century; indeed, it could be said to be the dominant medium of women's contribution to art for the last 160 years, that is, until the last thirty years. The recovery of this history and the extent of women's practice as artists is the still incomplete project of feminist art history. It

is worth reiterating the inverted pyramid of women's success as around 60%-75% of art students since the late nineteenth century, but less than 16% of professors, 20% of art reviews in magazines, 5%-15% of most museum collections and even in contemporary art biennales only 20%-40% of contributing artists (Cliché et al. 2001; Deepwell 1992). Such statistics are a reminder of the persistence of discrimination in life, as much as the discriminations made by art critics and historians. These figures – while they have shifted in the last thirty years in favour of women artists, and women's professional status is rarely in question these days – have not resulted in any extensive recovery of the legacy of women artists within mainstream art history and art curricula.

The representation of the woman painter as the 'magnificent exception' continues especially through one of the dominant tropes in art history: the 'monograph approach to the development of an artist' as painter in which an artist's biography is wound up with events in their life. Numerous critiques of this position have been written, most notably by Linda Nochlin, Griselda Pollock and Christine Battersby for their reinforcement of the 'genius' and its associated myths (Nochlin 1971 and 1989; Pollock 1980; Battersby 1989). The culture industry has not been slow to recognise the value in the myth of the great woman artist: Frida Kahlo, Gwen John, and Paula Modersohn-Becker are some of the most well-known examples. This trend is reinforced by scholarship of a liberal feminist kind (particularly in America) where the lives of women artists stand as role models and the interpretations constantly reinforce the message of struggle and success in overcoming obstacles in their lives. Recognition of work of contemporary women painters has not kept pace with the historical reassessment of a history of women painters and its popularisation in exhibitions and revised historical accounts: e.g. feminist art historical studies of Gentileschi, O'Keefe, Cassatt, Goncharova, Popova, and Lee Krasner to mention just a few more. Yet the complex interplay of the artist and the artist's life has been behind the 'success' of women artists like Yayoi Kusama and Louise Bourgeois in terms of 'art history'. Here their critique of the 'enigmatic' feminine is widely recognised as the feminist contribution of their work.

Maybe now, finally, at the start of the twenty-first century can we demystify the idea that a woman painting or a woman artist is an unusual, rare or special thing. Or that woman's claims to the privileged space of painting do not rest on their dependence on a male artist who was their

lover, husband, partner, or colleague (Chadwick 1996; Deepwell 1998). Feminist historical research and recovery of women painters from the basements of national museums has had an impact upon how women painters have re-positioned themselves and developed their working practices. The critique of women as the feminine Other to a male counterpart in a 'history of dominant/emerging painting movements' has had an important role in redefining the contribution of women artists to modernism. The dominant value system has been questioned if not disturbed or displaced. The aims of the selectors of *Kunstlerinnen International 1877-1977*, as described in *Spare Rib*, were to "make clear that women artists are under-represented on all sides and that they can look back to their predecessors. For women's understanding of their own abilities, a knowledge of their own cultural tradition is important, and not only in relation to artistic work" (*Spare Rib* (59) 1977: 35-37). Yet in spite of the many exhibitions recovering the history of women artists, many women artists today still regard as problematic their alignment with or acknowledgement of any history of women's art practice as part of their rationale or thought processes in their own work. However, as Valie Export argued forcibly in "Women's Art: A Manifesto" (1972) for the exhibition catalogue of *Magna* (1975):

> The position of art in the women's liberation movement is the position of woman in the art's movement...Women must make use of all media as a means of social struggle and social progress in order to free culture of male values. In the same fashion she will do this in the arts knowing that men for thousands of years were able to express herein their ideas of eroticism, sex, beauty including their mythology of vigour, energy and austerity in sculpture, paintings, novels, films, drama, drawings, etc and thereby influencing our consciousness... [T]he arts can be understood as a medium of our self-definition adding new values to the arts. These values, transmitted via the cultural sign-process, will alter reality towards an accommodation of female needs. (Export 2001: 206)

Does the problem with any rearticulation of painting for feminists lie in its association with a tradition in which women artists were devalued, marginalised, silenced, or is it the problematic identification with the development of painting as a category, as the model for art itself and

thus a question about the automatic reinvestment in the values which actually sustain this system, which discriminates against women? How to produce an effective set of feminist possibilities in painting without re-instating the purity of painting or re-investing again in its overblown status remains the issue. Is a feminist claim for recognition of women painters based on the claim for recognition of sexual difference? Or a place for the feminine subject?

Griselda Pollock is rightly critical of the ways in which the question for feminism about 'aesthetic practices' has appeared to be reduced to a simple set of oppositional choices for or against painting or another form of practice – for example, scripto-visual work (Pollock 1992: 170). However, if what is at stake in feminist interventions in the field of signi-fications is not to be reduced to choice of medium, it is equally the case that transformative work on the codes and conventions does not exclude the possibility of transformation in or using painting as one of a number of possible visual resources.

In the late 1980s, John Roberts identified three feminist approaches to painting and sexual difference: firstly, the anti-painting argument where painting in its late modernist and social realist variants is regarded as a double obstacle to the specificities of the representation of gender; secondly, the anti-functionalist argument, in which painting stands as a radical resource for women, linking up bodily experience with a distinct female aesthetic or 'visual economy', and, thirdly, the female centred ap-proach, defending the descriptive powers of the figurative tradition as the basis for a feminist narrative or mythological painting (Roberts 1990: chapter 7). Feminist debates about painting still largely fall into these three categories and I have rehearsed above some of the arguments in re-lationship to the first two positions. I would situate my own position, and the position taken in my previous essays, as a defence of the latter option.

In 1986 Sarah Edge and Jill Morgan, curators of *The Issue of Painting* – deliberately referencing in the title the show *Issues* organised by Lucy Lippard at the ICA in 1980 – argued that their "exhibition proposes a critical and effective role for painting, in opposition to the recent tenden-cy for women's painting to be classified as 'romantic' or 'natural', thereby blunting its critical edge... [The works] are informed by structuralism, yet none of them are using what has been argued as the theoretically 'correct' method of photo-text, the theory rather influences the structure of their paintings. There is no method of production that is radical by nature;

radicalism is in the intent and the ultimate ability of the work to communicate effectively to its audience" (*The Issue of Painting*, 1987).

Conceptually, a critique of femininity, its norms and expectations, is central to feminist politics. Holding the distinction between feminine and feminist has been central to defining this route. Linguistically, in different languages this presents problems for feminist criticism (Irigaray 1987; Deepwell 2002). A revaluation of the feminine space has also been seen as a feminist move in a culture which denigrates or falsely reifies femininity in particular ways (Betterton 1996).

Painting practices have not been static over this period. The range and type of paintings exhibited, discussed, overlooked, and marginalised has varied. Clearly, women painters continue to be present in every emerging tendency: in every revival and crisis in representation during the last twenty-five years you can find a plethora of women painting. To read discussions of painting in the mainstream journals you would not quite believe this. A short history of feminist approaches to painting is one of constant negotiation/recognition of the emergence of women artists within the mainstream and of developing a critical relationship to 'male' dominated areas of work in all areas of contemporary painting since the 1970s: hard-edge/soft-edge abstraction; pattern painting; conceptual approaches to painting practice; the 'return to figuration' or 'post-pop' to 'postmodernism'; the question of 'realism'/its critique as painting approached photography or film stills; 'performative approaches to painting practice' where the action is often more significant than the 'outcome'; a re-engagement or redrawing of historical tropes and motifs; the parodying of abstraction; 'graffiti art'; neo-conceptualism; or painting redrawn into a three-dimensional installation or rendered directly as a wall painting.

In the *Feministische Kunst International* (1979), shown in the Hague, the organisers chose to exclude from the exhibition contemporary women artists working with abstraction. Marlite Halbertsma argued in the introduction that the show was not about the representation of all contemporary women's practices, but a selection based on the content of the work and the feminist message read through the subjects tackled. She positioned the organiser's decision as a means to make a critique of the essentialism involved in the search for a feminine aesthetic (the debates of Judy Chicago and Lippard in early 1970s) (*Feministische Kunst International*, 1979). She advocated instead works which employed forms of realism which "visualise the specific situations and problems of

women" and whose purpose, "is primarily to attack the validity of present patterns of behaviour. The exhibition also promoted ideas of collective practice amongst women. The selected artists included Joan Semmel, Nancy Spero, Mary Beth Edelson, Verita Monselles and Marianne Wex. Such a model for feminist engagement also embraced the work of two women painters prominent in Britain's emerging women's art movement: Margaret Harrison and Monica Sjoo (Pollock 1987: 4-6, 94, 191), whose figurative strategies used role reversal and whose images were both the subjects of police enquiries for obscenity and blasphemy.

There have been other rich veins mined by feminist painters in relation to the figurative tradition through a re-discovery or identification with female role models or the placing of oneself in relation to representations and to history painting in the work of artists as diverse as Gisela Breitling, Rose Garrard, Sylvia Sleigh, Lubaina Himid and Sutapa Biswas.

Figurative Strategies: Three Approaches

This essay concludes with three examples of different approaches to figuration by women artists which are feminist strategies in painting.

In Ida Applebroog's 5-panel painting *Noble Fields* the viewer is presented with a startling array of images and realities which suggest, provoke and finally elude a definitive reading across their dispersed time frames. In the largest image in the left-hand panel, a woman with a mask-like Medusa head, without the conventional snake-like hair, stares out at you. Then you notice her ball gown and then her arm in plaster. The confrontational expression changes, perhaps, from one of aggression into a representation of a battered woman who has finally turned to face her aggressor. Such a reading appears reinforced by the right-hand panel where in a vertical strip of line drawn images, a man carrying a woman is repeated twice, then a line of dancing girls, and then a woman's face and shoulders fill the bottom foreground. The depiction of the single woman runs along the top strip, curled on the floor in pain, standing looking at her watch, and as a double image, with a friend watching TV and then finally, in the last strip, there are the children. The strangeness of this juxtaposition becomes apparent as one's eyes drift back to the central panel where a child sits eating in a field of watermelons. Is this the internalised image of the girl as child, or the greed of the boy abuser? Or a sign of the simplicity of childhood pleasures as a contrast with the complexities of adult conflicts?

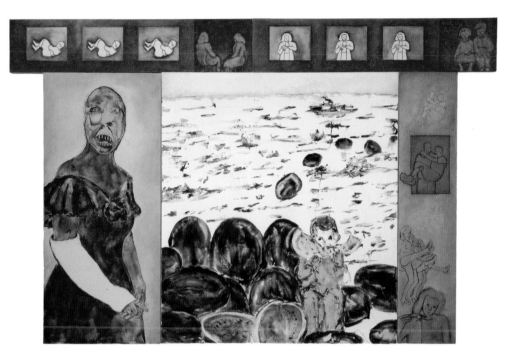

Ida Applebroog: *Noble Fields*, 1987. Oil on canvas, 5 panels, 218 × 335 cm. Collection of the Solomon R. Guggenheim Museum, New York. Courtesy of Ida Applebroog, New York. Photo: Jennifer Kotter.

How does one read these images as views of contemporary realities infused with seeming memories, with different frames of reference, and with different pictorial strategies? Ruth Bass makes an analogy between Applebroog's work and that of David Salle, Robert Longo and Barbara Kruger, arguing that her depiction of "ordinary people" draws elements from popular culture into "a chaos of unnameable possibilities through repetition, grotesqueries, humor, and surreal dislocations" (Bass 1988). Mira Schor has alternatively suggested that Ida Applebroog successfully employs Brechtian dis-identificatory practices – typically reserved for the discussion of photo-text/scripto-visual works – in painting, highlighting her refusal of a modernist agenda in painting (Schor 1997: 70-71; Applebroog 1993). These two readings align Applebroog with the return to painting and sculpture, a refusal of meaning and, at the same time, the anti-aesthetic politically-engaged wing of postmodernism. Historical images are never simply quoted in Applebroog's work, they are always subject to translation and mediation – they are cropped, repeated and juxtaposed to open up a new space for meanings to arise. The images in

Marginalia, for example, borrow from medical textbooks, what appear to be images of torture instruments, and a whole popular genre of photography of the weird and wonderful, but then use a graphic 'realism' to depict the marginalised people of metropolitan life: beggars, the sick, babies, misfits, and a range of adults manifesting a crazed, even projected, sense of their exterior as both vulnerable and defensive. Applebroog refuses the convention of the painting as a 'window on the world' – a view into a singular spatial reality. *Marginalia* is installed as an array of freestanding double-sided paintings arranged across the floor of the gallery. The majority of her work takes the form of multi-panelled composite works or repeated single image panels in vellum framed like film stills or multiple TV displays with different ironic captions. For example, against the image of a couple embracing and about to kiss, one reads "I am a pharmacist" and the same image in another work is captioned "You're rat food". This stark juxtaposition heightens the 'alert' message about the absence of any form of trust or respect as elements of love between consenting sexual partners. The fact that this bleakness in the nightmarish contradiction of modern life hits one with such humour and playfulness is the success of Applebroog's work. Reading work for ideological effects has been central to feminist critiques of images of women and to judgements made about the value of art. Is this what Ida Applebroog refers to when she positions herself as a female flaneur and states "I'm conducting a cultural anatomy of what makes us miserable today" (Applebroog 1993). For feminists this view of the value of realism in representing social realities and possibilities for transformation and change takes on a whole set of new meanings and possibilities when women's perspectives of the world (in all their diversity and possibility) are foregrounded.

Two final examples of contemporary painting by women which I wish to discuss are the work of Simone Aaberg Kærn and Cornelia Hesse-Honegger. Hesse-Honegger lives in Switzerland and has been producing detailed paintings of insects since the late 1960s (Hesse-Honneger 2002). Her works are not scientific illustrations although they do share this language as the precise attribution of the insect species, their malformations and the discovery of them at a particular location are always given in the titles. The works – although they are titled individually and could be read as individual works – make more sense cumulatively and collectively in terms of their general enterprise and as a method for enquiry. Hesse-Honegger's series developed in the 1990s, documenting

Cornelia Hesse-Honegger: *Vier Flügelpartien aus Anse St Martin mitte der Bucht nähe La Hague/Pentatomidae, Carpocoris purpureipennis, Four Tree Bugs from near La Hague*, 1999, 47 × 40 cm. Courtesy of Cornelia Hesse-Honegger.

Simone Aaberg Kærn:
Sisters in the Sky, 1998.
Installation view,
Louisiana Museum
of Modern Art,
Humlebæk, Denmark.

the malformation of leaf bugs within a five mile radius of nuclear power stations in both Europe and America, is particularly noteworthy. There remains not only an ecological but a scientific intent to the project, even though its scientific basis in visual observation is unusual. And at the same time, the assembly of information collected as 'paintings' all point to a different function for painting when treated as a figurative 'window on the world'. A documentation of this work in photography might currently be more within scientific norms, but her use of close observation and of painstaking methods of painting point to other uses of painting itself as a practice for making representations of the world around us. The tradition of this kind of observational work in the natural sciences links her to early scientific illustrators, many of whom were women; but there

are also important links to using modern forms of realism to highlight injustices by exercising painting's documentary appeal.

Simone Aaberg Kærn's *Sisters of the Sky* (1998) is an attempt to recover the history of Russian women war pilots who fought in World War II. It was widely shown first in *Nuit Blanche: Scenes Nordiques: les annees 90* (Paris: Musee d'art moderne de la ville de Paris, 1998) and in *d'APERTutto*, 48th Venice Biennale, 1999. The paintings produced are part of the work, an installation with video. The representational strategy takes place on two levels. First, in the video, where the women now in their seventies and eighties recount their experiences as pilots. Secondly, in the paintings themselves where the women as they were between 1939-1945 are painted in sepia tones as heroes of the revolution, or brave

socialists and pioneers in a Socialist Realist manner. This heroic form of depiction was used frequently for male pilots but rarely for women. Yet, the brown tones, and not naturalistic colours, signify a nostalgia for this kind of celebration as much as the nostalgia for a time past in these women's lives. The depiction of both remains incomplete. The viewers must negotiate their own experience between the contemporary reality of the video, 'the real' of these women's lives today, and the 'incomplete' reality represented within the paintings.

Here painting is just another form of signifying practice, but its place is quite specific and the installation speaks to the problems of the representation of its subjects as much as to the missing history the work as a whole addresses but cannot completely recover.

Bibliography

Antoni, Janine (1995), *Slip of the Tongue*, CCA, Glasgow and IMMA, Dublin.

Applebroog, Ida (1993), *Ida Applebroog*, Derry: Orchard Gallery, March-April, Dublin/ IMMA, May-June.

Baker, Bobby (2000), "Drawing on a Mother's Experience", *n.paradoxa* vol. 5, *About Time*: 59-62.

Bass, Ruth (1988), "Ordinary People", *Art News* vol. 87, part 5: 152.

Battersby, Christine (1989), *Gender and Genius*, London: The Women's Press.

Betterton, Rosemary (1996), "Bodies in the Work: The Aesthetics and Politics of Women's Non-Representational Painting", in *An Intimate Distance: Women Artists and the Body*, London and New York: Routledge: 79-105.

Betterton, Rosemary, ed. (2004), *Unframed: Practices and Politics of Women's Contemporary Painting*, London: IB Tauris.

Chadwick, Whitney and Isabelle de Courtivron (1996), *Significant Others: Creativity and Intimate Partnership*, London: Thames and Hudson.

Cliche, Danielle, Ritva Mitchell and Andreas Joh Weisand (ERICarts/ ZfKf), eds. (2001), *Pyramid or Pillars: Unveiling the status of Women in Arts and Media Professions in Europe*, Bonn: ArCult Media.

Deepwell, Katy (2002), "Défier l'indifférence a la différence: les paradoxes de la critique d'art féministe", in *L'Invention de Critique D'Art*, ed. Pierre-Henry Frangne and Jean-Marc Poinsot, France: Presses Universitaries de Rennes: 191-205.

Deepwell, Katy (2000), "Women, Representation and Speculations on the End of History 'Painting'", in *History Painting Reassessed,* ed. N. Green and P. Seddon, Manchester: Manchester University Press: 131-148.

Deepwell, Katy, ed. (1998), *Women Artists and Modernism*, Manchester: Manchester University Press, 1998.

Deepwell, Katy (1994), "Paint Stripping: Feminist Possibilities in Painting After Modernism", *Women's Art Magazine* no. 58, May/June: 14-17. Reprinted in Hilary Robinson, *Feminism-Art-Theory: An Anthology, 1968-2001*, Oxford and Malden, MA: Blackwell, 2001.

Deepwell, Katy (1992), *Ten Decades: The Careers of Ten Women Artists Born 1897-1906*, Exhibition Catalogue of Arts' Council Touring Exhibition, Norwich Gallery, NIAD.

Deepwell, Katy (1987), "In Defence of the Indefensible: Feminism, Painting and Postmodernism", *Feminist Art News* vol. 2, no. 4, September: 13-15. (Special issue on Painting edited by Katy Deepwell.)

Export, Valie (2001), "Women's Art: A Manifesto", in *Art and Feminism*, ed. Helena Reckitt and Peggy Phelan, London: Phaidon: 206.

Fried, Michael (1968), "Art and Objecthood", in *Minimal Art: A Critical Anthology*, ed. Gregory Battcock, New York: 116-147.

Greenberg, Clement (1965), "Modernist Painting", *Art and Literature* no. 4: 193-201.

Halbertsma, Marlite (1980), "Feminist Art – An introduction", in *Feministische Kunst International*, exhibition catalogue, Den Haag: Haags Gemeentemuseum.

Hesse-Honegger, Cornelia, "Leaf-bugs, Radioactivity and Art", *n.paradoxa* vol. 9 *(Eco) Logical*: 48-60.

Hesse-Honegger, Cornelia (1997), *The Future's Mirror*, Newcastle: Locus+.

Irigaray, Luce (1987, 1993), "Linguistic Sexes and Gender", *Je, Tu, Nous*, London and New York: Routledge: 72-73.

The Issue of Painting: Margaret Harrison, Sutapa Biswas, Glenys Johnson (1987), Rochdale: Rochdale Art Gallery.

Issues (1980), exhibition catalogue: ICA.

Kelly, Mary (1981), "Reviewing Modernist Criticism", *Screen* vol. 22, no. 3, and in *Rethinking Representation: Art After Modernism*, ed. Brian Wallis, New York: New Museum of Contemporary Art/Godine, 1984.

Krauss, Rosalind (1985), "The Originality of the Avant-Garde", in *The Originality of the Avant-Garde and Other Modernist Myths*, Cambridge, MA: MIT Press.

Kunstlerinnen International 1877-1977 (1977), *Spare Rib* (59): n.p.

Kuspit, Donald (1993), "The Hospital of the Body: Maria Lassnig's Body Ego Portraits", in *Signs of the Psyche in Modern and Postmodern Art*, Cambridge: Cambridge University Press.

Lee, Rosa (1987), "Resisting Amnesia: Feminism, Painting and Postmodernism", *Feminist Review* no. 26.

Lippard, Lucy (1980), "Sweeping Exchanges", *Art Journal* vol. 41, no. 1/2.

Lippard, Lucy (1981), "Hot Potatoes: Art and Politics in 1980", *BLOCK* (4): 2.

Nochlin, Linda (1971), "Why have there been no Great Women Artists", *Art News* vol. 69, January: 22-49. Republished in *Art and Sexual Politics*, ed. E. Baker and T. Hess, New York, London.

Nochlin, Linda (1989), *Women, Art, and Power*, London: Thames and Hudson, New York: Harper and Row, 1988.

O'Bryan, Jill (2005), *Carnal Art*, Minnesota: Minnesota University Press.

Orlan (2003), "Manifesto of Carnal Art/L'art Charnel", *n.paradoxa* vol. 12, *Out of Order*: 44-49.

Orlan (2002-2003), *Orlan: Element Favoris: Exposition Retrospective*, France: Carqufou, FRAC des Pays de la Loire, 2002-2003.

Pollock, Griselda (1992), "Painting, Feminism and History", in *Destabilising Theory*, ed. A. Phillips and M. Barratt, London: Polity: 138-176.

Pollock, Griselda and Rozsika Parker (1987), *Framing Feminism: Art and the Women's Movement, 1970-1985*, London: Pandora, RKP.

Pollock, Griselda (1980), "Artists, Mythologies and Media Genius, Madness and Art History", *Screen* (London) 21: 1.

Roberts, John (1990), *Postmodernism, Politics and Art*, Manchester: Manchester University Press, 1990, especially Chapter 7, "Painting and Sexual Difference".

Roberts, John (1984-1985), "Fetishism, Conceptualism, Painting", *Art Monthly*, December-January: 17-19.

Rosenbach, Ulrike (1989), *Ulrike Rosenbach: Video, Performance, Installation, 1972-1989*, exhibition catalogue, Art Gallery of York University, Toronto and Art Gallery of Ontario, Toronto, 1989. (Essay by curator Claudia Lupri.)

Rosler, Martha (1977), "The Private and the Public: Feminist Art in California", *Artforum* vol. XV, no. 1.

Schneemann, Carolee (2001), *Imaging Her Erotics*, Cambridge, MA: MIT Press.

Schor, Mira (1997), *Wet: On Painting, Feminism & Art Culture*, Durham, NC: Duke University Press.

Schweizer, Nicole (2004), "WARSPACE: an interview with Mirian Cahn", *n.paradoxa* vol. 13, *Domestic Politics*: 57-66.

Tupitsyn, Margarita (1990), "Unveiling Feminism: Women's Art in the Soviet Union", *Arts Magazine* vol. 65, no. 4, December: 65-66

Verwoert, Jan (2005), "Conceptuality versus Medium Specificity", *Afterall* vol. 12: 7-16.

Warped: Painting and the Feminine (2001), exhibition catalogue, Nottingham: Angel Row Gallery.

Yoshimoto, Midori (2005), *Into Performance: Japanese Women Artists in New York*, New Brunswick, New Jersey and London: Rutgers University Press.

Matter and Meaning: 'The Slime of Painting'

Rune Gade

In 1968 Marcel Duchamp retrospectively motivated his abandonment more than half a century earlier, in 1912, of painting in favour of the ready-made. Duchamp explained that he abandoned painting because "the painter was considered stupid, but the poet and the writer were intelligent" (Blocker 2004: 92). Duchamp's turning to work in other media than painting was, in other words, motivated by his desire to appear intelligent rather than stupid. Read literally, he achieved this through associating himself with the reflexive practice of working with words, thoughts and ideas rather than with the corporal practice of working with paints and brushes. A well-known dichotomy between mind and body is being rehearsed, it seems – a dichotomy that carries with it implications regarding gender as well, stretching back to the Aristotelian distinction between woman as passive 'matter' and man as active 'form'.

Put forward in 1968 Duchamp's statement can be read as one out of many in that specific moment in history that promoted conceptual art and denounced painting. It is, in other words, one statement out of many that declared 'the end of painting', thereby invoking the teleological and apocalyptic logic that Yves-Alain Bois has shown inherent in such declarations of 'the death of painting' (Bois 1990: 241). However, what I want to discuss here is not so much whether or not this 'end' of painting has in fact occurred. Rather, I want to question the gender implications that are involved in the declarations of 'the end of painting' that were being made at this specific time in history. And I want to discuss whether such genderings of painting are still present today. Specifically, I want to look at a

recent work that explicitly makes gender its primary theme and discuss how issues of 'form' and 'matter' manifest themselves within the work.

Gendering of Painting

It is well known that Marcel Duchamp is considered the 'father', or indeed "Big Daddy" as painter Mira Schor prefers to call him, of conceptual art, his early ready-mades typically posing as proto-conceptual instances in art historical textbooks of recent date (Schor 1997: 23). Duchamp did not acquire this position until the late 1950s, however, and his position grew in significance in proportion only with the dominance of conceptually informed art practices. Thus, Duchamp's explanation in 1968 of his abandonment of painting in 1912 does not only make a historical claim of biographical nature but also produces effects on the contemporary art scene at the time when the explanation was offered.

In her recent book, *What the Body Cost*, American art historian Jane Blocker has analyzed the discourses on painting during the moment when body artists informed by, among other things, feminism made their appearance in the late 1960s. In Blocker's account the rhetoric of 'the death of painting', which came into being in the 1960s, is closely connected to both a somaphobic and misogynist tendency that denounces and eliminates the parts of painting that it itself feminizes through the establishment of a discursive association between painting, bodily fluids and femininity, all of which are negatively valorized and stigmatized. Blocker uses the psychoanalytic term 'displacement' to describe what happens. In her own words, she registers a "displacement of fears about the body onto painting through a shift of rhetoric" (Blocker 2004: 102). Blocker's analysis is historiographical; it examines texts that are written on painting in which instances of the thesis of displacement can be found. The gendering of painting that Blocker speaks of is not, in other words, essentially given by the medium. Instead, it takes the shape of discourse; a discourse that speaks of painting in gendering terms.

Blocker calls attention to a lot of instances from the time when conceptual art made its appearance that substantiate this tendency, although the 'stupidity' of painting which Duchamp talks about in the course of time has various other designations ascribed to it. Thus the dissociation from painting is motivated by its autonomous and inanimate character, its objectness, its commercial potentials as a commodity or its founding

in a humanistic ideology. To Blocker these differences in how the dissociation from painting is motivated are of less interest than the bias they share, namely, the bias towards the body and particularly the female body. In close readings of essays from the period Blocker observes a general aversion to the 'mess' of painting, its surface of 'slime', its 'wet' and 'sticky' character. These are all feminized features, which require dissociation because they disturb a patriarchal idea about purity, not least intellectual purity.

The most significant artwork that makes this manifest is Yves Klein's *Anthropometry performance* from 1960, in which the artist literally dissociated and distanced himself from the 'mess' of painting while simultaneously feminizing it by having naked female models act as what he called 'living brushes', covering themselves in blue paint and rolling on sheets of paper under the direction of Klein who, dressed in a tuxedo and wearing a pair of white gloves, remained 'clean' during the entire performance. As noted by Amelia Jones, this gendered splitting of the process of painting and the body of the painter can be seen as involving an ironic comment upon an Abstract Expressionist painter such as Willem de Kooning and his famous *Woman* series (Jones 1998: 89). With the splitting of process from producer, painting from painter, Klein undermined the common idea of painting as an index of the painter's body, and consequently also the connection to a more 'vulgar' expressive tradition in favour of the less bodily potentials of painting as an intellectual and reflexive practice. Jones has pointed out that in this perspective Klein's gesture can be seen as critical towards an expressive tradition, although the use of naked female models can hardly be regarded as anything but reactionary.

In any case, Klein's *Anthropometry performance*, in accordance with Blocker's observations, is a work that describes a conceptualization of painting. It is "more like Warhol or Duchamp than Pollock" as Jones writes (Jones 1998: 89). In this, in the designation of a 'patrilineage' going back to Duchamp, it escapes the risk of being perceived as 'stupid' painting and instead appears as 'intelligent' and ironic painting. Which does not, of course, change the fact that it can be seen as misogynist. In Blocker's reading, Klein's simultaneous use of, and dissociation from, painting becomes a prototypical gesture that is followed by a series of attacks on painting. Attacks that are motivated on the one hand by the medium's bodily and feminine connotations and on the other hand by its 'captivating delights', its close connection to something pleasurable

and seductive, indeed to desire. These are precisely the elements that conceptual art carefully distanced itself from – including more specifically Charles Harrison, the British art theorist and member of Art & Language, who is in fact the originator of the expression 'captivating delights' (Blocker 2004: 92).

Jane Blocker allies herself with the artist Mira Schor in order to explain what the rejection of the 'captivating delights' can be about. Schor has examined this issue in many of her writings. "The desire for an art," she writes, "from which belief, emotion, spirit, and psyche would be vacated, an art that would be pure, architectural, that would dispense with the wetness of figure – Marcel Duchamp calls for 'a completely *dry* drawing, a *dry* conception of art' – may find a source in a deeply rooted fear of liquidity, of viscousness, of goo" (Schor 1997: 149). Schor, like Blocker, explains this conceptual aspiration to 'dryness' with a masculine fear of 'wetness' that *is* maybe not feminine in any ontological sense, but is nonetheless in the male consciousness *imagined to be* specifically feminine.

In so far as painting is repeatedly being rejected via the establishment of an analogy between the medium and some feminized elements, Blocker concludes that it is a rejection made on false premises. "Painting is dangerous," she writes, "not because of its complicity with capitalism, not because of its obsolescence, not because of its role in institutionalizing the avant-garde, not because it is a tired object, but because of its role in securing the power of male artists and masculine modes of expression and representation" (Blocker 2004: 98). In this view painting is a threat to masculine identity and power, which is why it is excluded, rejected and declared dead. Blocker's point is that this occurs at a historical moment where feminism and a lot of female artists enter the art scene where they manifest a real threat against the dominance of male artists.

Post–conceptual Painting

One would like to think that the situation today, forty years after the 1960s, is different. The break with a certain modernist understanding of the artwork initiated by conceptual art is, if not completed, then at least disseminated in a way that has changed the conditions for the production of art and indeed the whole art context, which is today quite different from what it was forty years ago. To use the terms that Yves-Alain Bois

has introduced, we may be situated within the framework of the same *game*, but a new *match* is taking place (Bois 1990: 241). The situation today could be termed post-conceptual and the painting that is being practised today could be called "post-conceptual painting," as claimed by art historian Jason Gaiger in a recent publication (Gaiger 2004).

The breaks and discontinuities that conceptual art originally involved are often incorporated into today's painting practices. We can no longer talk about a simple split between, on the one side, opponents who in a progressive fashion completely reject painting and, on the other side, supporters who in a regressive fashion continue and repeat painting. Painting is no longer the dominating or superior medium that it once was, but is now considered one among many possibilities for artists. According to Gaiger this opens the possibility for a third position beyond rejection or repetition, namely, the possibility of "continuing to work with the limited means of painting in full cognisance of the challenges with which it is confronted, while yet maintaining a dogged belief in its critical and emancipatory potential" (Gaiger 2004: 98). The critical potential in post-conceptual painting manifests itself in its "dogged refusal to accept the split between art's social function and its autonomy" (Gaiger 2004: 131).

In the light of Jane Blocker's feminist reading of the criticism of painting from the 1960s, however, it is interesting that the only example of such a post-conceptual practice offered by Gaiger is the German painter Gerhard Richter, whose work is qualified among other things by a reference to Marcel Duchamp and conceptual art. According to Gaiger, one can observe the tense combination of three different or even unlikely components in the paintings of Richter: "the concept of the readymade, the iconography of photography, and the practice of painting" (Gaiger 2004: 112). In this understanding, post-conceptual painting is a practice that relates to contemporary media culture in an appropriative and conceptualizing manner, in the case of Richter through the means of the photographic medium. The more 'formless' and 'slimy' aspects of Richter's paintings, and indeed the works' obvious appeal to retinal pleasure, remain unnoticed. This suggests that maybe the idea of post-conceptual painting continues parts of the dissociative mode that conceptual art introduced, and that the gender-specific and somaphobic implications that Blocker observed in the 1960s live on today.

The Staging of Gender in "Mor"

The contemporary artwork that I want to discuss is an example of post-conceptual painting in the sense that the work, not unlike what is taking place in contemporary art in general, does not present itself as a framed painting, but rather integrates the gesture *to paint* in a larger, performative, and hybrid practice of installation. This abolition of the autonomy of the singular work in favour of its integration in a both physical and textual space that reflects new media such as photography, television and the Internet is typical of contemporary painting and demonstrates the continuation of conceptual strategies. The work which I would like to examine in more detail was exhibited in the so-called X-Room at Statens Museum for Kunst in Copenhagen during the autumn of 2005. It was made by Danish artist Tal R (b. 1967) in collaboration with the German artist Jonathan Meese (b. 1970), and entitled *Mor* ("Mother"). I want to discuss a few aspects of the very complex and heterogenous installation that was made up of more than fifty single works, and I want to discuss the discourse informing the work. As is symptomatic of the situation in Denmark at the moment, there has been no critical reception of the work, but a lot of interviews with the artists.

The work is based on collaboration between two artists who have not worked together before. Tal R is primarily known as a painter whereas Jonathan Meese is known for his installations and performances, but both have worked widely in various media. Not surprisingly, *Mor* was not a traditional painting at all. However, it can still, I believe, be seen as a continuation of a tradition of painting. Although it may look more like installation art than painting, it incorporated painting in various ways. The work presented itself as an architectural structure within the x-room, a kitschy fortress or castle with walls and towers with loopholes painted in pink. The pink fortress or masculinized body of the mother filled out most of the room, leaving only a small passage between the walls of the x-room and the walls of the fortress. On the front of the pink fortress was a semi-circular opening that allowed people to enter into the fortress, but only after bending slightly, the height of the opening being only about 1.5 metres.

Inside the fortress one was met by a chaotic accumulation of diverse objects and signs that appeared only to be united by their physical proximity and the expressive and playful handling of a diversity of materials

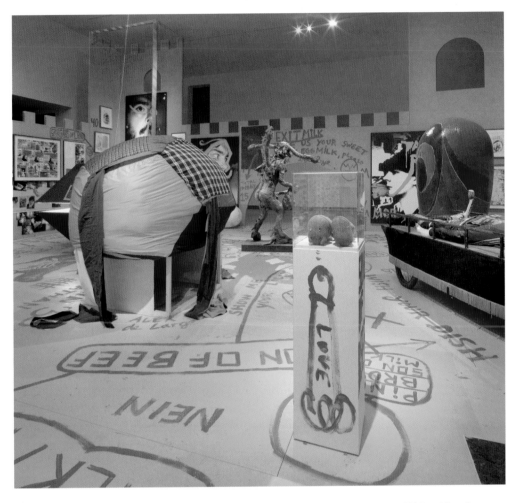

Tal R and Jonathan Meese: *Mor*. Mixed media-installation at Statens Museum for Kunst, 2005.

and subjects. The general impression was a strange mixture of the aesthetics of expressionism, of kindergarten and of comics. Clearly, the pleasure in playing with the materials, 'instinctively' manipulating things, 'the captivating delights', had priority. Apparently everything was subordinated to the structure of a game, underlining the artificial character of the fortress, its reference to the bouncy castle of the playground rather than medieval architecture. The mixture of figurative sculpture, abstract objects, drawings, photos, paintings and collages was held together by a structure of words and signs that had been applied directly to the floor,

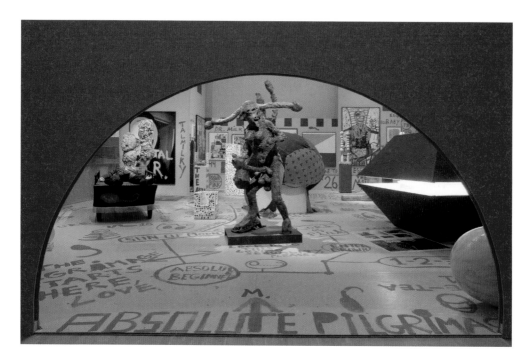

Jonathan Meese: *Der propagandist*. Mixed media-installation at Statens Museum for Kunst, 2005.

to the walls and to the various objects themselves with brown and pink painting. A board game structure was indicated through numbers and specifications of directions or movements between different numerical positions and fields.

From the outset, it was made clear that *Mor* was part of a game, the work was 'for fun', playful rather than deeply serious. Infantility was paraded with pride, so to speak, allied with what looked like spontaneous pleasure in expression and play with materials, even slimy and gooey ones. But the chaotic and playful was subordinated to a totalizing ordering concept that worked both in spatial and semantic ways: spatially through the architectural framing and semantic through the uniting sign structure miming the board game. Of course, it is necessary to add to this the title of the work, *Mor*; with its rich reservoir of connotations the title showers the work with meaning. Within this totalizing concept, creative chaos ruled alongside the infantile preoccupation with conception, fecundation, motherhood, sex and death, which seemed present everywhere.

The artists have explained that the work was intended as a *hommage* to a generalized mother figure, and more specifically to their own mothers. "The mother sows the seeds of everything. She creates life; something the two of us cannot do. Everything begins with the mother and everything has a mother. Even objects have a mother. We simply celebrate life with this show" (Hermansen 2005; my translation). *Mor* was a work that explicitly made gender its subject, both in the work itself and in the discourse the artists imbued with the work. However, it was hardly an unambiguous celebration of the mother or a brave male admission of womb-envy. "The show is not so oriented towards an agenda that it cannot contain a mother with a penis," the artists explained, referring to the monstrous figure with breasts and several erect penises, confronting the audience as they entered the fortress. The somewhat androgynous figure, a bronze sculpture by Jonathan Meese entitled *Der Propagandist*, is, said the artists, "a creature that points in many directions, and its penis is not just a penis. It is a metaphor for pure energy as well – or pure love, which can also be a mother's message" (Hermansen 2005).

This discursive conquest of female fertility and creative power, which in this quote is ascribed to the penis, could also be found several times within the work itself, which excelled in gender-ambiguous signs and figures that simultaneously established and problematized the distinction between masculine and feminine. The clash between masculine and feminine was even coded colourwise, repeatedly staged as a conflict between brown and pink painting. In the words of the artists, the colours should be read in a "completely Freudian" manner. They elaborated this point: "We are acquainted with psychoanalysis already in school and a carrot like this one symbolizes a penis. In the same way our pink castle symbolizes a pink pussy. You must write this in your article. We are the museum's pink pussy" (Hermansen 2005). The neutralizing spaces of modernism, the museum's white cube, is here transformed – with a giggle – into a pink cube that is not simply associated with the uterus, but more significantly with pornography's term 'pink' as a metaphor for sexualized depictions of the vulva.

Considered as expanded painting *Mor* made both gender and the body its subjects, but it did so in a 'bad boy' manner that tended to cancel the subversive potential of the work, offering instead blunt heteronormative gender stereotyping. *Mor* may have been a messy, slimy and gooey work; its construction may have been based on a 'stupid' – in the

sense of non-conceptual (more like Pollock than Warhol and Duchamp) – and certainly 'captivated' handling of the materials. But it carried with it stereotypes about gender that brought nothing new. Almost forty years after the most severe announcements of the death of painting, painting is here used by male artists who, on one hand, integrate experiences from conceptual art in it and, on the other, reach back to an expressive tradition preceding conceptual art. One could ask whether it is still considered 'stupid' to pose as the stupid painter, or if it is not in fact today – as opposed to 1968 – somewhat prestigious to appear anti-intellectual.

What could have been a promising new combination of different aesthetic modes, the captivated surrender to the 'slimy' aspects of the medium within a reflexive framework that does not stigmatize the material substances of painting and does not confuse matter with Mother, turned out to be a continuation of well-known ideas about masculinity and femininity: man as the sower, the creative fertilizer of the female earth. What initially looked like a 'dry' reflexion in 'slime', an intelligent articulation of gender experiences, turned out rather to be a staging of heteronormative stereotypes. The playful use of painting within a performative and hybrid installation may in itself be seen as challenging and innovative, but the semantic reflexions on the mother figure and gender relations seem deeply conservative. If painting in the late 1960s could be rejected and dismissed because of its feminine and somatic associations, today it can be embraced because of the very same associations, which does not mean, however, that the fundamental stigmatization of femininely coded somatics has changed.

Bibliography

Blocker, Jane (2004), *What the Body Cost: Desire, History, and Performance*, Minneapolis: University of Minnesota Press.

Bois, Yves-Alain (1990), "Painting: The Task of Mourning", in *Painting as Model*, Cambridge, Mass.: The MIT Press: 229-244.

Gaiger, Jason (2004), "Post-conceptual painting: Gerhard Richter's extended leave-taking", in *Themes in Contemporary Art*, ed. Gill Perry and Paul Wood, New Haven: Yale University Press: 89-135.

Hermansen, Tom (2005), "Mors drenge", *JP København*, 8 October.

Jones, Amelia (1998), *Body Art/Performing the Subject*, Minneapolis: University of Minnesota Press.

Schor, Mira (1997), *Wet: On Painting, Feminism, and Art Culture*, Durham: Duke University Press.

Part Five: Painting, Institutions, Market

The Longing for Order: Painting as the Gatekeeper of Harmony

Gitte Ørskou

ARoS and the Art of the Future

"Why do museums and collectors continue to give high priority to painting? Is it because painting is intensively promoted commercially, i.e. in galleries and at art fairs? Or is it because many museums and collections are already, by virtue of their institutional history, specially geared to exhibiting paintings?"[1] These questions were posed to me when asked to write this essay. So naturally, as a curator in one of the country's largest art museums, I had to make it my first task to find out how many paintings ARoS had bought over recent years. The number was quite surprising. Since we moved to a new and much larger building in 2004 – on the same occasion changing our name from Aarhus Kunstmuseum to ARoS – we have bought two paintings during a period of one and a half year. One of these, by Robert Rauschenberg, was created on the basis of a photograph. By comparison, we have acquired fifteen photographs, three videos and two installations over the same period of time.

However, if we take a tour of our collection – which covers the period from the end of the eighteenth century to the present day – it will be discovered that painting represents such a substantial part of it that the history of art seems almost exclusively to be based on paintings. But while, by the very nature of things, the oldest part of the collection consists of art in the traditional media, the more recent part of the collection contains a far larger representation of new art forms – photography, installation art, video, etc. This puts the massive presence of painting into perspective.

The exhibition gallery The 9 Spaces on the bottom floor of the museum exclusively shows art of a high international standard by artists such as Bill Viola, Pipilotti Rist, James Turrell and Tony Oursler. It should be noted that this part of the museum is dedicated solely to art that has been defined as being *something other* than painting in its traditional form: video, light, installations, objects, space.

For although, by virtue of its broadly based collection, ARoS naturally continues to focus on painting as the most common historical form of artistic expression – and possesses a broadly based and striking collection of more recent, young painting – there is also implicit in the museum's identity a clear desire to create an optimal framework for *new* kinds of art. With its high ceilings, flexible walls and the presence of The 9 Spaces, the museum is founded on the realisation that the role of the museum has changed: While *The White Cube* defined and constituted the framework par excellence for painting, *The Black Box* – which is also implicit in The 9 Spaces – and, most importantly, the idea of flexibility have become the background to and premise for the art of the future. It is on the basis of this recognition that The 9 Spaces and the museum's general approach to new art forms have come into being.

ARoS is far from being the only museum where architecture and ideology are intended to place the new art forms – or the "Art of the Future" as we also call it – in a broader museum context. In Japan, the 21st Century Museum of Contemporary Art at Kanazawa, which opened in 2004, is built in a circular shape and based on spatial principles that invite installation art rather than traditional painting. And in 2003 the Dia Art Foundation opened the museum Dia: Beacon, Riggio Galleries close to the Hudson River in Beacon. The museum exclusively mounts large formats from the Dia collection, and although it contains numerous paintings, its permanent exhibitions are experienced as spatial installations rather than as paintings exhibited in a classical, linear progression.

The Premise of Discussing Painting in a Museum Context

An important premise for discussing the role of painting within the context of the art institution is how painting is *dealt with*. The traditional division between different media as the core of the museum leaves no room for discussing different *kinds* of paintings as well as the idea of "painting in the expanded field". When registering the art objects of a

museum collection, painting is defined as a square, flat surface covered with paint and either figurative or abstract in content. An installation, on the other hand, is regarded as something spatial. For example, the work *Limelight* from 1987 by the Danish artist Peter Bonde, which consists of numerous paintings installed in a space circling two golden objects is registered as an *installation* in the ARoS collection. In a theoretical discussion, one could, of course, argue that Peter Bonde's work is an early example of painting in the expanded field. Within the museum, however, we still deal with the traditional categories.

So this essay will *not* focus on painting from the view of an artistic practice, *nor* from an exclusively theoretically based position. Rather, it will try to sketch out the traditional role of painting in the art museum both regarded as a physical object and as a concept deeply rooted in the identity of the art museum and the museum visitor. And, as mentioned above, defined in the Greenbergian sense as *a square, flat surface covered with paint and either figurative or abstract in content.*

By dividing painting and installations into *categories* rather than actual works, this essay will focus on the expanded *curatorial* field rather than attempt to analyse the artistic field by polemically caricaturing the positions of the art forms. The traditional painting within the art institution seems to possess a certain set of codes that defines both the curatorial approach and the reception of it by the public. And this is deeply embedded in the art institution.

Painting – a Sure Winner in the Museum of Contemporary Art?

Is painting given higher priority than new art forms in the art institution, as indicated in the introduction to this anthology? I have neither collected statistical information nor made a closer analysis of the purchasing policies of museums either in Denmark or abroad. So I cannot unreservedly start out from the assumption that museums basing themselves on contemporary art aim as much at new art forms as at painting. Nor can I claim with any certainty that in several cases they acquire installations, photography and video in far greater numbers than paintings.

Besides, I do not have any basis on which to maintain that the role of painting in an institutional and museum context appears to be based on an art-historical necessity. Indeed, I cannot even postulate that the rumour of the central role of painting on the stage of the art institution is

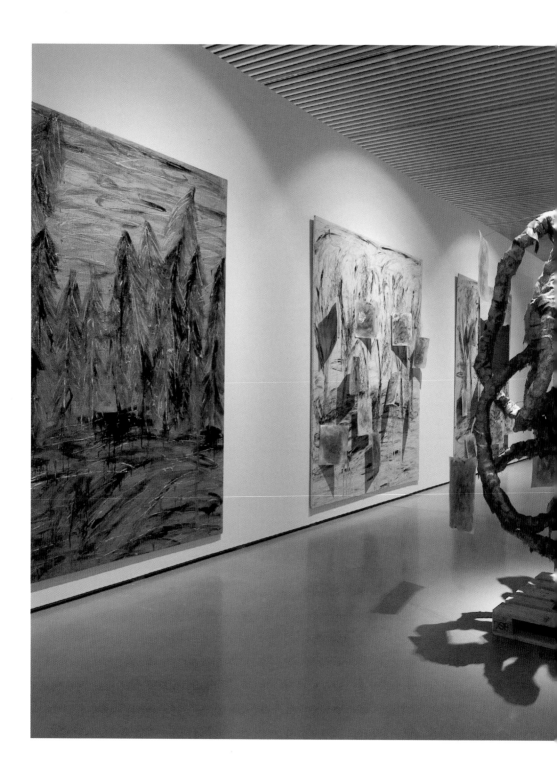

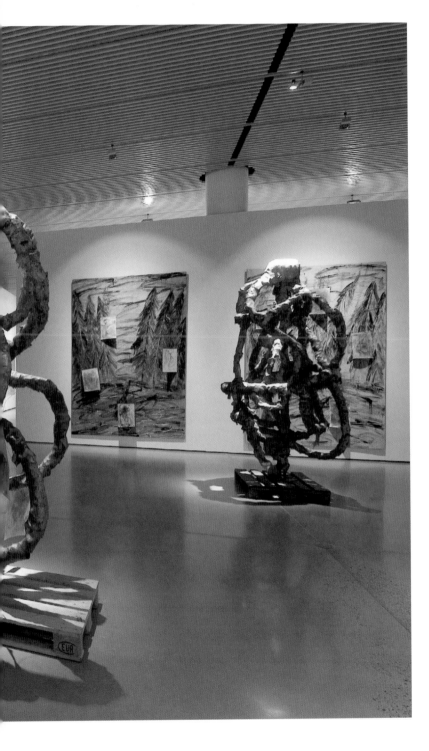

Peter Bonde: *Limelight*,
1987. Installation shot,
ARoS. Photo: Ole Hein
Pedersen.

greatly exaggerated, and that museum visitors of today may find painting just a *little bit* boring and at best rather old-fashioned in relation to the spectacular and sensational expression of installation and video art.

Instead, from the position of the art institution, I can attempt to pin down the role of painting in an institutional context, which has changed dramatically over recent years. For if we maintain that painting today is part of a wider field, this is surely to a great extent due to the fact that painting has accepted and adopted the more recent art forms, including photography, video and installation art. At the same time, the virtual, digitalised world that has been created with the advent of the computer has sharpened the visual sense of the viewer and opened the eye to a spatial and interactive virtual world that is far beyond the quite limited means of traditional painting defined as *a square, flat surface covered with paint and either figurative or abstract in content*. Therefore, viewers have started to behave differently towards art as a result of their encounter with the new artistic genres that demand a physical, visual and cognitional approach of a quite different kind.

By comparing two of the exhibitions that have been mounted in ARoS I want to analyse how the museum is dealing with painting in a *curatorially* expanded field. On the one hand, I want to look at painting and, on the other, at installation art from an institutional and reception-based position. The spatial, reception-based and institutional qualities of the two art forms are analysed on the basis of the thesis that both painting's exhibitive qualities and its relation to the public – that is, its context and its reception – have been strikingly influenced by the so-called new art forms.

And this ultimately means that painting does not only find itself in an expanded field from the point of view of the artist, but has also in an institutional and reception-based – and ultimately curatorial – sense crystallised into an expanded field that raises questions about the traditional categories on which most museums are based.

Pop Classics

I will now turn to two examples of exhibitions at ARoS, each of them representing different curatorial approaches. The first, *Pop Classics*, retains the iconic status of painting and the viewer's reception and interaction with the works within the strictly defined form of *The White Cube*. The

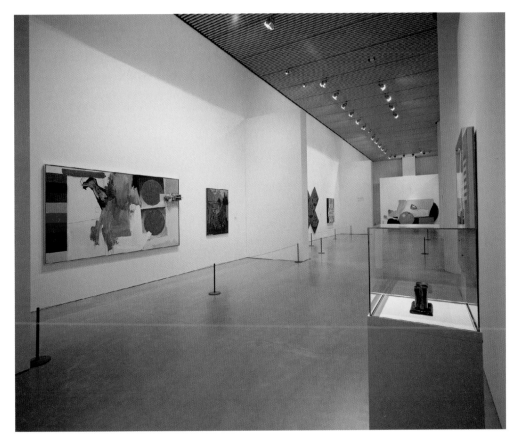

Installation shot from the show *Pop Classics*, ARoS 2004. Photo: Ole Hein Pedersen.

second, *Olafur Eliasson: Minding the World*, challenges and shatters the autonomy of the viewer's reception and offers a new relationship between art and viewer. Finally, the show entitled *Michael Kvium: Jaywalking Eyes* is briefly introduced since it works with painting in the manner of an installation and so, roughly speaking, transfers the experiences of installation art into the world of painting.

The first temporary exhibition to be mounted in ARoS shortly after the opening of the museum in the spring of 2004 was *Pop Classics*, showing works from Museum Ludwig in Cologne. Even the title of the exhibition indicated that it was to be seen as a "classic" with works that have been accorded iconic status in their own time. Artists such as Robert Rauschenberg, Andy Warhol, Roy Lichtenstein and Jasper Johns

were the stars in the parade of modern masterpieces that made up the contents of the exhibition. The exhibition was put on display in the gallery in the museum that is reserved for temporary exhibitions, a gallery which, with seven metres to the ceiling, a long curving outside wall, and polished concrete floors, has a very contemporary look. This exhibition gallery was divided into rectangular rooms and lengthy sections of wall, all of which were painted white.

While the installations – for instance Kienholz's *The Portable War Memorial* from 1968 and Rosenquist's *Horse Blinders* from 1968-69 – were exhibited in specially designed rooms, the paintings were hung at eye level. Careful account was taken of the hanging and the lighting on the individual works as well as the way in which the walls were divided. At the same time, works requiring interactivity – for instance Rauschenberg's *Soundings* from 1968 – created a living, dynamic exhibition gallery. Nevertheless, the hanging must be viewed as 'classic', starting out from *The White Cube*, and as such emblematic of the way in which the vast majority of museums deal with art, especially painting. *Pop Classics* was neither radical nor controversial – it was well within the clearly defined framework of the White Cube. The catalogue, on the other hand, was created with a boundary-crossing layout and represented a radical breach with the traditional form of the exhibition catalogue.

Viewed historically, the paintings of Pop art are defined precisely by openness and receptiveness to popular culture. The images of other media – strip cartoons, press photographs, etc. – combine directly with the unique authenticity of painting, and it is this very tension that is at the bottom of Pop art's enormous importance in the history of art. But today the paintings of Pop art have become a kind of post-modern classics. Just like Picasso, Matisse and van Gogh, the best-known Pop artists, who all have painting in common, take the great exhibitions all over the world by storm.

So considered from the point of view of reception, the paintings of Pop art appear to demand a familiar manner of behaviour. As viewers, we approach Pop art on the basis of a series of acquired norms that are already embedded in our body when we enter the museum. The manageable size of the paintings, the serial hanging, the progressive sequence that is indicated by the linear presentation of the rectangular canvases – all these parameters require a viewer whose body has been geared beforehand to the experience of painting. And the body carries out a

well-known performative practice. We move more slowly; we stop and we study selected paintings, and the viewer's path through the exhibition gallery is defined beforehand by the meticulous placing on the walls – a path that tells a continuous story. It is here that the paintings become icons, *masterpieces*. Phenomenologically viewed, the subject is separated from the object and still possesses its autonomy. This safe and familiar behaviour when faced with a painting that reflects the autonomy of the subject and ensures its unity can, however, result in *new* insights because of the familiarity of the situation.

Olafur Eliasson: Minding the World

The museum's next temporary exhibition presented works by the Danish-Icelandic artist Olafur Eliasson, who works with installations of widely different kinds. The exhibition was based on the work with which Eliasson was represented in the Danish Pavilion in the Venice Biennial 2003, which I curated. However, it adopted a completely different form in Århus, as Eliasson's works are based on a close study of the place in which they are to be shown. *Minding the world* was the title given to it – and the very ambiguity residing in the word 'minding' was essential to Eliasson, who regards the viewer as the creator of meaning: the sense of 'taking care of' or 'being bothered by' Eliasson's work depended on the individual's eye.

The exhibition was in the form of a total installation engaging different sense registers in the viewer and actively bringing in the public as co-creators. For example, in one of Eliasson's best known works, *Yellow corridor*, it was the viewer's retina that created the complementary colour that emerged at the sight of the monochrome yellow light. The 'work' was not somewhere out there in the world, but in the viewer's own eye. Apart from the *Yellow corridor*, the exhibition contained, among other things, an artificial waterfall, a camera obscura, a rainbow – again created in the eye of the beholder – a gigantic gallery of mirrors with a floor of lava, a huge sculpture of mirrors created of kaleidoscopic shapes, a room filled with geometric bricks made from compacted earth, and several movable light works. *The cubic structural evolution project*, which was exhibited in the museum's Junior Section, was an enormous table with a mirror surface that was filled with white Lego bricks. It was then up to the public to arrange the Lego bricks. The 'work', however, was not the final shape that

the Lego bricks produced, for the shapes were constantly being broken down and transformed. No, the work was the *situation*.

Whereas the visitors in their meeting with the *Pop Classics* exhibition were physically geared to the massive presence of painting in a traditional hanging, the encounter with Olafur Eliasson's exhibition was one prolonged challenge and a dismantling of the viewer's expectations: The *Yellow corridor* robbed viewers of their sense of colour, while the imposing gallery with its patterned lava floor and mirrored ceiling demanded a quite different physical action. The sense of space, orientation and linear perspective was dissolved by the body being suspended between the geometrical patterns in the lava floor and the extensive mirrored ceiling. Thus it was not an autonomous, complete self. The "I" was IN THE PICTURE – if we quote Lacan's anecdote about seeing a sardine tin in the river as forming the basis of his theory of the gaze (Lacan 1973: 69). And people were not singular subjects, but inseparable from a collective, formed by and in constant interaction with their surroundings.

In the meeting with Eliasson's total installation, there were no well-known patterns of movement or familiar systems into which the experience could be channelled. On the contrary, most people visiting the exhibition were unprepared for what they would experience. For here people sensed and experienced something they had never experienced before. And the insight was not, as had been the case with Pop art, formed by knowledge, insight and familiarity with the work of art presented in a traditional way, but on the contrary based on physical and visual experience, sensation and interaction. Viewed phenomenologically, the body of the viewer was not part of an autonomous self that defined the relationship between the work of art and the viewer. On the contrary, the body of the viewer was exactly the tool generating and shaping the artistic experience.

The Characteristics of Curating and Experiencing Traditional Painting and New Installations

By comparing the two exhibitions, one might be able to find some of the characteristics that define the curatorial approach to traditional painting and new installation art as well as the visitor's approach to two distinctly different curatorial strategies. Whereas painting in the way it was exhibited in the show *Pop Classics* confirmed the viewer's general cultural

Installation shot from the show *Olafur Eliasson – Minding the world*, ARoS 2004. Photo: Ole Hein Pedersen.

education because of the rectangular, linear hanging, installation art in the form of Olafur Eliasson's exhibition took apart all acquired cultural education. Whereas the painting, in both a literal and a metaphorical sense, became linear when it was hung together with other paintings in *Pop Classics*, the installations by Eliasson were exclusively spatially orientated.

If for a moment we allow ourselves to regard painting in the way defined by Greenberg as "the flat surface, the shape of the support, the properties of pigment", we might be able, as an experiment, to see the argumentation of this comparative analysis from the point of view of the spectator. Thus one could set out the positive characteristics of painting as the following: In a world that is defined by the economics of experience – rather than meditation – painting is outstandingly anti-spectacular. Painting guarantees authenticity, intimacy and a sensual presence that might seem to be needed in an age characterised by a culture of digitalised, virtual and infinitely reproducible images. In this latter case, the fact that we are familiar with the painting makes it into a phenomenon that we welcome with the feeling of security resulting from custom, and which we decode and absorb at lightning speed. As such, it becomes the gatekeeper of harmony.

On the other hand, the anti-spectacularity of painting also forms the problem of experiencing painting. We have seen it so often that we are neither spellbound by it, nor are we exposed to new insights in our meeting with a medium that both via physical experience and on a cognitive level has become part of us.

So, viewed radically, one could line up the following schism between painting and installation art, provided we allow ourselves to regard them as traditional *categories* rather than actual works: Whereas a painting encourages physical stability, installation art is physically challenging. Whereas a painting is based on acquired habits, installation art is innovative. Whereas painting is static, installation art is mobile. Whereas painting ensures the autonomy of the subject, installation art fundamentally considers the subject as something relative. Whereas painting is an autonomous unity, installation art is based on interaction. And, finally, whereas painting is old-fashioned when seen through the optics of lifestyle, installation art is simply *sexier*.

Seen in relation to installation art, painting is both boring and authentic, both static and intimate, both anti-spectacular and present. But

on the other hand, to be boring, static and anti-spectacular is also what defines art as the opposite of commercials and entertainment. And this is the schism of traditional painting within the art institution.

Painting as Installation?

Now, it is always dangerous to think in terms of essential characteristics when one deals with visual art. For, of course, some paintings are spectacular and some installations are static. There are paintings that completely suspend all connection with the history of painting, and there are installations that constitute a direct extension of the painting tradition. An individual painting can have more in common with installation art, video art, photography or even with net-based art than its media-specific fellows. And to me this seems to be the essential premise of discussing painting today in the context of the art institution. So there are far more sides to this discussion than I have touched on.

For not only has contemporary painting adopted the new visualities and expanded the field of painting – as is for example the case with the Danish artist John Kørner, whose painterly practice is surely as much installation as painting – but also the actual approach to painting as *a square, flat surface covered with paint and either figurative or abstract in content* has changed. If we view a painting by Rauschenberg after going through Olafur Eliasson's exhibition, I venture to assert that the painting will be viewed through an optic that has been slightly changed and met with a body that has experienced itself in a new and different way.

As a museum we have a duty to absorb these experiences – at least in our dealings with contemporary art. The exhibition *Michael Kvium: Jaywalking Eyes* at AroS in 2006 shows an artist whose paintings are characterised by a figurative, traditional expression rooted as far back as the masters of the seventeenth century, so one can really speak of *a square, flat surface covered with paint and figurative in content*. However, in the exhibition these paintings, of which there are over a hundred, were presented in a quite new way. They were hung without reference to chronology and thus avoided the common curatorial approach to painting as something to be experienced in a linear way. In various places they extended from floor to ceiling in expressive, mosaic-like hangings, while elsewhere they had coloured background walls and were accompanied by specially laid carpets. In this case, the physical sense of locality is put

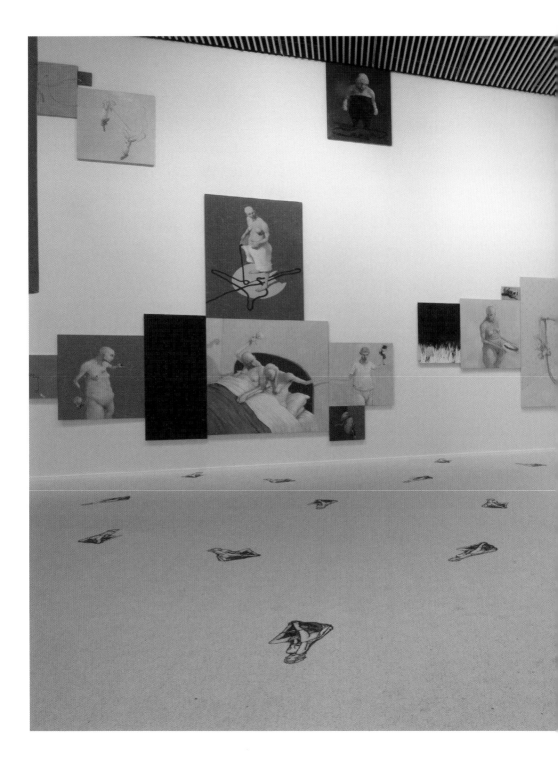

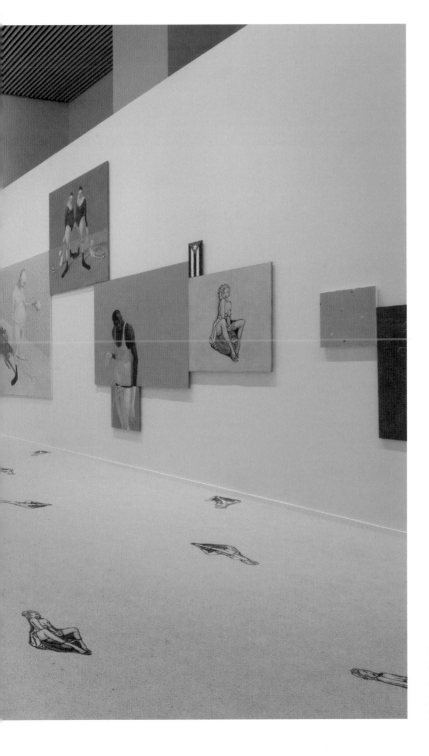

Installation shot from
the show *Michael Kvium
– Jaywalking Eyes*, ARoS
2006. Photo: Ole Hein
Pedersen.

out of action, preparing the ground for a spatial and physical disorientation that challenges the subject's autonomy.

The experiences resulting from the expanded field of art influence both the creation and reception of contemporary painting. So of course there is a certain tension between painting and the other art forms within the museum institution – a tension I consider very productive indeed. However, I do not believe that it is because of anything as profane as determined gallery owners or art fairs that painting plays an important part in museums today – as suggested by some critics [see citation in the beginning of the article and note 1]. Of course, if you press a gallery owner and ask why painting circulates so much in the art system, the explanation will probably be that painting is *transferable* – limited in size, with decorative qualities, and yet quite unique here in the age of technological reproduction. If you ask a museum representative, on the other hand, the explanation will refer less to the marketing and financial implications and more to the maintaining of an unambiguous history that is suited to general communication, that is, that painting simply *fits* into a long historical perspective.

The paradox, then, is that – as far as I can see – not a great deal of contemporary painting is bought and exhibited in museums of contemporary art. What is bought and exhibited is work by artists who have attained iconic or classic status on the art scene – from Picasso to Polke with Georgia O'Keefe as the only woman; but this is less because they are painters than due to their role in the history of art. To me, the tension between the art forms in our extreme visual culture, creating viewers with a much more expanded visuality than the one defined by the curatorial approach of the white cube, is the most interesting aspect in the contemporary museum. And to my mind the main task of museums is to stretch the canvas and set the stage for this tension and the encounter that is being enacted between these different art forms and visualities. Thus, for curators the focus must be on preparing the ground for a new visuality without any prejudices of media-specificity.

Note

1 Call for papers, *Contemporary Painting in Context*, section 3: "Painting, Institutions, Market".

Bibliography

Bourriaud, Nicolas (2002), *Postproduction: Culture as Screenplay: How Art Reprograms the World*, New York: Lukas & Steinberg.

Greenberg, Clement (1961), *Art and Culture: Critical Essays*, Boston: Beacon Press.

Ingemann, Bruno and Ane Hejlskov Larsen (2005), *Ny dansk museologi*, Aarhus: Aarhus Universitetsforlag.

Jensen, Mona (2004), *Pop Classics*, Aarhus: ARoS Aarhus Kunstmuseum.

Lacan, Jacques (1973), *Les quatre concepts fondamentaux de la psychanalyse*, Paris: Éditions du Seuil.

Larsen, Ane Hejlskov, ed. (2001), "Interzone 5: Fremtidens kunstmuseum", *Passepartout – skrifter for kunsthistorie* IX, no. 18, Aarhus: Aarhus Universitet.

Merleau-Ponty, Maurice (1972), *Phénoménologie de la perception*, Paris: Gallimard (1945).

Merleau-Ponty, Maurice (2000), *Kroppens fænomenologi*, Copenhagen: Det lille Forlag.

O'Doherty, Brian (1976), *Inside the White Cube: The Ideology of the Gallery Space*, Santa Monica: The Lapis Press.

Ørskou, Gitte (2004), *Olafur Eliasson: Minding the World*, Aarhus: ARoS Aarhus Kunstmuseum.

Ørskou, Gitte (2006), *Michael Kvium: Jaywalking Eyes*, Aarhus: ARoS Aarhus Kunstmuseum.

YBA Saatchi? – from Shark Sensation to Pastoral Painting

Chin-tao Wu

Introduction

Both YBA (young British artists) and Charles Saatchi have for the last decade or so been buzzwords continually on the lips of the chattering classes who so eloquently talk up the contemporary art scene in Britain today.[1] But what's in a name? Saatchi's has the advantage of covering an unusually wide and varied spectrum: collector, dealer, curator, publicist, self-publicist, trend-setter, aesthete, and power broker. After a decade of successfully branding and promoting a whole generation of young British artists, Charles Saatchi has transformed himself not only into a quintes- sentially British brand, but even, by now, into an institution. The extent to which Saatchi is able to exert power over the contemporary British art world is tellingly revealed by the fact that, when he opened his new gallery in London's County Hall in 2003, within walking distance of Tate Modern, both the Saatchi Gallery and the man himself were perceived as direct challenges to the hugely successful Tate Modern and its godfather/ director, Sir Nicholas Serota. When it came recently to celebrating the twentieth anniversary of his collecting career, it is significant that Saatchi chose to give the grandiloquent title of *The Triumph of Painting* to the ser- ies of three exhibitions he organised for 2005. This is a move that is both prospective and retrospective. This article sets out to investigate some of the reasons why this advertising-executive-turned-dealer/collector, hav- ing built himself an international reputation as a patron of cutting-edge art, of shock and sensation, is now turning to traditional painting on can- vas as the new love of his life. By looking into his commercial strategies,

his manipulation of the media and the art market, and the sales of some of the artists he has patronised, the article will attempt to answer the question, Why Be a Saatchi?, and offer an explanation of why painting should now have come to play so prominent a role in the professional activities of the U.K.'s leading contemporary art collector/dealer.

Publicity

Before proceeding, we need to point out one crucial aspect that must not be lost sight of, namely, that any research concerning Saatchi's operations will, whether we like it or not, be carried out according to the rules of the game as established by Saatchi himself. Apart from some auction sales which placed certain facts into the public domain, information on each and every one of Saatchi's dealings, selling as well as buying, is tightly controlled by the various publicity mechanisms that he employs. This is to say that we can know only what Charles Saatchi himself wants us to know about him and his operations. Those outside the closed circle of his personal network have to rely solely on published information, while those on the inside are not necessarily able to speak their mind freely. One consequence of this – and an ironic one – is that any writer on Saatchi is bound to add more oxygen to his vast publicity machine, and this reluctant complicity, of course, and alas, includes the present article and its writer.

The extent to which the phenomenal rise of YBA on to the international stage is to be explained by the patronage of Charles Saatchi is, of course, an intriguing and difficult question. Without the YBA generation of artists, Saatchi would arguably have been merely one name among many others in the art world. While the question who "made" whom is admittedly important for understanding how contemporary art functioned in the 1990s, it is more relevant for this article to investigate where Saatchi's power and influence are actually located and the many different ways in which he exercises that power and influence.

Saatchi's power comes directly from his money – that much is clear. The power he wields as a result of his economic capital is of course something of which he is acutely aware. When asked if he believed that the rich have any responsibility towards society, Saatchi's cynical and evasive reply was, "The rich will always be with us."[2] In other words, let us accept my being a multi-millionaire as a fact of life, and take it from there. The

difficulty with this approach, however, is that while there is no short-age of multi-millionaire/millionairess collectors of contemporary art in Europe, or in the world for that matter, Charles Saatchi occupies a unique position among them. Like other collectors, he collects; but unlike other collectors, he also regularly de-collects, and then re-collects. These three different operations obviously give Saatchi the edge over other collectors, but it is also these multiple activities that cause him to tread the narrow dividing line between collector and dealer.

In terms of collecting, Saatchi is distinct from other collectors in two respects; firstly, he is well-known for buying works from artists at a very early stage in their careers, barely out of the doors of art school. Secondly, and not unrelated to the previous strategy, he also conducts buying on a quasi-industrial scale, that is, he is well-known for buying the entire show of a particular artist. The combination of these two strategies enables Saatchi to buy cheap and sell dear, with huge profits should any artist in his stable then achieve blue-chip status on the market. It also means that, with the control of a substantial number of works in his hands, especially if they are perceived to be key works of a particular artist, he can dictate not only the exhibition agenda of that artist, but also the actual value of his or her works in the marketplace.

But what, above all, distinguishes Saatchi from other collectors such as Dakis Joannou from Greece, or Patrizia Sandretto de Rebaudengo from Turin, is his infallible capacity to place himself centre-stage and remain the focal point of media attention in both the quality newspapers and the tabloids, and to keep each and every journalist constantly on their toes.[3] One would, of course, expect an advertising mogul to have the skill to manipulate publicity, but the extent to which Saatchi maintains celebrity status and promotes his own brand is truly extraordinary. Trawling, for example, through London's four "quality" newspapers in search of mentions of Charles Saatchi (now a routine task thanks to electronic databases), you find his name popping up almost every day in an average week at the present moment (see Table 1 on the following page).[4]

To keep this gigantic publicity machine rolling, Saatchi has to generate a variety of media-enticing topics at regular intervals, in addition to the routine exhibition reviews he receives. But central to this media-savvy power is what the media like to see as his "media-shyness," his mysterious reluctance to speak openly about his operations to the press or elsewhere. As one commentator succinctly remarked, "Silence

Table 1 Number of search "hits" for "Charles Saatchi" in London's major newspapers

	1995	1996	1997	1998	1999	2000	2001	2002	2003	2004	2005	Total
The Times	35	24	53	40	56	65	56	64	118	95	72	678
The Independent	28	25	49	55	57	71	56	48	100	116	77	682
The Guardian	29	12	41	33	34	53	32	29	55	60	31	409
Daily Telegraph	N/A	N/A	19	11	9	15	42	61	71	98	56	382
Financial Times	17	6	13	13	8	18	11	3	26	34	28	177
Total	109	67	175	152	164	222	197	205	370	403	264	2328

* The Times, The Guardian, Financial Times and The Independent data are compiled from Lexis database; the Telegraph data are compiled from the Telegraph.co.uk website.

has been the currency of his power" ("Saatchi Talks at Last" 2004). It must be difficult for him to bite his lip and forgo the pleasure of hitting back at the press or correcting some of their more imaginative inventions. But it is precisely because of his hard-to-get attitude that people continue to pay attention to him. And when finally the piper decides to call the tune, everyone in the media seems obligingly to dance.

Over the last twenty years or so, Saatchi has authorised only a very small number of extended interviews. And even when he did grant an interview, it was reported that the journalist was under instructions not to quote him directly. It goes without saying that when Saatchi does choose to speak, the timing is of crucial importance. In 1999, when the *Sensation* exhibition at the Brooklyn Museum in New York stirred up controversy over Chris Ofili's *Holy Virgin Mary*, and when the then Mayor Rudolph W. Giuliani refused funding, Saatchi consented to an interview with Deborah Solomon from *The New York Times*, which was then reprinted in *The Guardian* (Solomon 1999a, 1999b). The most extensive published interview with Saatchi dates from December 2004 when *Art Newspaper* and Saatchi organised an email Question & Answer session, and this proved to be the first time ever that Saatchi has talked in detail about his collecting. Charles Saatchi's decision to place himself in the spotlight came at a critical moment when he was launching his planned year-long series of exhibitions *The Triumph of Painting* for 2005.

This provides a revealing insight into how skilfully Saatchi is able to manipulate media publicity. He is not only good at generating momentum and heightening expectations in advance of the event, but

also at exploiting the sort of discourse that will attract media attention. News of the *Painting* exhibition was released at the beginning of October 2004, a full three months ahead of its actual opening date. And none of London's four quality newspapers failed faithfully to report Saatchi's dramatic change of direction and his conversion from figurehead of the sensational YBA generation to that of a new age of seemingly "conservative" painting (Burleigh 2004; Higgins 2004a; Malvern 2004; Reynolds 2004). Saatchi called for a public debate on painting with a veiled criticism of the Turner Prize: "For the last ten years", he was quoted as saying, "only five of the forty Turner Prize artists have been pure painters" (quoted in Malvern 2004). To criticise the Turner Prize, openly or otherwise, is of course to rekindle what has been perceived to be the long-standing rivalry between Saatchi and Sir Nicholas Serota and the Tate institutions he directs, and this tactic was guaranteed to attract wide media attention. If one sees this announcement as some sort of foreplay, then the *Art Newspaper* interview, published at the end of November, just a month ahead of the exhibition, was surely intended as some sort of climax. In this interview Saatchi made the headline-grabbing claim that he had offered to donate his entire art collection, estimated to be worth around £200 million, to the Tate, but that the offer had been turned down by Serota (Brooks 2004). By generating a high-profile row, and by forcing the Tate to issue a reply denying that the offer had in fact been a gift, Saatchi secured a supply of free column inches in the press for several days in a row, in addition to all the publicity he had received before the actual publication of the interview. While it is not possible to decide on the merits of his claim and the Tate's counter-claim, what better means of keeping Saatchi's name in the forefront of public consciousness could he have found?

His unusual readiness to take part in a media exercise of this sort has also to be decoded in the context of Saatchi's increasing loss of status in the contemporary art scene in the U.K. Since the opening of the Saatchi Gallery on the south bank of the Thames, Saatchi's exhibitions have been much criticised, especially the *New Blood* exhibition which was launched in late March 2004 and which was "greeted by almost universal critical derision" (Higgins 2004b). A couple of months later a fire in an east London storage facility destroyed a substantial part of his YBA collection, further weakening his position. If the *ArtReview*'s power list of the top one hundred movers and shakers of the art world is anything

to go by, Saatchi's position fell to seventh in 2004 from sixth place in the previous year, and from first place in 2002.[5] The interview, along with its mischievous spat with Nicholas Serota, can thus be seen as a last-ditch attempt to regain the powerful position that he had enjoyed since the *Sensation* exhibition, and to ensure that the media would pay sufficient attention to his next big show, *The Triumph of Painting*.

Publicity/Collecting/Dealing

Interviews are, of course, only one of the numerous means that Saatchi uses to generate publicity. In a more "positive" light, Saatchi is known from time to time to donate works of art to various institutions and to set up various sorts of student bursaries. The former includes a donation of one hundred works to the Arts Council Collection in 1999 and of fifty paintings to Britain's hospitals through the charity Paintings in Hospitals in 2002 (*The Saatchi Gift*, 2000). For the latter, Saatchi orchestrated a much talked about auction sale of 130 works by ninety-seven artists which realised some £1.6 million in order to fund student bursaries for the four London art colleges in 1998.

But typically Saatchi's publicity stunts are of a more sensational kind. Stella Vine, for example, was reported to have found herself promoted "from complete obscurity to the art world's 'next big thing,'" thanks to the sale of her first painting to Charles Saatchi (Alleyne 2004). All the classical ingredients of the headline-setting agenda were there: as a single mother of 35 (with an 18-year-old son) who worked as a stripper, Vine seemed to be just waiting to be discovered by Saatchi. The £600 painting in question was a portrait of Princess Diana entitled *Hi Paul, Can you Come Over*. Given the mass hysteria surrounding the death of Princess Diana in 1997, it did not take Saatchi's sensitivity as an adman to know that anything to do with Princess Diana with a title like that was certain to create an immediate stir in the media. Saatchi's claim to have "discovered" artists such as Stella Vine in addition to the YBA generation, including the likes of Ron Mueck and Martin Maloney, contributed significantly to establishing his prominence and to confirming his position as arguably *the* leading collector of contemporary British art.

Claims that he is a skilful collector (if this is indeed the point) have to be seen in the context of Saatchi's capacity to buy and sell art. Two illustrations of Saatchi's ability to intervene in the art market are

commonly repeated in the media. One is what is widely considered to be his ability to set the auction price for particular artists. This is something that the Saatchi Gallery considers worthy of boasting about in their press releases, and something that journalists seem to be unusually eager to accept without discussion and to obligingly regurgitate. Unlike the practice followed by dealers in commercial galleries of not disclosing art market transactions, auction house sales can give the misleading impression of being more open to scrutiny, if not actually more "transparent." Auctions operate in the public arena and their records of sale prices are publicly available. The value of art works at auction seems, indeed, to be openly determined by public demand from amongst collectors and buyers from around the globe, thus validating the "real" market value of the work in question. But by playing, as they do, on the personal egos and the limitless acquisitiveness of the very wealthy, public art auctions are in fact open to manipulation. Ahead of *The Triumph of Painting* exhibition, and in an obvious effort to keep Saatchi's pet project of a painting exhibition in the news, Saatchi was reported to have broken the auction record of the South African painter Marlene Dumas by paying £666,000 for a portrait by her (Gleadell 2004b). But if breaking the record requires little more than a huge bank balance, what, one may ask, is there to boast of in the achievement?

The other aspect of Saatchi's power in the art market is his frequently sensational sale of art works connected with the YBA. Like other Saatchi media operations before this one, the news of the possible sale of Damien Hirst's shark in formaldehyde first appeared as a "rumour" (some might say a leak) towards the end of November 2004 (Gleadell 2004b). Then reports of possible deals followed regularly until finally the sale of the shark was signed and sealed in January 2005. A newspaper report would typically feature the original purchase price, in the case of Hirst's shark a reportedly £50,000 in 1991, and the subsequent sale price, reportedly between £6 million and £7 million. And for the more sensational journalists, the astronomical percentage of so-called "profit" would add more spice to the news of the magical Saatchi Midas touch. A *Daily Telegraph* journalist gleefully reported that Saatchi made an 11,538 percent profit with the sale of Marc Quinn's *Self*.[6] These figures are of course sensational for sensationalism's sake, carefully avoiding, for example, taking any account of the changes in the value of the pound between 1991 and 2005. But what is even more intriguing about Saatchi's dealings

is the little known fact that, in stark contrast to his imagined power over the market, the companies that he has set up to deal with his art enterprises have been consistently reported as making negative profits.

There are at least two companies with which Saatchi is associated in terms of his art trading activities: Danovo Limited and Conarco Limited (though two more, Marchill Ltd and Marchill Investment LLP, were registered in August 2005 at the same address as these two).[7] Several issues surrounding these companies are intriguing and mysteriously unclear. Firstly, Danovo, whose seventy percent majority shareholding is registered to Charles Saatchi (another thirty percent is owned by the trustees of a mysterious Upwards Pension Fund, concerning which any data are difficult to find), was set up by Saatchi to operate the Saatchi Gallery. Very few art galleries in the U.K. choose to register their companies under a different and non-transparent name.[8] Secondly, although there is no doubt that Saatchi is the "ultimate owner" of the gallery, or what the court record described as the "moving spirit" behind the gallery and the person who "owns and runs" it, Saatchi has never acted as a director of it.[9] A distance has thus been created between the name of the company and the gallery, and between the company and Saatchi's ownership of it. One cannot avoid wondering why. While Charles Saatchi and Saatchi Gallery constantly figure in the British media day in and day out, Danovo Limited has hardly been reported in the same media, and only the firm's involvement in a high-profile law case brought it to wider notice.

Thirdly, while the independently certified accounts for other leading commercial galleries such as the Lisson Gallery or the Sadie Coles Gallery are openly and easily available, the accounts filed by Danovo at Companies House are surprisingly vague. From the accounts up to 31 May 2004, it is known only that Danovo had net tangible assets and shareholders' funds of about £3.4 million, and no data are available either for its turnover or profit before taxation.[10] Nor is the company report for Conarco of any help in understanding Saatchi's operation in the art market (see Table 2). Conarco, one of only four companies (to my knowledge) to which Saatchi lends his name as director, declares that its "principal activity is to deal in works of art and antiques through its investment in the partnership of Conarco" [sic]. In stark contrast to the millions of pounds of profit sensationally and widely reported in the past from Saatchi's sale of art works, Conarco has consistently reported an

Table 2 Financial Profile of Conarco Ltd

PROFILE	3/31/2003	3/31/2002	3/31/2001	3/31/2000	3/31/1999	3/31/1998
	12 months	12 months	12 months	12 months	12 months	12 months
	GBP	GBP	GBP	GBP	GBP	GBP
Turnover	-1,440	21,036	-2,979		-4,788	-13,990
Profit (Loss) before Taxation	-2,940	19,421	-5,144	2,689	-5,176	-16,224
Total Assets	2,846,878	2,848,318	2,835,239	2,838,218	2,836,084	2,838,797
Total Assets less Cur. Liab.	2,826,515	2,829,455	1,701,541	1,706,685	1,703,996	1,707,097

PROFILE	3/31/1997	3/31/1996	3/31/1995	3/31/1994	Average
	12 months	12 months	12 months	12 months	10 years
	GBP	GBP	GBP	GBP	GBP
Turnover					-432
Profit (Loss) before Taxation	-12,029	-10,508	-16,281	-69,776	-11,597
Total Assets	2,852,787	2,850,922	2,869,250	2,874,917	2,849,141
Total Assets less Cur. Liab.	1,723,321	1,735,210	1,744,232	1,760,164	1,943,822

annual loss, except for the accounting years ending in 2002 and 2000. Even then the profit for these two years was very meagre (£19,421 for 2002 and £2,689 for 2000). It is therefore ultimately puzzling that such a shrewd businessman as Saatchi should allow his companies to make such a consistent financial loss.

There are, then, two sides to the Saatchi marketing operation, the glamorous and successful, lending itself to endless publicity, self-promotion and hype, and the darker, wheeler-dealer side with its lack of transparency and its apparent insolvency, artfully concealed from public view. To create and sustain the glamorous image it is often necessary for the less glamorous mirror image of mystery and ma-nipulation to be brought into play. This is particularly true for the latest visitor figures that the Saatchi Gallery released for *The Triumph of the Painting* exhibition. Under the headline "Saatchi Painting Gamble Pays Off", the *Daily Telegraph* told us that 360,000 visitors, a "world record for a contemporary art exhibition", were reported to have attended the show, the figures being, of course, Saatchi's own, without any attempt at

independent verification (Reynolds 2005). Teaming up with the *Sunday Times*, the Saatchi Gallery made available to visitors "an exclusive 2-for-1 ticket offer", despite the fact that, in the gallery's lawsuit with its landlord (which ultimately meant that the gallery had to leave London County Hall) this was precisely one of the issues in dispute, namely, that the Gallery had illegally breached its tenancy terms in relation to their profit-sharing formula with its sub-landlord, Cadogan Leisure Investments.[11] In addition, the Saatchi Gallery followed the practice of hiring ten or so young people whose job it was to patrol immediately in front of the gallery to solicit passers-by to enter the gallery by offering them a free T-shirt. Every member of this team was awarded an extra £10 if he or she managed to get 350 people in each day. But presumably in a drive to boost the visitor figures even more, a new bonus scheme replaced this one, involving simply a commission of 50 pence per head for every visitor they enticed to enter, in addition, that is, to the miserly minimum wage of £4.85 per hour that they earned.[12]

This sort of commercial gimmick to encourage the public to visit the Gallery and to boost its entrance figures brings us closer to the problematic role of Charles Saatchi and the way in which he operates in the world of contemporary art. Although Saatchi has always been publicly referred to as a collector, his whole enterprise of buying, selling, and operating his gallery brings his role much closer to that of a dealer. Almost all the public galleries in Britain are free; so are commercial galleries. An entry ticket to the Saatchi Gallery, on the other hand, is dear (£9.00 and £6.75 for concessions). While commercial galleries are, in fact, places that deal in, and sell, works of art, the Saatchi Gallery was not the kind of shop where you can just walk in and purchase art on the spot. The impression it gives is that it displays its art for the public good and has no commercial agenda. But actually no other public art gallery or commercial gallery has ever attempted to market its exhibitions by exploiting the same commercial gimmicks that one usually associates with supermarkets selling shampoo or ice cream. If the elevation of the human spirit is indeed one of the purposes of art according to bourgeois ideology, Saatchi has certainly managed to bring art down into the cut-and-thrust of the marketplace.

Publicity/Collecting/Dealing/Power/Art Institution

Saatchi's economic and cultural power over the art market has, of course, to be seen in the context of his power and influence in other spheres of British social and political life. He and his brother Maurice (now Lord) Saatchi were part of the inner circle of advisors to the former British Prime Minister Margaret Thatcher. Not only was Saatchi & Saatchi, their former advertising company, the world's biggest advertising agency in the mid-eighties, but also, and closer to home, it was they who ran Thatcher's election campaigns, thus giving them a powerful base for political power. When the Labour Party came to power in 1997, the brothers' company M&C Saatchi continued to obtain valuable commissions from the Labour government. When Maurice Saatchi became co-chairman of the Conservative Party in 2003, the political power of the Saatchis reached its climax. As Pierre Bourdieu points out, cultural capital, economic capital and social capital (and why not political capital as well?) are interchangeable. This is not to say that Charles Saatchi is necessarily able to exercise direct political power, but it can be argued that he has easy access, potentially at least, to the corridors of political power. On a more personal level, when he married the British self-styled domestic goddess Nigella Lawson, the TV celebrity cook and daughter of former Tory chancellor Nigel Lawson, in 2003, his intricate social and political network of contacts was significantly expanded.[13] It is not surprising to find Mr and Mrs Saatchi being referred to as a "power couple".

Saatchi's power in the art market and over other art institutions is not, however, to be seen as a permanent feature of the cultural landscape. His losing the lawsuit with his landlord in October 2005 and being evicted from London's County Hall was a sign of an over-inflated ego ready for deflation. If one sees the *Sensation* exhibition in New York as a sort of peak in Saatchi's power, when he was able to exert influence across the Atlantic and stir up a great deal of media brouhaha involving Hilary Clinton and Rudolf W. Giuliani, there has been no event since then which has enabled him to enjoy anything as comparably high profile. Indeed, since the relocation of the Saatchi Gallery to the South Bank in April 2003, Saatchi's reputation has been on the decline. As the American curator Robert Storr put it: "It is long past the time when anyone could speak of Charles Saatchi as collector." Saatchi is, as he bluntly put it, "a speculator" (Storr 2005). This criticism has a lot to do with Saatchi's

lack of consistency in collecting, a quality that is widely perceived as a pre-requisite to building a valid collection. Saatchi is no leopard when it comes to changing spots; as one *Times* art critic unkindly put it: "Saatchi changes his taste when he changes wives. In his Nigella years, he's been rewound to his toddler stage" (Gill and Januszczak 2005). His lack of consistency is such that it can jeopardise his credibility and leads to his judgement being devalued. When a substantial part of the Saatchi collection was destroyed by fire at the Momart storage facility in May 2004, he was quoted as saying that the works lost were "irreplaceable in the history of British art" (Aspden 2004). A few months later, when asked for his thoughts on the history of British art in the late twentieth and early twenty-first centuries, he replied that "Every artist other than Jackson Pollock, Andy Warhol, Donald Judd and Damien Hirst will be a footnote" ("I Primarily Buy Art", 2004: 31).

To properly understand Saatchi's dual operating skills in the media and in the art world, his rise to power in the 1990s has to be placed in a wider historical, geo-economic and geo-political context. Compared to other European collectors such as Dakis Joannou from Greece, Patrizia Sandretto de Rebaudengo from Turin, or Ingvild Goetz from Munich, Saatchi has the immeasurable advantage of having London as his operating base. As the capital of a highly centralised state, London has over the decades developed a complex structure of art-support systems, networks and markets that nourish a whole variety and generation of different art professionals, including artists, curators, art writers and critics and dealers. It is well developed not only in the public sector, with regard to its various art schools, the Arts Council's grant-giving mechanisms, and the London Art Board, but also as a complex commercial art market with all the major international auction houses, and hundreds of commercial galleries and dealers. What London's contemporary art world has to offer is not likely to be duplicated, for example, in Athens, even though Greece is a highly centralised state too. In other words, while other European collectors operate at best like oases in a desert, whether their base is in the country's capital or not, Saatchi operates much more like a fish in water, swimming easily and congenially in a beneficial and supportive environment. Without the whole art structure that London offers, Saatchi could not possibly have reached the position of power that he has.

Among the substructures of the contemporary art world that facilitate Saatchi's power, the most tangible and the most obvious is

the existence of a whole circle of what, for lack of a better term, might be called "courtesan" journalists and writers – people, in short, who are ready to report whatever Saatchi has leaked, released or whispered in their ear. Take the example of Saatchi's row with his landlord: on 28 September 2005, before the formal legal proceedings scheduled for October 2005, all five major British newspapers, whether left or right on the political spectrum, dutifully reported that Saatchi was moving his gallery out of County Hall in 2007 because of an "endless campaign of petty unpleasantness" and the "malevolent atmosphere" created by his landlord, which made it impossible for his gallery and his staff to continue working there (Malvern 2005). Although *The Guardian*, *Financial Times* and *The Independent* had mentioned in passing that the Japanese company's side of the story was not available for report, all the newspapers based their accounts solely on the Saatchi Gallery's press releases and what its media spokesperson and Saatchi had put out. No attempt at impartial reporting was made, even though by early 2004 two court judgements were widely and easily available on the Internet. In one of the judgements, the court recorded that Saatchi was reported to have subjected his adversaries to "collateral allegations of a most serious nature" and to "covert investigation by private investigators," the latter charge being one to which Saatchi has readily admitted.[14] Biased reporting on this scale shows that what is needed in order to create and sustain media power is more than a few uncritical and acquiescent journalists; it requires a whole circle of complicit media collaborators who are eager and willing to be spoon-fed by Saatchi.

Complicity of this kind, be it conscious or inadvertent, probably has a lot to do with what seems to be some sort of national pride among the British. It has always been said that British culture is not a very visually orientated one. Although since the post-war years a few individuals such as Henry Moore or David Hockney have become well-known figures in the international art world, they remain individuals and isolated cases.[15] What has been lacking is a group of artists with a clear and recognisable identity capable of drawing the world's attention to the British art scene as a whole. Whatever the reservations one may have about the YBA generation, they at least succeeded in creating a moment and a situation in which vitality was injected into contemporary art practices in Britain and thus capturing the world's attention. This explains, at least partially, why most British art journalists are favourably disposed towards the art

and artists that Charles Saatchi has promoted in the past, and more than willing to dance to the tunes that he calls.

There are naturally other factors that underlie Saatchi's rise to power and related issues. Among these we have time to mention, but only briefly, friendly art professionals who, collectively, have had an important role to play in facilitating his activities and shaping his image, journalists who have, with few exceptions, been well disposed to Saatchi and his agenda, and art bureaucrats and curators from the public sector have proved to be equally accommodating to his plans and ambitions. Quite how and why this unusual state of affairs has come about, and what the special circumstances are that could explain such unanimity, is still, from the vantage point of the present, far from clear.

The Triumph of Painting

The portrait I have painted of Charles Saatchi as a collector/dealer and his various enterprises in the art market has, I hope, answered my own question, "YBA Saatchi?" However, his venture into painting had something of a chequered beginning; the triumph of Saatchi's glorious announcement of *The Triumph of Painting* was not realised; rather, it was on something of a roller coaster for a considerable time. It was announced triumphantly and had an auspicious start. In the middle of 2005, it was optimistically expanded from three to six parts, stretching over not one but two and a half years (see Table 3). Then all of a sudden, as a result of the County Hall eviction fiasco in October 2005, the noise and fury suddenly fell silent: the whole enterprise, as readers of the Saatchi Gallery website were then euphemistically informed, had been put "on hold". Painting in the hands of a fickle collector/dealer like Saatchi is far from having a certain future, still less a stable present.

But why painting in the first place? The question is not easy to answer. There is, as I have already explained, a consistent wall of silence and secrecy surrounding Saatchi's operations, and when I tried to ask those people who are widely known to be associated with him, the typical answer was: "Sorry I can't be more helpful – and good luck in your quest." Having attempted to put bits and pieces of the jigsaw puzzle together, I have to admit that my answer is frustratingly incomplete, with large blank spaces still left in the overall picture. However, one of the art world figures within Saatchi's inner circle did mention in passing, in something

Table 3 The Triumph of Painting exhibition schedule*

Part I: 26 January 2005 – 3 July 2005	Martin Kippenberger; Peter Doig; Marlene Dumas; Luc Tuymans; Jörg Immendorff; Hermann Nitsch
Part II: 5 July 2005 – 30 October 2005	Albert Oehlen; Thomas Scheibitz; Wilhelm Sasnal; Kai Althoff; Dirk Skreber; Franz Ackermann
Part III: 4 November 2005 – 5 February 2006	Matthias Weischer; Eberhard Havekost; Dexter Dalwood; Dana Schutz; Michael Raedecker; Inka Essenhigh
Part IV: 10 February 2006 – 7 May 2006	Daniel Richter; Stefan Kürten; Lothar Hempel; Jonathan Meese; Andy Collins; Wangechi Mutu; Tal R; Amy Sillman; Ena Swansea; Jules De Balincourt
Part V: 12 May 2006 – 5 September 2006	David Thorpe; Cecily Brown; Hernan Bas; Christoph Ruckhäberle; Till Gerhard; Joanne Greenbaum; Lucy McKenzie; Barnaby Furnas; Johannes Wohnseifer; Tilo Baumgartel; Muntean & Rosenblum
Part VI: 12 September 2006 – 12 April 2007	New Young Artists

* The artists due to feature in the planned six-part exhibition were substantially changed over the course of 2005. This table is compiled from material available on the Saatchi Gallery website before it was closed down by court order in October 2005. Part III and beyond have not therefore taken place.

of a throw-away remark, that the reason he was buying paintings was "[p] robably because they are fashionable." Fashion in the art world is as fickle as it is elsewhere. As a topic of discussion, the return of painting does not come up as often in Britain as it does in France, for example, where it has been described as a false debate, a "chestnut" in journalistic jargon, that comes round every year just like the holidays or the opening of the hunting season. There have, however, been signs over the last few years that painting was indeed making a comeback in Britain as well as in Europe (Blain and Lamy 2002: 80). It was reported, for example, that ninety-eight percent of students enrolled at Goldsmiths College in London wished to follow a painting course in 2003, and this in a college that used to be considered the headquarters of conceptual art and the place that nurtured the majority of the YBA generation (Ezard 2003). A *Financial Times* journalist could herald a "perfect climate for painting to triumph" in 2005,

with the painting exhibitions held at various galleries in London during the year apparently being the ones that received the most media coverage and the greatest commercial success (Coxhead 2005).

In an interview in *The Art Newspaper*, Saatchi was in fact asked whether, in devoting his exhibitions exclusively to painting, he was setting a trend or following one. He typically did not answer the question directly, but went on to say that "[p]eople need to see some of the remarkable painting produced, and overlooked, in an age dominated by the attention given to video, installation and photographic art. Just flick through the catalogues of the mega shows, the Documentas, the Biennales, of the last 15 years" ("I Primarily Buy Art", 2004: 30). Judging from past experience with Saatchi, it is not what he says that counts, but what he does not say and what he actually does. What this also means is that we have no means of knowing the real reasons that have motivated him in his conversion to painting. It is certainly true that the various Documentas and biennales over the last fifteen years have been largely taken over by videos and installations, but if biennales are any guide, there does seem to be signs of a return to painting in the most recent ones, such as the 2005 Venice Biennale and the Lyon Biennial. In the Italian Pavilion, for example, where the curated show is often taken as representative of the entire Venice Biennale, just over a quarter of the artists could be traditionally defined as painters.

The fact is that painters have always been with us, and they have for centuries formed as it were the backbone of the art establishment. Their eclipse some years ago by the new technological media attracted little critical attention at the time, and it is only now, when painters are beginning to re-emerge on to the exhibition scene, that observers are led once again to take notice of their existence. Even in the case of Saatchi, painting has always had a presence in his collection. In the *Sensation* exhibition, for example, that caused so much controversy, about thirty percent of the artists exhibited were actually painters, including the most famous (or notorious) of them, Chris Ofili, Jenny Saville, and Gary Hume. It was certainly an exaggeration to say that *The Triumph of Painting* was a "change of heart" or a "volte-face of a lifetime" for Saatchi. What was a new departure, however, was the exclusive and extended concentration on the single medium of painting.

But what is more intriguing in the exhibition is that Saatchi has changed from concentrating on "pure" British art works to showing

European and international, in particular German, works. In his planned six-part exhibition, German painters were to have outnumbered painters from any other country (see Table 4). But numbers do not tell the whole story. For the first two exhibitions, each featuring six painters, German artists were given pride of place. The first part of the exhibition featured Jörg Immendorff and Martin Kippenberger, while the second part was almost wholly devoted to German painting (including Albert Oehlen, Thomas Scheibitz, Kai Althoff, Franz Ackermann and Dirk Skreber), the exception being one solitary Polish painter, Wilhelm Sasnal. In the absence of any obvious explanation for this, one is reduced to conjecture. If my past work on corporate sponsorship and corporate art collections is any guide, Saatchi's venture into buying German painting may well have something to do with the fact that the advertising company M&C Saatchi, which he and his brother set up in 1995, had plans to expand into the European market, with German expansion scheduled for 2006. This may sound too arbitrary an explanation or even too conspiratorial, but in corporate hands art has always been used as a promotional instrument, in particular when the intention is to break into a new market. It may also sound strange to speak of art in nationalistic terms, given the present centralising direction of the European Union; but by raising the profile of German painting in London, one can more or less guarantee positive media coverage in Germany. What better and ostensibly more inno-cent way can there be of getting the name of Saatchi into the European newspapers and prestigious art magazines?

Whether or not Saatchi's six-part painting exhibition will eventu-ally continue as planned, or come to the same sort of abrupt end as his gallery at County Hall, remains to be seen. While critical comment on this side of the Atlantic has, predictably enough, been muted, the American curator Robert Storr was more outspoken in his appreciation of *The Triumph of Painting* when he compared it to "a low-budget showcase movie for a failing studio that has cashed in on the expiring contracts of its older actors in order to launch cheaper new talents" (Storr 2005). As for Saatchi's most intimate motivation for buying art, he is, I think, unlikely to subscribe to the provocative views advanced by the former director of the Metropolitan Museum, Thomas Hoving, when he enthused: "Art is sexy! Art is money-sexy! Art is money-sexy-social-climbing-fantastic!" (quoted in Buck and Dodd 1991: 63). Indeed, Saatchi is on record as declaring: "I don't buy art to ingratiate myself with artists

Table 4 Origins of Artists in The Triumph of Painting Exhibitions and Countries Where They are Working

Countries of Origin	Total	Currently Working in	Total
Germany	15	Germany	17
USA	8	USA	11
UK	5	UK	4
Austria	2	UK and Austria	2
Israel	2	Denmark	2
Belgium	1	Austria	1
France	1	Belgium	1
Hungary	1	Poland	1
Japan	1	Trinidad and Tobago	1
Kenya	1	Total	40
Netherlands	1		
Poland	1		
South Africa	1		
Total	40		

or as an entrée to a social circle" ("I Primarily Buy Art", 2004: 31). When, on the other hand, he maintains that his ultimate aim is philanthropic, to buy art to show to the public at large in exhibitions, his actual words were, "I primarily buy art to show it off". Perhaps what he actually means to say is, "I primarily buy art to show off" – to show off his taste, his power and his influence, all the things, in short, that only his vast wealth can buy.

* I should like to acknowledge a generous grant from the National Science Council of Taiwan which enabled me to undertake this research project.

Notes

1 A shorter version of this article was delivered as an invited paper at the Third International Conference of the Novo Nordisk Art History Project *Contemporary Painting in Context*, held at the Royal Academy of Fine Arts and Louisiana Museum of Modern Art, Copenhagen, Denmark, in November 2005.

2 See "I Primarily Buy Art" (2004: 29). The ironic reference is to the well-known Biblical quotation, "The poor always ye have with you"; see *St John's Gospel*, ch. 12, v. 8.

3 Dakis Joannou is referred to as "Greece's equivalent to Charles Saatchi"; see Gleadell (2004a).

4 Searches of this kind include, of course, substantial discussions on Saatchi and his related businesses as well as simple mentions of his name. The latter are of significance in understanding how Saatchi has become a yardstick for his collecting activities, for example.

5 In the 2005 list, he fell further to nineteenth place; see "Power 100" (2005).

6 Saatchi bought *Self* for a reported £13,000 in 1991 and sold it for a reported £1.5 million; see Reynolds (2005a).

7 The address is 77 Eaton Square, London SW1W 9AW.

8 From 9 January 2002 to 6 August 2002, the company was briefly called Saatchi Gallery (County Hall) Limited.

9 *Shirayama Shokusan v Danovo* [2004] EWHC 390 (CH).

10 The account was filed, unusually, for the 18 months ending 31 May 2004, rather than the normal practice of 12 months; see company report for Danovo Limited, from FAME database.

11 *Shirayama Shokusan v Danovo* [2003] EWHC 3006 (CH).

12 Oral evidence from two such employees informally interviewed on 7 September 2005.

13 Nigella Lawson's father Nigel Lawson was the Chancellor of Exchequer under Margaret Thatcher between 1983 and 1989. Nigella's brother Dominic Lawson was editor of the *Spectator* between 1990 and 1995, and editor of the *Sunday Telegraph* from 1995 to 2005.

14 *Shirayama Shokusan v Danovo* [2004] EWHC 390 (CH).

15 Henry Moore was of course highly promoted overseas by government institutions such as the British Council. Hockney, on the other hand, went into voluntary exile.

Bibliography

Alleyne, Richard (2004), "The 'Saatchi Effect' Has Customers Queuing for New Artists", *Daily Telegraph*, 28 February: 6.

Aspden, Peter (2004), "Art Fire Payouts Could Amount to 'Tens of Millions' Saatchi Collection", *Financial Times*, 27 May: 5.

Blain, Françoise-Aline and Frank Lamy (2002), "Peinture en France: Les Nouveaux Tubes", *Beaux Arts Magazine* no. 219: 78-85.

Brooks, Richard (2004), "Saatchi Turns a Cold Eye on Britart Legacy", *The Times*, 28 November: 3.

Buck, Louisa and Philip Dodd (1991), *Relative Values or What's Art Worth?*, London: BBC.

Burleigh, James (2004), "Saatchi's New Take on Art: Paintings are Back", *The Independent*, 2 October: 3.

Coxhead, Gabriel (2005), "A Perfect Climate for Painting to Triumph", *Financial Times*, 13 April: 15.

Ezard, John (2003), "Eyes Have It: Painters Target the Turner", *The Guardian*, 21 April: 7.

Gill, A. A. and Waldemar Januszczak (2005), "Is It Art or Artifice?", *The Sunday Times Magazine*, 9 January: 27.

Gleadell, Colin (2004a), "Ascent of a Collector", *Daily Telegraph*, 21 June: 16.

Gleadell, Colin (2004b), "Contemporary Market", *Daily Telegraph*, 29 November: 18.

Higgins, Charlotte (2004a), "True Colours? Sharks and Beds Take a Rest As Saatchi Turns to Paintings", *The Guardian*, 2 October: 9.

Higgins, Charlotte (2004b), "Creator of the Stuffed Horse Is Top Artist", *The Guardian*, 28 October: 3.

"I Primarily Buy Art to Show It Off" [Charles Saatchi interviewed by email] (2004), *The Art Newspaper* no. 153: 29-31.

Malvern, Jack (2004), "Saatchi Says Goodbye to Hymn… and Hello to Her", *The Times*, 2 October: 6.

Malvern, Jack (2005), "Feud with 'Petty' Landlord Drives Saatchi to Move His Collection", *The Times*, 28 September: 28.

"Power 100" (2005), *ArtReview* 58, November: 84.

Reynolds, Nigel (2004), "Saatchi's Latest Shock for the Art World is – Painting", *Daily Telegraph*, 2 October: 15.

Reynolds, Nigel (2005a), "Painting Are the New Pickled Sharks", *Daily Telegraph*, 28 May: 2.

Reynolds, Nigel (2005b), "Saatchi Painting Gamble Pays Off", *Daily Telegraph*, 15 September: 2.

The Saatchi Gift to the Arts Council Collection (2000), London: Hayward Gallery.

"Saatchi Talks at Last" (2004), *Prospect* , December: 67.

Solomon, Deborah (1999a), "The Collector", *The New York Times Magazine*, 26 September: 44.

Solomon, Deborah (1999b), "Citizen Saatchi", *The Guardian*, 28 September: 4.

Storr, Robert (2005), "The Curator's Verdict", *The Sunday Times Magazine*, 9 January: 30.

List of Contributors

Katy Deepwell is founder and editor of *n.paradoxa: international feminist art journal*. She is Reader in Contemporary Art, Theory and Criticism and Head of Research Training, University of the Arts, London. She is the author of *Dialogues: Women Artists from Ireland* (London: IB Tauris, 2005), co-editor (with Mila Bredhikina) of *Gender, Art, Theory Anthology, 1970-2000* (Moscow: Rosspen, 2005), and editor of *Women Artists and Modernism* (Manchester University Press, 1998), *Art Criticism and Africa* (London: Eastern Arts Publishing, 1997), and *New Feminist Art Criticism: Critical Strategies* (Manchester University Press, 1995).

Rune Gade is Associate Professor of Art History in the Department of Arts and Cultural Studies at the University of Copenhagen, Denmark. His general research area is contemporary art. Within this general field he has focused especially on the history and theory of photography, museology, performance studies and gender studies. He is the author of several essays on contemporary art and has co-edited *Symbolic Imprints: Essays on Photography and Visual Culture* (Aarhus University Press, 1999) and *Performative Realism: Interdisciplinary Studies in Art and Media* (Copenhagen: Museum Tusculanum Press, 2005).

Katharina Grosse is a German artist who lives and works in Berlin where she is Professor at the Kunsthochschule Berlin-Weissensee. Most of her work originates in the interstice between painting and site-specific installation art. She has exhibited in numerous museums and galleries all over the world, and her work is well documented in books and catalogues. Among the venues for her recent solo exhibitions are Neues Museum Nürnberg (2009), Galleria Civica di Modene (2008), Fundação Serralves, Porto (2007), De Appel, Amsterdam (2006), Palais de Tokyo, Paris (2006), Magasin 3, Stockholm (2004) and Kunsthallen Brandts Klædefabrik, Odense, Denmark (2004).

Jonathan Harris is Professor of Art History in the School of Architecture at the University of Liverpool, England. He is author and editor of many books, including recently (with Christoph Grunenberg) *Summer of Love: Psychedelic Art, Social Crisis and Counterculture in the 1960s* (Liverpool University Press and Tate Liverpool, 2005), *Dead History, Live Art?: Spectacle, Subjectivity and Subversion in Visual Culture since the 1960s* (Liverpool University Press and Tate Liverpool, 2007), *Writing Back to Modern Art: After Greenberg, Fried, and Clark* (Routledge, 2005), and *Art History: The Key Concepts* (Routledge, 2006).

Stephen Melville is Professor of the History of Art at Ohio State University, and author of *Philosophy Beside Itself: On Deconstruction and Modernism* (Minneapolis: University of Minnesota Press, 1986), *Seams: Art as a Philosophical Context* (Amsterdam: G+B Arts International, 1996), and, with Philip Armstrong and Laura Lisbon, *As Painting: Division and Displacement* (The MIT Press and Wexner Center for the Arts, 2001). He has written widely on contemporary art and theory as well as on the historical and conceptual foundations of art history.

Anne Ring Petersen is Associate Professor of Modern Culture in the Department of Arts and Cultural Studies at the University of Copenhagen, Denmark. She is the author of *Storbyens billeder. Fra industrialisme til informationsalder* ("Images of the City. From the Age of Industrialism to the Age of Information") (Copenhagen: Museum Tusculanum Press, 2002) and contributions to books such as *Ola Billgren. Måleri/ Paintings* (Malmö: Forlaget Bra Böcker, 2000), *The Urban Lifeworld: Formation, Perception, Representation* (Routledge, 2002), *Performative Realism: Interdisciplinary Studies in Art and Media* (Copenhagen: Museum Tusculanum Press, 2005) and *Fun City* (Copenhagen: The Danish Architectural Press, 2007) as well as catalogues on contemporary Danish artists. She is one of the editors of the series of anthologies with essays that stem from the conferences of the Novo Nordisk Art History Projects.

Barry Schwabsky is an American art critic and poet living in London. He is the author of *The Widening Circle: Consequences of Modernism in Contemporary Art* (Cambridge University Press, 1997), *Opera: Poems 1981-2002* (San Francisco: Meritage Press, 2003) and contributions to books and monographs on artists such as Alighiero Boetti, Karin Davie, Henri Matisse, Jessica Stockholder, and Gillian Wearing, as well as to *Vitamin P: New Perspectives in Painting* (Phaidon Press, 2002) and *The Triumph of Painting* (Saatchi Gallery/Jonathan Cape, 2005). Formerly Editor of *Arts Magazine* and Managing Editor of *Flash Art*, he currently co-edits the international review section of *Artforum*, and writes regularly for *The Nation*. He has taught at New York University, Yale University, and Goldsmiths College, among others.

Peter Weibel is Head of Zentrum für Kunst und Medientechnologie in Karlsruhe and Professor of Media Theory at the University of Applied Arts Vienna. His general research areas are contemporary art, media history, media theory, film, video art and philosophy. In his artistic and curatorial practices he has been working with conceptual art, performances, experimental film and computer art. He has been artistic advisor for the Ars Electronica since 1986 and has edited numerous books, including *Making Things Public: Atmospheres of Democracy* (The MIT Press, 2005) and *Iconoclash* (Karlsruhe: ZKM Center for Art and Media, 2002), both co-edited with Bruno Latour. Some of his other publications include *Gamma und Amplitude: Medien- und kunsttheoretischen Schriften* (Berlin: Fundus, 2004) and *Das offene Werk 1964-1979* (Hatje Cantz Verlag, 2007).

Chin-Tao Wu is Associate Research Fellow at the Institute of European and American Studies, Academia Sinica in Taiwan, and affiliated to University College London. Her general research areas are currently the globalisation of art, international biennials and the rise of diaspora artists. She is the author of *Privatising Culture: Corporate Art Intervention since the 1980s* (Verso, 2002), which has been translated into Turkish (2005), Portuguese (2006) and Spanish (2007). Recently, Wu has also published "Occupation by Absence, Preoccupation with Presence: A Worm's Eye View of Art Biennials" (*Journal of Visual Culture*, 2007), and "Worlds Apart: Problems of Interpreting Globalised Art" (*Third Text*, 2007).

Gitte Ørskou is mag.art. in Art History and (from 2001 to 2009) curator at ARoS Aarhus Kunstmuseum, Denmark. Since August 2009 she has been the director of KUNSTEN Museum of Modern Art Aalborg, Denmark. She has curated several exhibitions, among them *Hollywood Revisited* (2002), *Home Sweet Home* (2003), *Olafur Eliasson: Minding the World* (2004), *Michael Kvium – Jaywalking Eyes* (2006) and *Mariko Mori: Oneness* (2007). Her general research areas are contemporary art and visual culture. She has contributed to several books, and she has also contributed to and edited several catalogues, among them *Olafur Eliasson – The Blind Pavilion* (The Danish Pavilion, The 50th Venice Biennial, 2003), *Olafur Eliasson – Minding the World* (ARoS 2004) and *Modern Collection* (ARoS, 2004). In 2003 she was the curator of Olafur Eliasson's exhibition in the Danish Pavilion at the 50th Venice Biennial.